HOW TO DRAW
MANGA
FURRIES

The Complete Guide to
Anthropomorphic
Fantasy Characters

Hitsujirobo
Madakan
Muraki
Yagiyama
Yow

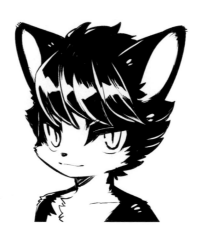

TUTTLE Publishing

Tokyo | Rutland, Vermont | Singapore

Contents

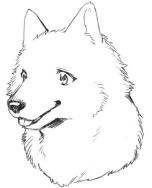

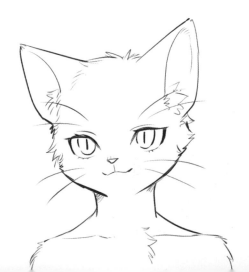

Welcome, Furry Fans!

Furries in the Spotlight

First off, thanks so much for picking up this book.

From the time of the ancient myths, legends of creatures that were half-human and half-beast have existed, from garuda and bastet to werewolves and minotaurs, only recently making their appearance as monsters in the world of games and manga. In fantasy and adventure tales set in other worlds, the flourishing animal anime scene has spurred the rise of a new type of mythical beast, slightly different from the traditional "monsters" of the past and who form their own genre: furries. They play a range of characters, from villain to sidekick to leading roles. Here we'll show you how to bring these compelling hybrids to life on the page or screen.

What's Inside

In this book, six categories of furries, including dog furries and cat furries are presented, starting with their physical structure and how to draw them. Counting subspecies and close relatives, there are 30 species of furries in total.

Furries of course are creatures that don't exist in reality. However, their foundations, their essential components, the elements that comprise them—humans and animals—do. We'll show you the tricks to drawing furries by introducing the physical characteristics and structures of the creatures that form each furry's foundations and explaining how to use the human figure as the base for combining them.

Apart from analyzing their bone structure, in order to explain the physical makeup of furries, we'll also look at how to draw their faces from the very first steps of blocking-in to the last whisker or tuft of fur. We'll also examine whether the creature is closer to being human or animal by looking at each body part—especially the limbs—in turn. The furry's appearance from various angles, capturing and expressing emotion and general tips for bringing your characters memorably to life are also covered. Whether you're a beginner just starting to draw furries or are more advanced and want to extend your range, this is the book for you!

Furries as Alternative Species

Furries can be reasonably seen as being a species separate from our own. However, just because humans and animals are different species doesn't mean that everything about them is different. Humans and animals have many similar features—skulls, ribs and toes, to name a few—that share basically the same construction. What do humans and animals have in common, and what's different about us? As you make your way through this book, consider your characters and your hybrid creations from the viewpoint of similarities and differences. They'll come all the more into focus for it.

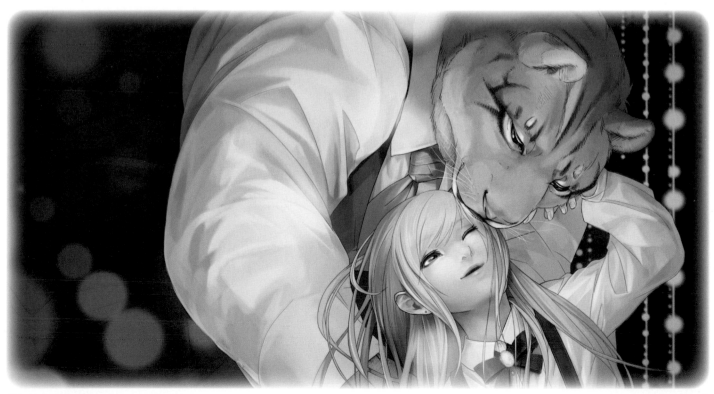

Illustration: **Yagiyama**

How to Use This Book

Imagination and Individual Taste

We'll show you the basics and you'll take it from there, adding unique and individual touches to your furry as you build it from the tail or paw up. In contrast to four-legged animals whose head and neck sections are not clearly divided, humans' heads are clearly distinct from their bodies. For this reason, our necks are a unique, extremely slender shape, a characteristic also seen in primates. Depending on whether or not this feature is incorporated on a furry determines whether its composition takes on a comical or realistic touch. It's details like these that will guide your characters as they come into focus. It's more than just fur, feather and scales.

Furries and anthropomorphic characters can be portrayed either comically or realistically. The two types have, in essence, the same bone structure and look, with only slight differences, very similar. You choose the direction you want to pursue!

Cat's face with a comical touch

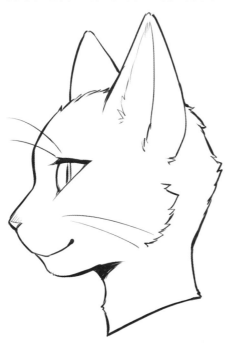

Goat's face with a realistic touch

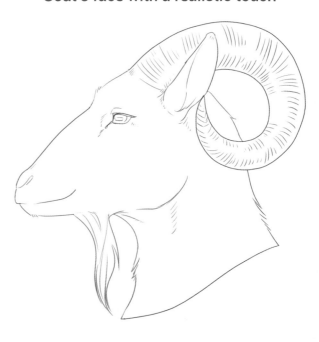

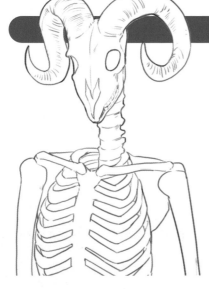

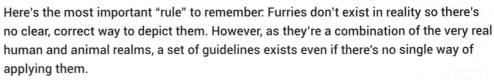

Design Hints

Here's the most important "rule" to remember: Furries don't exist in reality so there's no clear, correct way to depict them. However, as they're a combination of the very real human and animal realms, a set of guidelines exists even if there's no single way of applying them.

There's no one way to draw a furry, but convincing illustrations are easier to create if you focus on the basics: the skeleton and internal structure. So we've provided you with the essentials, the building blocks, the foundation or framework that will give rise to your wild or wooly human-animal hybrid. The rest is up to you and wherever your imagination takes you.

Chapter 1

Furry Foundations

What Are Furries Exactly?

What sort of creatures are furries? What are their characteristics and how should you create a base or template from which to draw them? Rather than designing them with no plan in mind, give a thought to the creature you're giving rise to.

Furry Facts

A furry fuses the human and nonhuman realms, tapping into the strengths and characteristics of each.

There are countless legends of such creatures, starting with the minotaur of ancient Greece or the werewolves that rose from the tales of northern Europe. These days, we're familiar with furries through their appearances as monsters and other characters in fantasy anime, comics and animated films.

Often, they're characterized as having the head of an animal and body of a human, with the skin, tail and other features also taking on animal characteristics. The structural elements of the body may also have animal characteristics, such as limbs and wings. They may also be given animal-like traits that form aspects of their character, such as walking on all fours in everyday life.

In this book, we'll mainly cover furries that walk upright, with a focus on the head, limbs, wings and other extremities of their base skeletons.

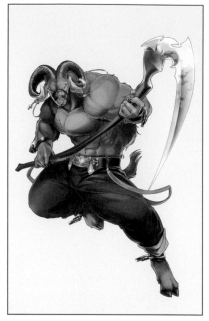

Illustration: **Yagiyama**

Furries' Origins

Before thinking about the design of your furry, consider its backstory or origin first. Was it born as a furry, or did it transform into one later? The degree of animal-like transformation and the affected body parts alter depending on the circumstances. Where did you furry come from and where is it going in the arc of your story? All important things to consider!

Villain

A species that has advanced to closely resemble beasts and humans

In the case of a villain, the characteristics of animals and humans are not acquired after birth, but rather the furry is born into the villain species. Think of it as developing so that its lifestyle as a beast and as a human intermingle. In this way, you can reflect the degree of development in your design by considering, for example, how its arms have developed or to what extent it has retained animal features in its feet.

Artificial Beast

A being engineered to combine human and animal traits

Genetic manipulation, magic, surgery: There are many ways of bringing about the transformations that result in a character combining different species. There's no limit to the number of creatures that can form the foundation. When combining multiple creatures, however, the degree of difficulty increases. Make sure your illustration is clearly defined.

Half-Blood

A hybrid born from the union of a beast and a human

A half-blood is a being born from the union of a beast (or a being with the appearance of one) and a human. It may also be the product of two different animal species. The focus is on which traits it has inherited from each of its parents. Because it's a highly fantastical form, this type of character affords more freedom in terms of how you design its inherited body parts.

Transformer

Having transformed from the original body to an altered state

We know the scenario: a curse turns a man into a snarling moonstruck werewolf. Magic is often the means of bringing these changes about. Whether temporary or permanent, the parts that are altered and the degree of transformation give you a chance to exercise artistic freedom. As in the case of a werewolf, be sure to really bring out the beast in your altered avatar.

Is It a Furry? What can be defined as a Furry?

What We Mean When We Say "Furry"

The established definition of the Japanese word for "beast," from which furry is derived, is that of "a creature covered in fur" and "a mammal that walks on four legs."

However, in this book, we work from the simple premise of a furry as being half-human, with the elements of a foundation animal comprising the other half. That other animal can be anything and need not have hair or be a quadruped. The animal, of course, doesn't even have to exist at all! The world of furries can accommodate anything your imagination can conjure.

Mammals

Classic furries

An existing species of animal that mostly bears live young that suckle. Most tame animals that live in close proximity to humans such as dogs and cats fit into this category. As many of the origin animals in this category are mammals, a significant number of internal structural body parts are similar.

Most species live on land, but their habitat also extends underground and into the water. Remember: Killer whales and dolphins that live in the sea are also mammals. As they suckle their young, combining this species with female furries works well.

Reptiles

Bodies covered by smooth skin and scales

This group of animals including crocodiles, snakes and lizards has scales that protect its skin. Most hatch from eggs and do not have any fur or feathers. Their outward appearance sets them apart from mammals, but like humans, they are vertebrates. In terms of their basic structure, their limbs, spine and ribs resemble that of humans. In recent years, Lizardman and other such furries have become popular in various fantasy formats.

Fantasy Creatures

Re-creating creatures that exist only in fantasy

Even mythical and fantasy creatures can be regarded as furries. Harpies and mermaids qualify. They exist as creatures in legends, while at the same time fulfilling the criteria to be identified as furries because they're half-human and half-creature. However, as we've limited the concept in this book to character with human bodies and animal-based heads, the fantasy creatures are limited to dragons only.

World Building

Before drawing furries, decide on the details of the world they will inhabit. Their forms may change significantly depending on the type of culture and lifestyle they lead in the world you're about to create.

Coexisting with Humans

Human culture vs. a culture that incorporates human characteristics

In the case of a world where humans and furries coexist and furries have entered into humans' daily lives, it's a lot of fun to consider the worldview. It's fine to think of furries as one of a race of humans, or conversely it might be interesting to think of a world where furries are the controlling or dominant presence and humans are in the minority.

It's easy to evoke the sense of a different world by having furries appear and feature in human society. Even if the setting is regular contemporary society, featuring a furry among the characters allows the reader to recognize that it's not exactly a normal world.

Furries are well-suited to the realms of fantasy, and even without introducing a special element such as magic, the presence of furries distinguishes the setting from the recognizable and the everyday and expresses a sense of the extraordinary.

Illustration: **Yagiyama**

Illustration: **Yagiyama**

A World Made up Exclusively of Furries

Charm with a worldview all of your own

In this worldview, humans hardly appear at all, with furries taking their place instead. The setting can be either a completely different world, or a world where furries have completely replaced humans.

In the type of world where furries simply replace humans in a story, their lifestyle is practically the same as that of humans and they're historically no different from humans—it's just that the characters are all furries instead. In this case, even if their heads are those of animals, their bone structure will basically follow that of a human.

In situations with different or alternative worldviews, it's necessary to carefully construct your characters' reality and setting. For example, you might want to consider how have the furries developed, how does their physical structure differ from humans'. In contemporary situations, dexterity is required to operate certain devices, such as a smartphone, so it becomes necessary to pay attention to the shape of the phone and other small objects. It's possible to overlook various details if you're focusing on the larger implications and realities of the world you're creating; either way, as an in illustration in which humans don't appear, it already contains a unique worldview.

Where Do They Live?

Imagining the parts that come from humans and the parts that come from animals

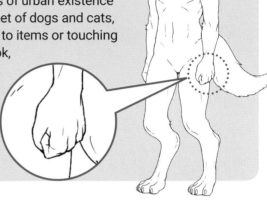

On land Picturing a terrestrial lifestyle

For furries that live on land, it's possible to imagine them living cultured, contemporary lives. If they're living in cities and leading lifestyles similar to humans, the trappings of urban existence can be factored into your world. Rather than retaining paws like the front feet of dogs and cats, five-fingered hands would make life much easier instead. When holding on to items or touching things, claws or large digits would present an inconvenience. So in this book, furries that live on land are designed to have hands similar to humans.

These characters also walk upright on two legs. In order to easily keep their balance, the joints are loosely angled. While the sections of paw that come into contact with the ground are small in real life, here they've been somewhat enlarged.

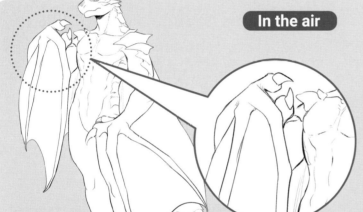

In the air Make the wing membranes larger for gliding

Furries have similar torsos to humans, meaning that unlike light-bodied birds, their body structure and weight make a lifestyle floating gracefully through the air difficult. For a feathered furry, it's fine to make the wings decorative rather than having the function of flight; just scale them down to a smaller size. The wyvern (two-legged dragon) in the picture is derived from the concept of a flying dragon. Its design is based on the premise that rather than having merely ornamental wings, making the wing membranes larger distinguishes the character as able to glide and soar through the sky.

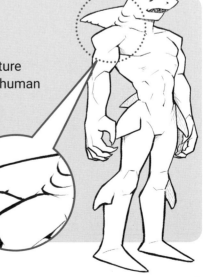

In the ocean Assume that the creature lives both on land and in the ocean and allow parts to remain

Aquatic furries are designed with an amphibious lifestyle in mind. Their bone structure includes a pelvis specifically designed for life on land. Their fins are also based on human ankle joints and divided into two.

On the other hand, it's assumed that they will also live in water, so the gills are clearly defined along the neck and the dorsal fin is prominent as well.

The dorsal fin stabilizes swimming and prevents the furry from being swept away by the current, so if the character has not abandoned life in the water entirely, include a dorsal fin in the design. For the same reason, other fins remain, essential for the realities of the amphibious life.

"Beastify" Your Characters: Step by Step

While *furries* is a catch-all term for this type of character, factors such as how animal-like they are and to what extent a creature can be called a Furry varies depending on who is drawing them. Here, the degree of "beastification" is divided into four steps to explain which parts change and in what manner.

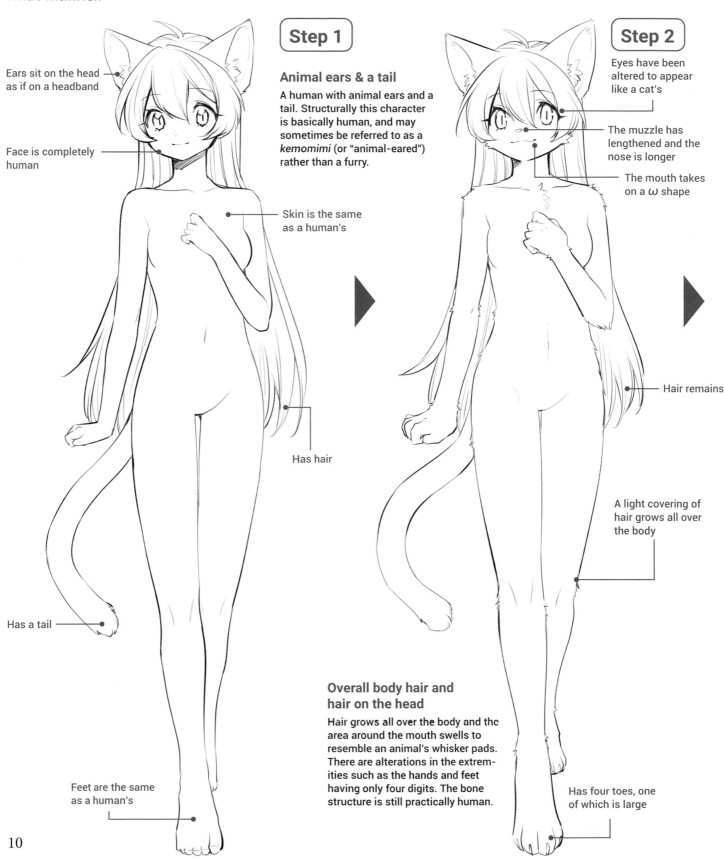

Step 1

Ears sit on the head as if on a headband

Face is completely human

Animal ears & a tail

A human with animal ears and a tail. Structurally this character is basically human, and may sometimes be referred to as a *kemomimi* (or "animal-eared") rather than a furry.

Skin is the same as a human's

Has hair

Has a tail

Feet are the same as a human's

Step 2

Eyes have been altered to appear like a cat's

The muzzle has lengthened and the nose is longer

The mouth takes on a ω shape

Hair remains

A light covering of hair grows all over the body

Overall body hair and hair on the head

Hair grows all over the body and the area around the mouth swells to resemble an animal's whisker pads. There are alterations in the extremities such as the hands and feet having only four digits. The bone structure is still practically human.

Has four toes, one of which is large

Treatment in this book

The furries easily recognized by the general public are those in steps 3–4. Of the steps laid out below, this book will focus on the furries featured in Step 3, where the structure of extremities such as the head and limbs resembles the animal they're modeled on. By introducing the characteristics highlighted in Step 3, Steps 1–3 will be explained to allow you to freely alter your designs, depending on how much you want to "beastify" your characters.

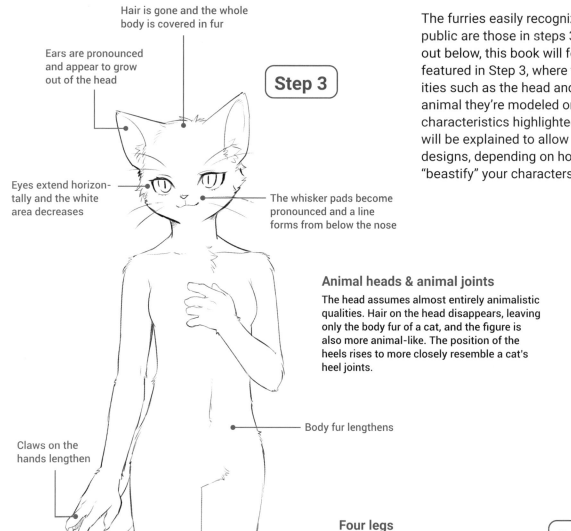

Hair is gone and the whole body is covered in fur

Ears are pronounced and appear to grow out of the head

Step 3

Eyes extend horizontally and the white area decreases

The whisker pads become pronounced and a line forms from below the nose

Claws on the hands lengthen

Body fur lengthens

The heel is raised

This part touches the ground

Animal heads & animal joints

The head assumes almost entirely animalistic qualities. Hair on the head disappears, leaving only the body fur of a cat, and the figure is also more animal-like. The position of the heels rises to more closely resemble a cat's heel joints.

Four legs

The figure has the same appearance as a real animal. The hands become forelegs and the creature walks on all fours. As the bone structure is that of a quadruped, the neck thickens to support the head and doesn't taper as a furry's would.

Step 4

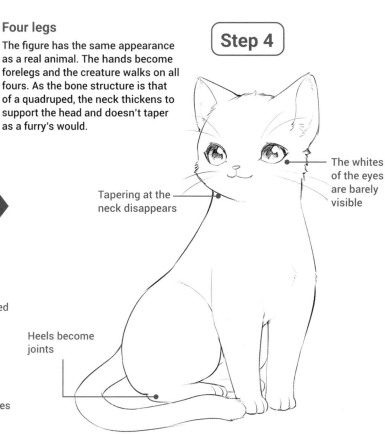

The whites of the eyes are barely visible

Tapering at the neck disappears

Heels become joints

11

Human-Animal Hybrids

At a glance, furries appear to have complicated structures. However, in reality, they can easily be constructed by alternately combining parts of humans and animals. Here, we look at various points on how to combine them.

The torso is human

Furries often have torsos that resemble those of humans. Whether or not they have fur, how thick the torso is and so on depends on the Furry. However, it is possible to consider that the basic structure of the torso is the same as that of humans.

The head is animal

Furries have animal heads. The eyes, shape of the head and so on are altered to some degree when combining the human and animal bodies.

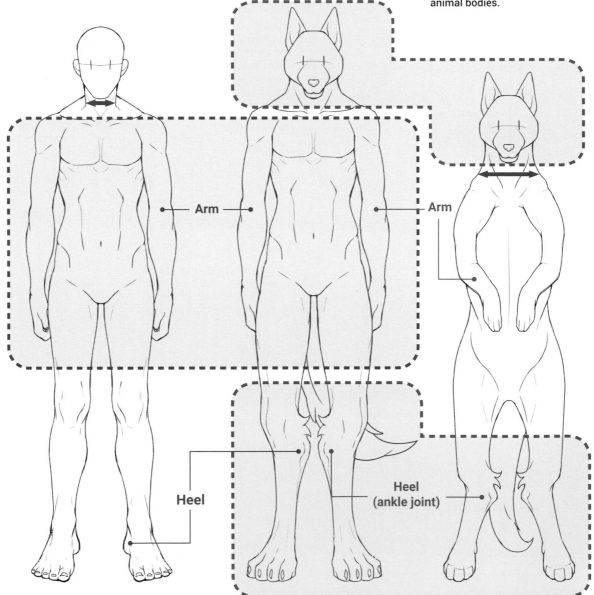

The feet are animal

The furries introduced in this book have feet similar to animals. In the case of mammals, the heel is the ankle joint, existing as a joint in a different position from where it's located on humans.

Human vs Animal Bone Structure

Although humans appear to have a unique bone structure when walking upright, once on all fours it is clear that their structure is similar to that of a dog. Here, we'll explain the similarities between animals and humans.

Basic bone positions are the same

Let's compare humans and dogs, which are both mammals. In the bone structure of humans, which have evolved from quadrupedal animals to bipedal animals, it's clear when looking at the leg bones and so on that humans have the same bones as dogs, which are quadrupedal animals. When humans are on all fours and supporting themselves only with their fingers and toes, their posture is the same as a dog or cat's regular posture.

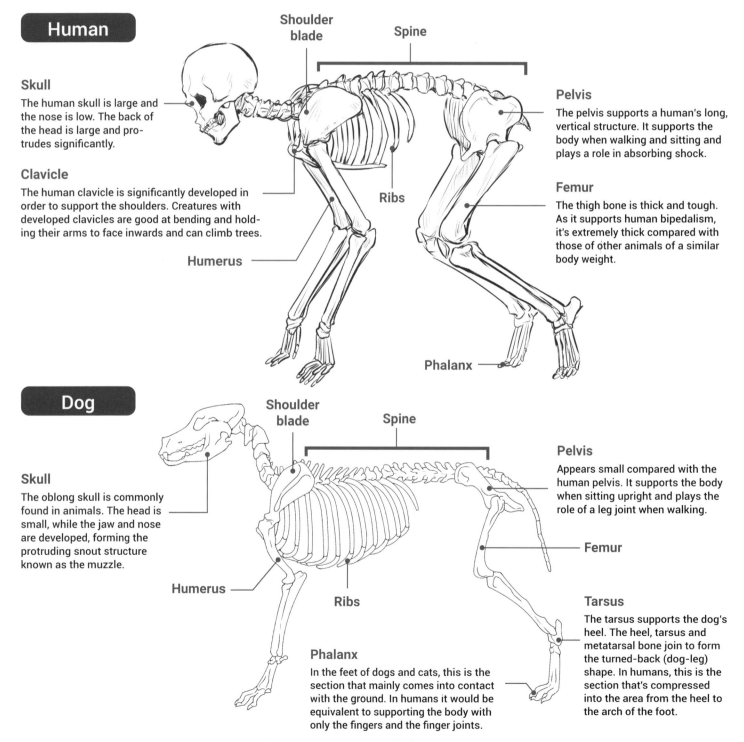

Human

Skull
The human skull is large and the nose is low. The back of the head is large and pro-trudes significantly.

Clavicle
The human clavicle is significantly developed in order to support the shoulders. Creatures with developed clavicles are good at bending and hold-ing their arms to face inwards and can climb trees.

Humerus

Shoulder blade

Spine

Ribs

Pelvis
The pelvis supports a human's long, vertical structure. It supports the body when walking and sitting and plays a role in absorbing shock.

Femur
The thigh bone is thick and tough. As it supports human bipedalism, it's extremely thick compared with those of other animals of a similar body weight.

Phalanx

Dog

Skull
The oblong skull is commonly found in animals. The head is small, while the jaw and nose are developed, forming the protruding snout structure known as the muzzle.

Humerus

Shoulder blade

Spine

Ribs

Phalanx
In the feet of dogs and cats, this is the section that mainly comes into contact with the ground. In humans it would be equivalent to supporting the body with only the fingers and the finger joints.

Pelvis
Appears small compared with the human pelvis. It supports the body when sitting upright and plays the role of a leg joint when walking.

Femur

Tarsus
The tarsus supports the dog's heel. The heel, tarsus and metatarsal bone join to form the turned-back (dog-leg) shape. In humans, this is the section that's compressed into the area from the heel to the arch of the foot.

Structure of Heads and Skulls

When trying to draw furries, the first wall that people hit is the muzzle (see Step 2 below). As the facial structure of animals is fundamentally different from that of humans, it can't be approached in the same way as a human's. Let's look first of all at the initial blocking-in stage.

Blocking-in shape A muzzle is attached to the basic form

❶ Blocking-in: circle

In order to understand the shape of the face, first of all use a sphere for the blocking-in. Next, draw the horizontal line across the center that forms the positioning for the eyes and the median line that determines the center of the face. The circle in the lower half is the blocking-in area designated for the muzzle.

❷ Blocking-in: muzzle

The muzzle is the part from the nose to the jawline that protrudes to form the snout of an animal such as a dog or a cat. In contrast to humans' faces, which are nearly flat, animals' faces are more three-dimensional.

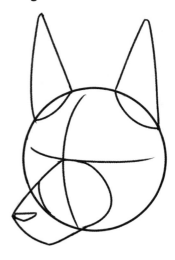

🐾 Check It Out!

Blocking-in for a human head
When blocking-in a human head, a long vertical oval shape is used. Be aware that when blocking-in an animal's head, a sphere or long horizontal oval is used instead.

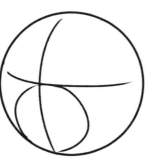

🐾 One More Thing!

Cup and sphere
In order to grasp the three-dimensional sense of the muzzle, image attaching a paper cup to your mouth.

Differences in blocking-in Let's look at the various blocking-in shapes for different creatures

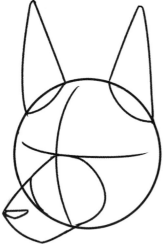

Blocking-in: dog
This blocking-in is for a basic dog face. The muzzle is long and extends down on a diagonal angle.

Blocking-in: killer whale
The blocking-in for the head is extended horizontally, and the muzzle protrudes like a beak.

Blocking-in: cat
Although a cat's face is relatively flat, the muzzle protrudes from the nose to the jaw. While not to the same degree as that of a dog, the tip of the nose is slightly below the center of the face.

Structure of Legs and Joints

The legs of a quadrupedal animal differ from a human's both in structure and how they maintain balance. Let's convert the joints for walking upright so that the body doesn't lose proportion or balance.

Tarsal joints

In the legs of quadrupeds, these may also be called reverse joints. However, they're properly referred to as tarsal joints. The joints aren't actually reversed, but rather the heel functions as a joint.

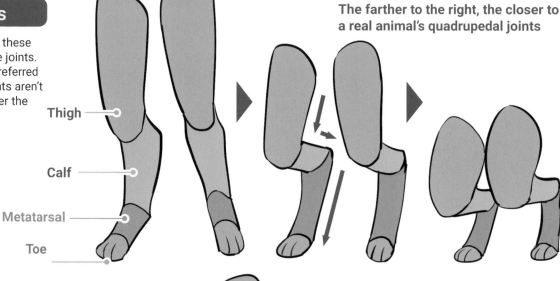

The farther to the right, the closer to a real animal's quadrupedal joints

Thigh

Calf

Metatarsal

Toe

Ease in finding the center of gravity

As the legs are extended, even if only a small part of the leg is in contact with the ground, the center of gravity is easily maintained.

Only this part is in contact with the ground

Angle and posture

When shifting the form of the joints to align with quadrupedal movement, the angle of the joints influences the posture. Extending the legs creates an upright form that makes for an easy walking posture. On the other hand, deeply bending the joints tilts the body forward and creates the need for assistance from the forelegs in order to balance.

The center of gravity is aligned, and the figure is balanced

The center of gravity is aligned, but the figure is slightly unbalanced

The figure tilts forward, creating a posture that's difficult to maintain without forelegs

Basics of the Eyes

The shape of the eyes alters the impression that a character's face makes. Here, we look at the shapes of human eyes and those of animals.

Basic Eyes and their Structures

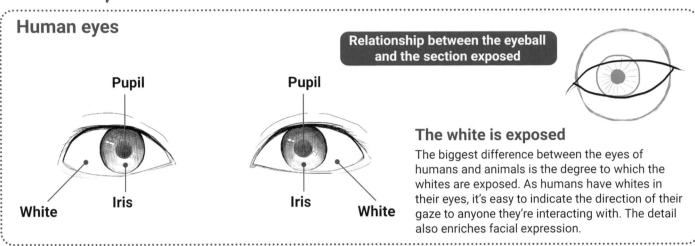

Human eyes

Pupil

Pupil

White

Iris

Iris

White

Relationship between the eyeball and the section exposed

The white is exposed

The biggest difference between the eyes of humans and animals is the degree to which the whites are exposed. As humans have whites in their eyes, it's easy to indicate the direction of their gaze to anyone they're interacting with. The detail also enriches facial expression.

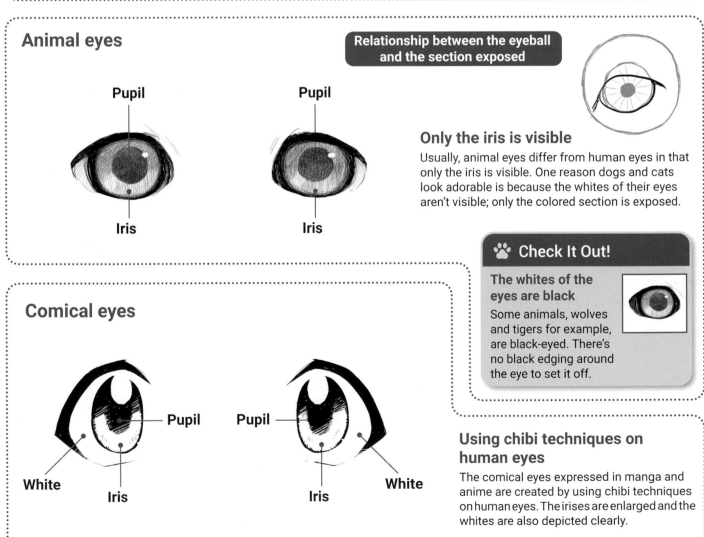

Animal eyes

Pupil

Pupil

Iris

Iris

Relationship between the eyeball and the section exposed

Only the iris is visible

Usually, animal eyes differ from human eyes in that only the iris is visible. One reason dogs and cats look adorable is because the whites of their eyes aren't visible; only the colored section is exposed.

> 🐾 **Check It Out!**
>
> **The whites of the eyes are black**
> Some animals, wolves and tigers for example, are black-eyed. There's no black edging around the eye to set it off.

Comical eyes

White

Pupil

Pupil

Iris

White

White

Iris

Using chibi techniques on human eyes

The comical eyes expressed in manga and anime are created by using chibi techniques on human eyes. The irises are enlarged and the whites are also depicted clearly.

Realistic Animal Eyes

Dogs

Have rounded pupils. Species such as wolves and huskies have pale-colored irises, for a striking impression. Lions, tigers and other large cat species also have pupils of this shape.

Cats

Have eyes with pupils whose shape contracts from a sphere to a long vertical shape depending on the amount of light. This is a common feature in small cat species and nocturnal animals. Foxes, which are in the Canidae family, have similar pupils.

Goats

Oblong-shaped pupils are found in goats, sheep and horses. Like other pupils, they get larger and rounder in dark places and narrower in the light. The oblong shape helps herbivores monitor a wide area around them to check for predators.

Birds

Birds have large round pupils within eyes that appear as exposed spheres. The eye on the right is that of an eagle while the eye on the left is that of a peregrine falcon. The impression made by the eyes changes depending on whether the luster in the eye is completely black or whether it's a pale color, creating a rounded appearance. Keep in mind also that eyes vary depending on the type of bird.

 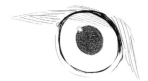

🐾 Check It Out!

Drawing realistic animal eyes

When drawing realistic animal eyes, block them in as triangle shapes. The reason for doing this is that animal eyes differ from human eyes in that they're exposed all the way up to the eyebrows. As the whites are not exposed in animals' eyes, draw the colored section of the eye all the way to the edge. Finally, draw in the pupil to complete.

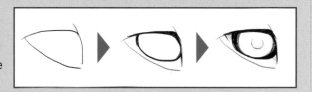

Altering the eyes completely changes the impression made

Let's see what happens when we incorporate comical eyes and real eyes into the same face. It's clear that even though only the eyes have changed, the overall look alters significantly. Choose the eye shape you think best fits the worldview of your drawing.

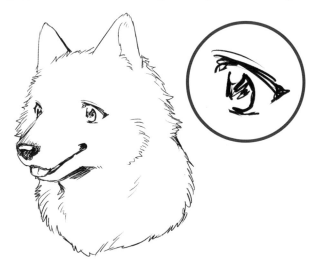 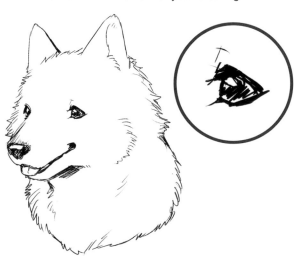

A Furries Matrix

Once you've grasped the basics, in order to create appealing furries, it's time to think about fundamental elements such as the design and skeletal structure. It's also possible to work in the reverse and create the worldview first to fit the furry you want to draw.

Visuals reflect the worldview

Monster types (real, cool)

A thick neck, piercing eyes and realistic looks inform this design. In fantasy works, these characters would often be classed as monsters. They make a strong impression on the viewer.

Unique worldview type (real, cute)

This style is realistic at the same time as making good use of animals' adorability. It's suitable for creating a unique worldview while playing up the cuteness and characteristics of animals.

Dramatic types (comical, cool)

A comical design and a slick or stylized persona meet in this type of drawing that works well with dramatic styles such as works of fantasy.

Heart-warming type (comical, cute)

In comical, cute types, human elements and adorability come to the fore via designs in which chibi techniques feature strongly. This style of drawing suits heart-warming tales.

Classification of character types

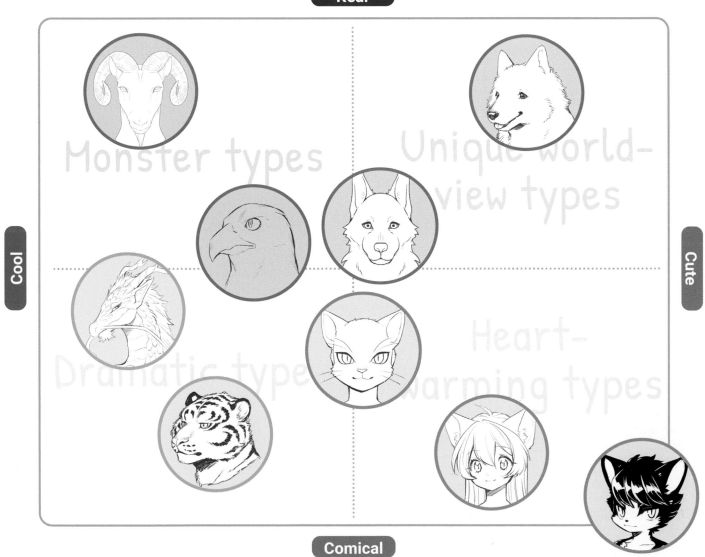

18

Unique Skeletal Structures

When drawing furries whose bone structures differ from humans, the design alters greatly depending on the degree and the way in which the skeletal forms are blended. Try adding variation to the silhouette via a unique skeleton that's just a bit different from a human's.

Wings

Should you draw wings or arms?

Many creatures with wings have them due to the process of evolution in which arms became wings. This is why, when drawing a winged furry with a structure resembling a real creature's, it's necessary to consider whether to allow the bone structure of the arms or that of the wings and feathers to remain. In this book, the structure of human-like hands is incorporated and the wings remain in a decorative capacity. The positioning of the wings is based on an archaeopteryx. Incorporating both human and avian elements makes it possible to create a unique, eye-catching character.

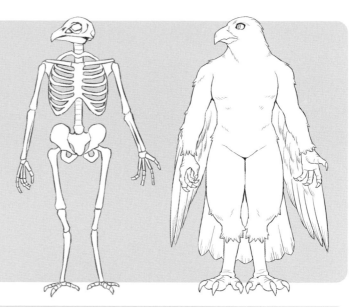

Dorsal fin

Show an atrophied skeleton

In the case of furries based on killer whales, dolphins, fish and other marine creatures, the lower section of the structure can be a point of concern. Take drawing a killer whale furry as an example: a structure in which human legs have fused together and knee joints are present.

In this book, however, in order to show that it lives exclusively underwater, this creature is based on an actual killer whale. In addition to the atrophied leg joints, drawing in a pelvis to support the body completes the form of this one-of-a-kind creature.

Wings and arms

Break the rules on purpose

Dragon-based creatures, too, present the problem of whether the arms or wings should remain. Here their structure comprises four arms, meaning both arms and wings are shown. A structure containing four arms is not commonly found in mammals, so this highlights the fact that this is most definitely a creature of fantasy.

Understand that by creating a unique skeleton as a base that builds on the method for drawing the regular bone structure, a fiercely original character can be created.

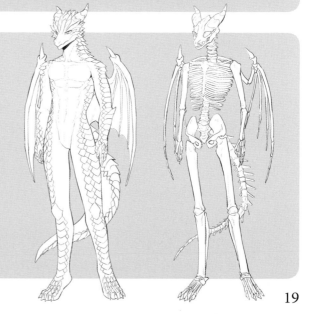

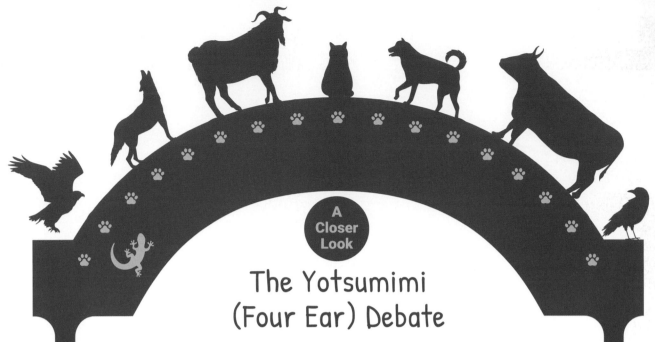

The Yotsumimi (Four Ear) Debate

Kemomimi refers to creatures that have human heads sprouting animal ears. Added to this are yotsumimi, who also have human ears on either side of their heads.

Fundamentally, all living creatures have two ears. So some people express criticism or skepticism about kemomi with four ears. On the other hand, others don't feel any resistance toward drawing human ears, resulting in disagreements (artistic differenc-es?) arising between the two camps.

What can be said for both yotsumimi and furries is that structural impossibilities don't prevent them from existing in the world of illustration. Keep in mind that in this book, the rules presented for drawing furries are just one way of approaching your character design. There's more than one way to draw a furry, so see where your imagination leads you.

Furries on Land

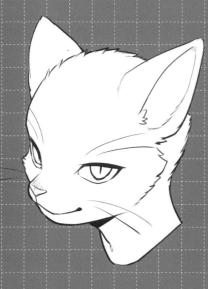

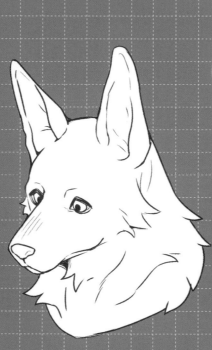

Canine-Based Furries: The German Shepherd

Dog-shaped furries have a familiar, expressive presence and can be used widely in scenarios ranging from fantasy to contemporary, everyday situations. Personality and appearance traits vary greatly depending on the breed of dog, making it easy to introduce a wide degree of freedom and license even within a single type.

Male Furry — The German shepherd: a powerful sheepdog

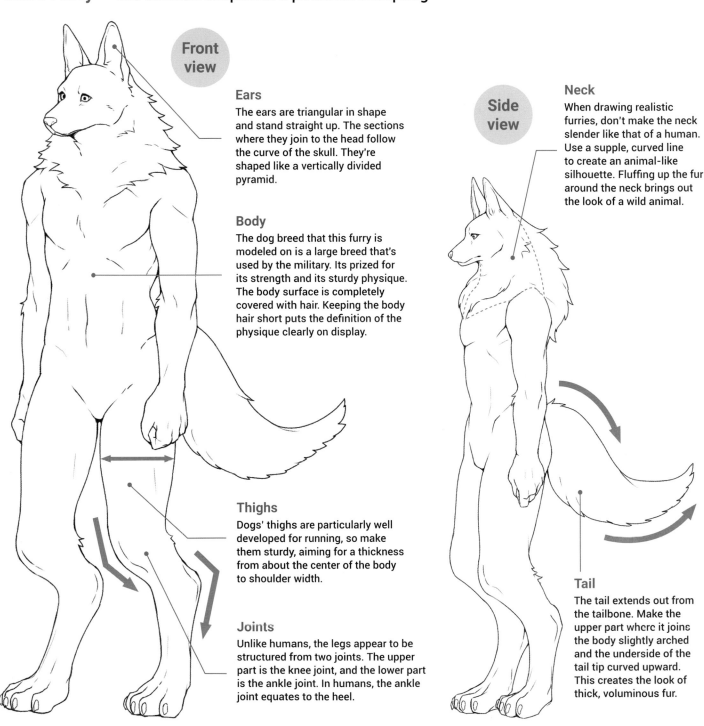

Front view

Ears

The ears are triangular in shape and stand straight up. The sections where they join to the head follow the curve of the skull. They're shaped like a vertically divided pyramid.

Body

The dog breed that this furry is modeled on is a large breed that's used by the military. Its prized for its strength and its sturdy physique. The body surface is completely covered with hair. Keeping the body hair short puts the definition of the physique clearly on display.

Thighs

Dogs' thighs are particularly well developed for running, so make them sturdy, aiming for a thickness from about the center of the body to shoulder width.

Joints

Unlike humans, the legs appear to be structured from two joints. The upper part is the knee joint, and the lower part is the ankle joint. In humans, the ankle joint equates to the heel.

Side view

Neck

When drawing realistic furries, don't make the neck slender like that of a human. Use a supple, curved line to create an animal-like silhouette. Fluffing up the fur around the neck brings out the look of a wild animal.

Tail

The tail extends out from the tailbone. Make the upper part where it joins the body slightly arched and the underside of the tail tip curved upward. This creates the look of thick, voluminous fur.

Female Furry A human-like design with comical touches

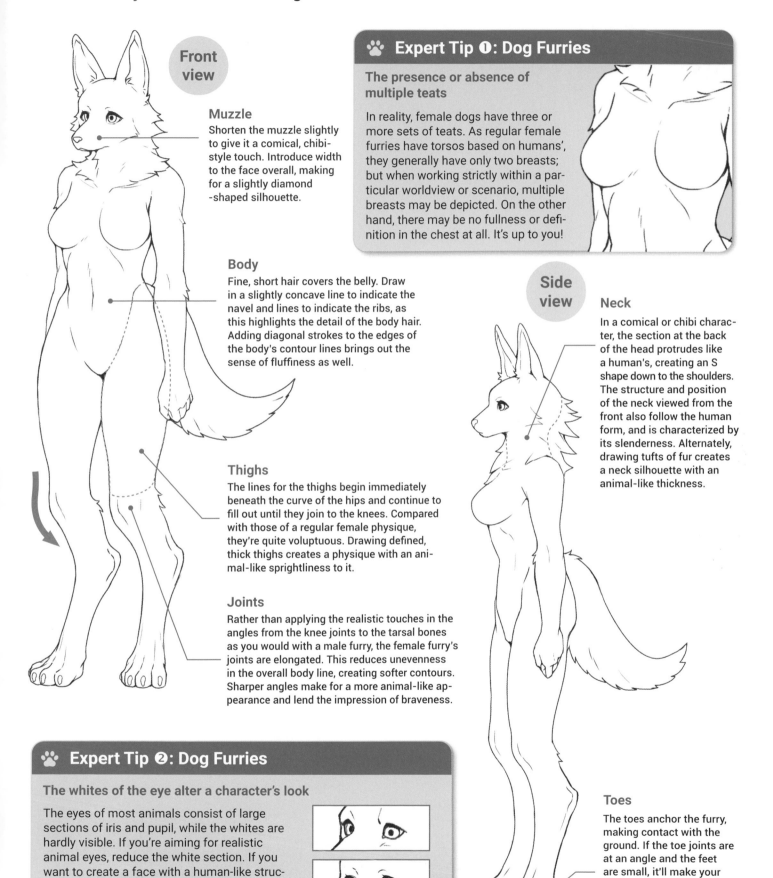

Front view

Muzzle

Shorten the muzzle slightly to give it a comical, chibi-style touch. Introduce width to the face overall, making for a slightly diamond-shaped silhouette.

Body

Fine, short hair covers the belly. Draw in a slightly concave line to indicate the navel and lines to indicate the ribs, as this highlights the detail of the body hair. Adding diagonal strokes to the edges of the body's contour lines brings out the sense of fluffiness as well.

Thighs

The lines for the thighs begin immediately beneath the curve of the hips and continue to fill out until they join to the knees. Compared with those of a regular female physique, they're quite voluptuous. Drawing defined, thick thighs creates a physique with an animal-like sprightliness to it.

Joints

Rather than applying the realistic touches in the angles from the knee joints to the tarsal bones as you would with a male furry, the female furry's joints are elongated. This reduces unevenness in the overall body line, creating softer contours. Sharper angles make for a more animal-like appearance and lend the impression of braveness.

🐾 Expert Tip ❶: Dog Furries

The presence or absence of multiple teats

In reality, female dogs have three or more sets of teats. As regular female furries have torsos based on humans', they generally have only two breasts; but when working strictly within a particular worldview or scenario, multiple breasts may be depicted. On the other hand, there may be no fullness or definition in the chest at all. It's up to you!

Side view

Neck

In a comical or chibi character, the section at the back of the head protrudes like a human's, creating an S shape down to the shoulders. The structure and position of the neck viewed from the front also follow the human form, and is characterized by its slenderness. Alternately, drawing tufts of fur creates a neck silhouette with an animal-like thickness.

Toes

The toes anchor the furry, making contact with the ground. If the toe joints are at an angle and the feet are small, it'll make your character look off-balance, so make the feet slightly large.

🐾 Expert Tip ❷: Dog Furries

The whites of the eye alter a character's look

The eyes of most animals consist of large sections of iris and pupil, while the whites are hardly visible. If you're aiming for realistic animal eyes, reduce the white section. If you want to create a face with a human-like structure and a comical sensibility to it, make the whites of the eyes larger.

Bone Structure Mixing the bone structures of dogs and humans

Furry bone structure

As with those of humans, the shoulder blades curve around at the back and the chest is supported by the clavicle. The bone structure of the torso section is practically the same as a human's, and the lower body is the same until the femur. The tibia, however, are short and the tarsal bones (heels) are raised high. Below them, the metatarsal bones are extended and the phalanges are highly developed in order to support the body.

Animal bone structure

The skeleton of an actual dog is unlike that of the diagram below left, as there's no clavicle. There are 13 pairs of ribs, each connected to the thoracic spine. The fore and hind legs are constructed differently. While the forelegs bend in a < shape from the shoulder blade to the humerus and then extend straight down to the phalanges, the hind legs form a zigzag from the pelvis down to the phalanges.

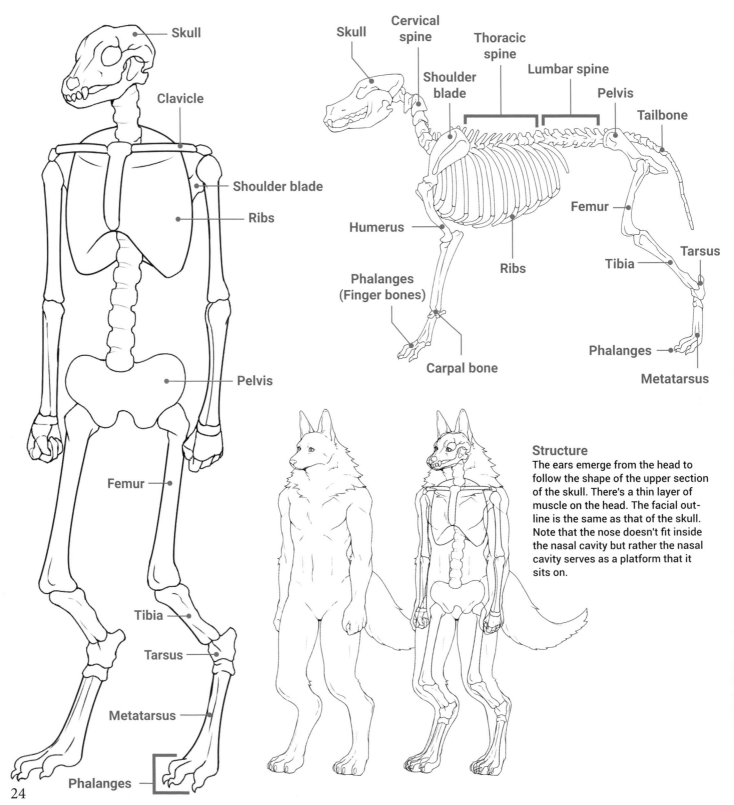

Structure

The ears emerge from the head to follow the shape of the upper section of the skull. There's a thin layer of muscle on the head. The facial outline is the same as that of the skull. Note that the nose doesn't fit inside the nasal cavity but rather the nasal cavity serves as a platform that it sits on.

How to Draw the Body Divide the body into blocks to start drawing

① Blocking-in

Divide the dog furry's body into blocks and block it in. Roughly dividing the body into the head, chest and lower limbs makes it easier to achieve overall balance.

The head is blocked-in as a conical shape as if it's covered with a sack. This makes it easier to ascertain the position of the neck.

Dividing the leg into the thigh, shin and below the ankle makes it easier to create depth.

② Rough sketch

Draw in the fur and muscle. From the head to the neck, fan out the fur in tufts to create realistic animal-like volume.

Drawing tufts of fur all over the body makes the furry look like a long-haired breed. Draw it only around the joints.

③ Line drawing

Neaten up the rough sketch and create a line drawing. Don't completely connect the outline of the face but rather use broken lines around the jawline so that the outline doesn't stand out too much.

Neaten up the vertical lines of the pectorals, navel and abdominals too. Using diagonal lines around the chest indicates the softness of the fur.

④ Completion

Apply black, referring to the markings of the German shepherd on which this furry is modeled. This breed is black around the eyes, so darken the color at the eyes' outer edges. Complete the work by applying the same color used on the back to the sides of the stomach.

German shepherds can also be a single color such as black or gray. Other coat patterns include black with brownish or grayish markings. In all cases, black hair known as a "mask" spreads from around the nose.

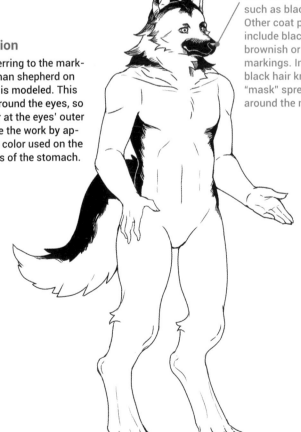

How to Draw the Face Mixing the bone structures of dogs and humans

Blocking-in for the face

Draw the circle that will form the foundation for the outline, then draw an oval in the lower half of the circle below the center line. Blocking-in for human faces usually starts with a vertically long shape, but here it's spherical, so keep that in mind.

Draw the second element at the point where the muzzle will be positioned

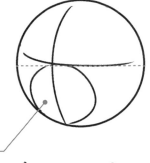

Blocking-in markings

Following the blocking-in for the muzzle, create a triangular tube shape. Conical ears are then added to the top of the head.

Draw the outline

Make the lower half of the outline a diamond shape and draw in the neck as if it's extending from the back of the head. Use the horizontal line of the blocking-in as a guide to draw vertical lines to determine the position of the eyes (pupils).

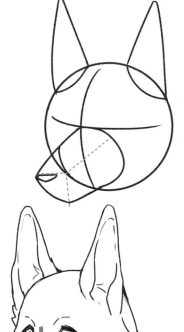

Clean copy

Draw in the eyes, muzzle and finer details. If you draw the muzzle line in so it overlaps the upper eyelid, it will bring the muzzle forward and add depth to the face. Draw tufts of fur around the neck and make them fan out to complete the picture.

Adding expression Express emotion through the angle of the ears

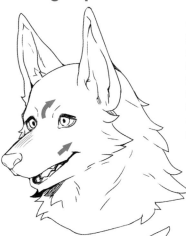

Joy

Elongate the line of the lips to around the inner corners of the eyes and then angle the line up from that point to create a smiling mouth. The eyebrows open out, changing from a ∧ shape to a <-like shape, creating an energetic, cheerful expression.

Rage

When dogs assume a threatening stance, wrinkles form in the area in the middle of their snout. The eyebrows also draw together, compressing the area above the eyes and creating a sharp, intimidating look.

Sadness

When afraid or feeling a sense of unease, dogs may flatten their ears, meaning their emotion can be expressed via their silhouette. Lowering the corners of the mouth and making a /\ shape with the eyebrows creates a comical expression that conveys a sense of unease.

Surprise

The ears stand straight up and the eyes and mouth open wide. The eyes grow round, revealing the whites around the iris. The wide open mouth reveals the black skin of the lips.

The skin around the mouth is black.

Angles of the Face

The silhouette changes significantly depending on the angle of the face

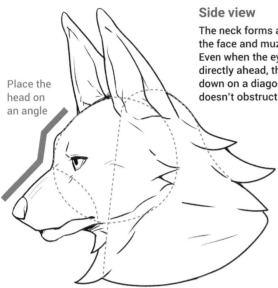

Place the head on an angle

Side view

The neck forms a base to which the face and muzzle are connected. Even when the eyes are looking directly ahead, the muzzle points down on a diagonal angle so that it doesn't obstruct the view.

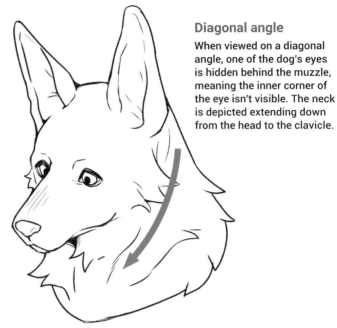

Diagonal angle

When viewed on a diagonal angle, one of the dog's eyes is hidden behind the muzzle, meaning the inner corner of the eye isn't visible. The neck is depicted extending down from the head to the clavicle.

Front view

Viewed from the front, the outline of the head forms a diamond shape. The muzzle extends slightly below the diamond shaped outline.

Draw the area below the eyes and the snout to make up the line of the muzzle.

🐾 Expert Tip ❸: Dog Furries

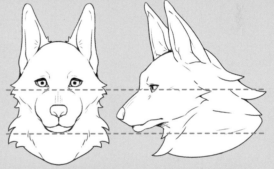

Make sure to capture the position and angle of the muzzle

Unlike the human nose, if the position and length of an animal's muzzle changes, the entire facial outline is altered. Establish the top of the muzzle and lowest point of the chin in order to accurately draw it.

View from above

When viewed from overhead, the face takes on the shape of a rounded mountain. The muzzle extends out from the face in the manner of a cup sitting over the inner corners of the eyes.

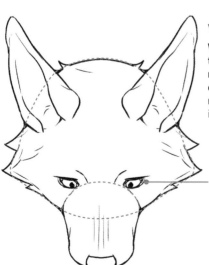

The shape of the eye approaches that of a semicircle.

View from below

Viewed from below, there's little unevenness and apart from swelling out around the snout section, the outline is practically straight.

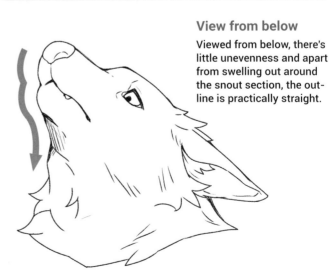

Beastly Hands Add dog parts as you go

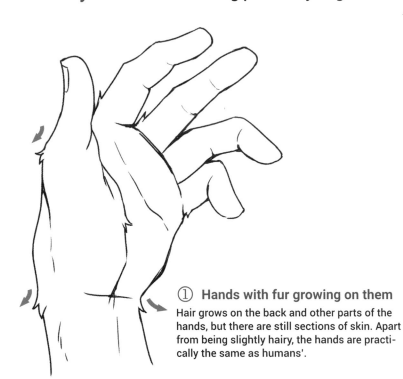

There are paw pads on the thumb too

① **Hands with fur growing on them**

Hair grows on the back and other parts of the hands, but there are still sections of skin. Apart from being slightly hairy, the hands are practically the same as humans'.

② **Hands that have developed paw pads**

There are paw pads on the palms of the hands, but the nails are still human-like rather than having become claws.
The appearance of paw pads instantly makes the creature more animal-like.

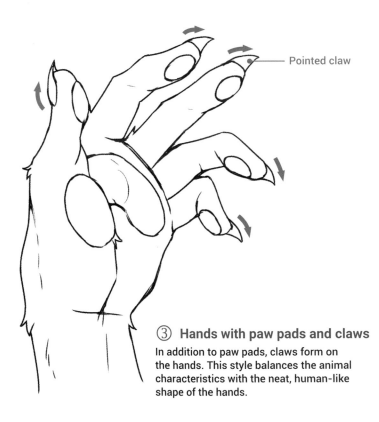

Pointed claw

③ **Hands with paw pads and claws**

In addition to paw pads, claws form on the hands. This style balances the animal characteristics with the neat, human-like shape of the hands.

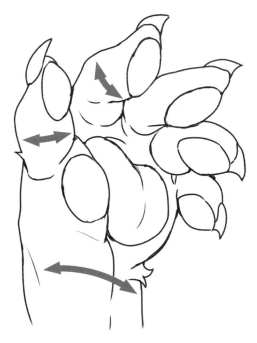

④ **Animal paws**

The paw pads extend to the center of the palms. The fingers thicken, with the section from the second joint to the tip joining together. As this hand is more animal-like from a skeletal level, this style is recommended for when emphasizing their beastly qualities is desirable.

💡 The atrophied big toe of the foot

In reality, dogs have only four visible toes on their feet. The fifth is concealed by fur.

Beastly Feet The bone structure approaches that of a dog

① Feet with fur growing on them

These practically human feet sprout hair from some areas such as the ankles. This style is recommended for characters who are only slightly beastlike, such as those with no fur on their face but with animal ears, or beasts whose bodies have some areas of skin.

② Feet with claws

The toes have lengthened and sprout claws. The volume in the tips of the toes creates an uneven silhouette, making for a more beastlike impression.

Five toes

③ Feet with four toes

The bone structure approaches that of a dog, with the big toe shriveling to leave four toes. The heel no longer makes contact with the ground, instead rising high above it.

Less hair

④ Animal feet

The heel is completely raised. As the phalanges support the body, they're larger to allow for balance.

Muscle tautens

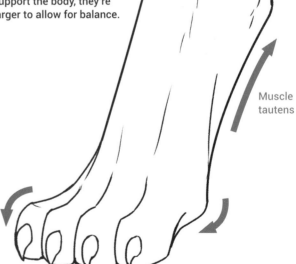

🐾 Shoes especially for furries

When characters with tarsal joints wear shoes, the heels are positioned at a significant height, making it difficult for them to wear designs created for humans. For this reason, it's common to depict the feet of furries wearing shoes using the human-like bone structures of Steps 2 and 3 above. Alternatively, enjoy designing your own original shoes to suit the character.

Dog Furries' Physiques

Use fat and muscle distribution to show differences

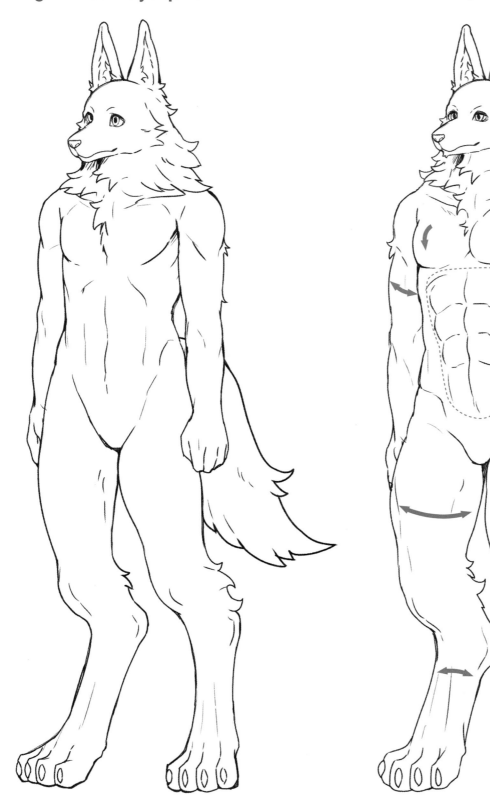

Lines showing the tautness of the muscle increase

Draw in lines for the muscles on the arms

Average

In the case of a large-dog breed of furry, even if it has an average physique, give it a bit of muscle. The outlines of furries with short fur have a tendency to appear soft, so use the physique to create a more defined, dynamic look.

Muscular

This type of massive physique often appears in works of fantasy. Make the chest muscles large and the abdominal muscles look activated by clearly drawing in a "six pack."

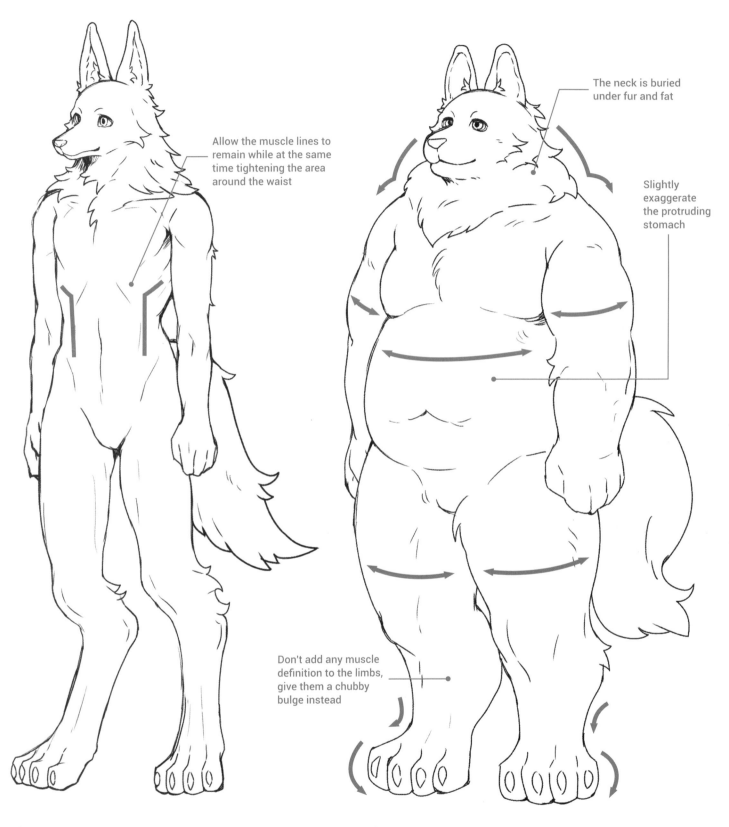

Allow the muscle lines to remain while at the same time tightening the area around the waist

The neck is buried under fur and fat

Slightly exaggerate the protruding stomach

Don't add any muscle definition to the limbs, give them a chubby bulge instead

Slim

Overall, the physique is slim and lithe. Make the muzzle, waist and thighs slender and draw in the lines of the ribs to create a lean look.

Plump

The silhouette varies markedly from those of other physiques. The outline of the face changes from a diamond shape to an oval, and from the chin down, the muzzle is twice as wide as the others.

Dog Furries' Ages Draw features to show age differences

Expert Tip ❹ : Dog Furries

Droopy ears and erect ears

German shepherds' ears are droopy in puppyhood but straighten up as they grow older, although some dogs' ears remain droopy even as adults. For this reason, correctional devices may be used.

Expert Tip ❺ : Dog Furries

The size of the eyes is significant

Drawing bright, large eyes on a child furry makes for a cute appearance, while positioning them slightly low on the face creates balance. On the other hand, small eyes in a higher position create a mature air.

Youth (6–14 years)

To enhance a childlike appearance, the facial features are human-like, the neck is slender and the back of the head protrudes. As with an average-sized child, the body height is five times that of the head. Rather than using dynamic lines to create the physique, keep things even and regular to build a rounded, childlike form.

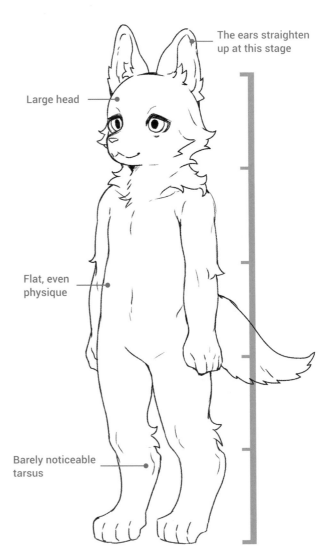

The ears straighten up at this stage

Large head

Flat, even physique

Barely noticeable tarsus

Infancy (0–5 years)

As they're quadrupeds in infancy, dog furries closely resemble dogs. Make effective use of chibi techniques and create a large head for a young, cute impression. Shortening the muzzle and using a ω shape for the mouth brings out a puppy-like look.

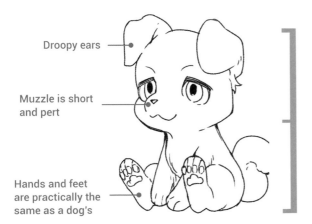

Droopy ears

Muzzle is short and pert

Hands and feet are practically the same as a dog's

The ages indicated are based on human ages.

Adulthood (20 years and over)

In what would be adulthood in human terms, the muzzle is clearly elongated and the facial structure is that of a mature dog. Making the eyes smaller creates the impression of an adult. The neck thickens and from the shoulders to the back of the head, the bone structure is the same as that of a dog.

Adolescence (15–19 years)

As the face becomes broader, the body height is seven times that of the head. The muzzle lengthens slightly, and the groove below the nose stands out against the ω-shaped mouth. The physique becomes slightly more muscular and the pectorals develop. The undercarriage becomes more solid, with the thighs thickening and the tarsal bones becoming more defined.

Mouth elongates at the ends

Muzzle lengthens slightly

Physique takes on shape rather than being flat

Pectorals develop

Lean physique

Make firm

Feet get larger to support the large body

33

Variation ❶ Shiba Inu Dog

Inner eyebrows

On the inner section of a shiba inu's eyebrows, there's a part where the color is pale, like those of humans with sparse eyebrows. Define this area with line drawing to create an appealing effect.

Ears

Although small, the upright ears are thick and form a clear triangular shape. Draw hair inside the ears as well to bring out depth.

Ruff

Present also on a real dog's neck, this is the section that is filled out above the shoulders. In reality it's in the upper part of the shoulder blades, but on a dog furry it's drawn above the clavicle.

Shiba Inu

A Japanese dog native to Japan. Actual shiba inus are small- to medium-sized dogs about 15 inches (40 cm) in height. Their coat color can be red, sesame, black or cream, with the red color particularly well-known.

The breed tends to be loyal, stubborn, independent and lively. Among the Japanese dog breeds, the shiba inu is on the small side, but originally it was used as a guard dog and for hunting. Genetically, it has characteristics similar to those of wolves, and while its physique is small, it's muscular and physically tough.

Tail

Commonly seen in Japanese dogs, the tail is curled. While the tail hangs straight on other breeds, the shiba inu's tail twists around tightly.

Legs

In order to show the length of the torso, shorten the legs. Creating a shallow V shape in the crotch gives the impression of short legs.

Body

The physique is short and sturdy. The shiba inu is a breed with a long torso, so give the rest of it a short, stout look.

🐾 Fox faces and raccoon dog faces

Shiba inu can usually be divided into types with "fox faces" and those with "raccoon dog faces." The fox face type has a long muzzle and long, lean physique, while the raccoon dog face type has a short muzzle and a sturdy, rounded physique. The fox face type is also called "Jomon shiba" as it's perceived as having inherited the characteristics of the ancient dogs that lived with humans during the Jomon period.

Variation ❷ Golden Retriever

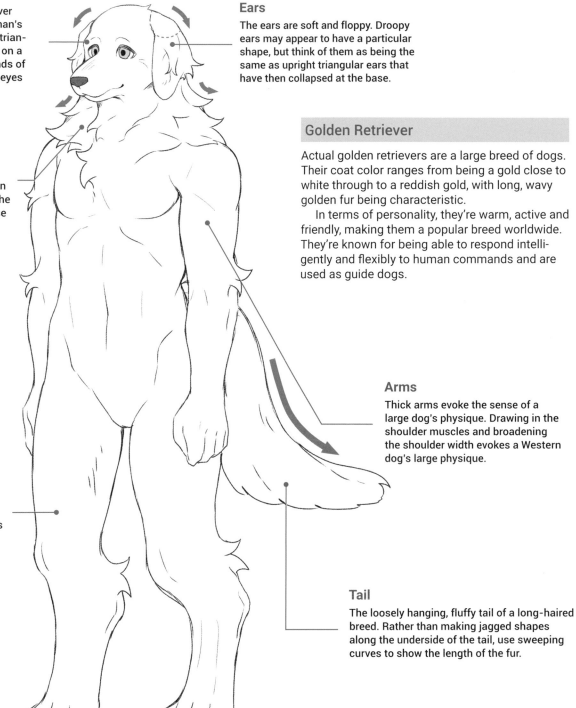

Eyebrows

The parts of a golden retriever that are equivalent to a human's eyebrows appear as plump triangular shapes. When viewed on a diagonal angle, the outer ends of the brows protrude and the eyes droop.

Ears

The ears are soft and floppy. Droopy ears may appear to have a particular shape, but think of them as being the same as upright triangular ears that have then collapsed at the base.

Golden Retriever

Actual golden retrievers are a large breed of dogs. Their coat color ranges from being a gold close to white through to a reddish gold, with long, wavy golden fur being characteristic.

In terms of personality, they're warm, active and friendly, making them a popular breed worldwide. They're known for being able to respond intelligently and flexibly to human commands and are used as guide dogs.

Neck

Create plenty of fluffy tufts around the neck in order to show the length of the fur on this long-haired breed. As the fur grows in long ripples, use long strokes to draw it.

Arms

Thick arms evoke the sense of a large dog's physique. Drawing in the shoulder muscles and broadening the shoulder width evokes a Western dog's large physique.

Legs

Solid, thick legs. Long fur covers the entire body. As unevenness on the surface of the skin is concealed by the fur, use diagonal strokes to show the direction of the fur rather than drawing in the muscles.

Tail

The loosely hanging, fluffy tail of a long-haired breed. Rather than making jagged shapes along the underside of the tail, use sweeping curves to show the length of the fur.

🐾 There are no more purebreds...

The golden retriever is the most popular large dog breed in Japan. They originated from the St John's water dog, a breed native to Canada. They were imported to Japan from England, however after repeated cross-breeding, the purebred St John's water dog now no longer exists.

Eyes

The eyes of wolves are black from the inner to outer corners, making the whites of the eyeballs appear black. In actuality, the whites do not show and the eyelids and surrounding fur are black.

Ears

The ears of the gray wolf may sometimes be black at the tips. The fur that covers the entire body is gray, but may be blackish in some sections. It depends also on the individual animal.

Wolf

Wolves are native to much of the Northern Hemisphere. Also known as the gray wolf, they're characterized by their fur, which is a mixture of gray and black. Actual wolves are between 25 to 35 inches (60–90 cm) in height. Their large physique can be pictured more clearly if you think of a Siberian husky, which has similar facial structure and is a large dog breed averaging 20 to 25 inches (50–60 cm) in height.

The eyes of a wolf have pale irises in colors such as yellow and blue. As they're rimmed in black, the eyes appear sharp and keen.

Body

Being a wild animal and giving the impression of strength, incorporate these two elements into a strongly muscular physique. Think of the abdominals of being divided in six beneath the fur and use soft curved lines to render them in.

Tail

The upper part and tip of the tail is a blackish color. The fluffy tail has a rounded overall shape and hangs loosely.

Legs

Make the thighs quite thick, with the angled joints large and solid. The powerful core differentiates wolves from dogs.

Claws

As they live in harsh environments and need to be powerful, make the claws well-defined. The claws of wolves are black because they contain melanin.

💡 A dog and wolf hybrid

Dogs and wolves are considered to be separate species, but their correct classification is subspecies. In other words, it is possible for dogs to breed with wolves. The resulting animals are known as wolf hybrids or wolf dogs.

How To Draw a Wolf's Face

Pay attention to the way the fur spreads around the neck and the helmet shape of the facial outline

① **Blocking-in**

Block-in a circle, then add the muzzle in the shape of a paper cup and then the triangular ears.

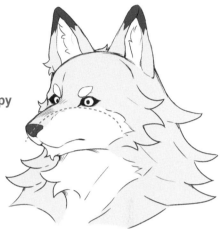

② **Add to the blocking-in**

Draw the outline of the jaw below the blocked-in circle and add the mountain-shaped neck so that it overlaps with the head to form the facial outline. The bridge of the nose was matched up to the center line of the blocking-in and corrections were made.

③ **Draw in details**

Using the blocking-in as a base, draw in the thickness of the ears and the tufts of fur around the neck. Wolves have particularly thick fur around their jawlines, so make sure to focus on that area.

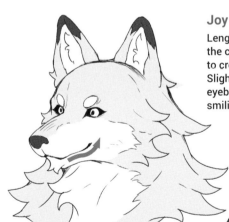

④ **Make a clean copy**

Draw in the eyebrows and eyes and apply fur color. The markings spread out basically along the bridge of the muzzle and in an arch beneath the eyes.

Wolves' Expressions

Exaggerate the mouth and the heads of the eyebrows to create human-like expressions

Joy

Lengthen the lips and bring the corners of the mouth up to create a gentle expression. Slightly round the heads of the eyebrows to create a sweetly smiling face.

Rage

To express rage, curl the lips up to expose the teeth. Wrinkles form between the eyebrows, so the heads of the eyebrows are lowered.

Sadness

Making the eyebrows form a /\ shape and turning down the corners of the mouth creates a sad expression. In the same way as with a dog, the ears lower when feeling ill at ease or threatened.

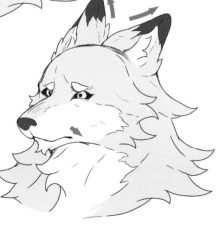

Surprise

The eyes open wide and the irises are completely exposed. By opening up the eyes so wide, the whites are revealed. Make the edges of the irises white.

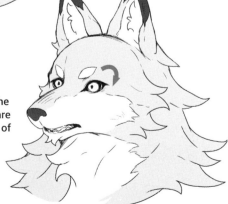

37

Other Species ❷ Fox

Eyes

Like cats, foxes have vertical pupils. The eyes range in color from yellow to gold. As the eyes are rimmed in black from the inner to outer corners, there's something of a smiling look or appearance them.

Fur quality

Foxes are characterized by their soft, fluffy fur. It's particularly thick from the neck down to the chest.

Ears

The upright ears are large and triangular and black at the back. From the front they appear to be outlined in black, with fluffy white and black fur growing inside.

Fox

This animal of the family Canidae is found all over the world. The color usually called "fox" refers to the red fox. At 12 to 20 inches (35–50 cm) tall, the fox is relatively small, with coat colors including red, black and silver.

Their intelligence and quick wit have contributed to foxes being assigned mischievous personalities and cunning roles in fairy tales and folklore. Conversely, in Japan they're objects of worship at places such as Inari Shrine.

As they often prey on small animals, the jaw and facial structure overall are on the small side. They have a unique appearance that differs from that of dogs.

Tail

The fur on foxes' tails is long and bushy. Use sweeping, curved strokes to draw the tufts of fur that create the long tip of a comical fox's tail.

Arms

The arms and legs of a red fox are covered with black fur as if it's wearing gloves. The sections of the body that are black depend on the individual, with some being black from the upper arms down and others only black from the paws down.

Legs

The black legs are commonly called socks or black tights. The claws of the red fox are mainly white, with glimpses of color showing on the black feet.

💡 The fox wears socks

The Japanese red fox can largely be divided into two groups: Vulpes vulpes japonica, which is found mainly on the main island of Honshu, and the north fox, which is found mainly in Hokkaido. The north fox has black fore and hind legs, making it look as if it's wearing dark socks, and because they live in colder habitats, their body fur is abundant and fluffy.

How to Draw a Fox's Face A small face with a cute but wild edge

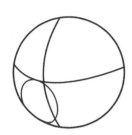

① Blocking-in

Block-in a circle, and make a cross on it that's directed slightly downward. Add an egg shape for where the muzzle will go in the lower left of the circle.

② Blocking-in markings

As the chin on a fox is small, make the blocking-in for the muzzle slightly short. Block-in large triangles for the ears.

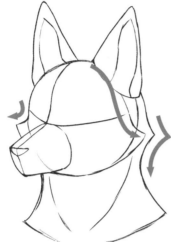

③ Overall rough sketch

Add the helmet-shaped sketch to overlap with the head and make the head appear slightly small. Make the outline of the face stick out along with the helmet-shaped outline and make the neck taper in.

④ Clean copy

Draw in tufts of fur to follow the shape of the blocking-in. Make the base of the muzzle cover the inner corner of the right eye to bring out depth. Use a triangle shape as a base to draw the eyes and complete the work.

Foxes' Expressions Accentuate the droll, intellectual look

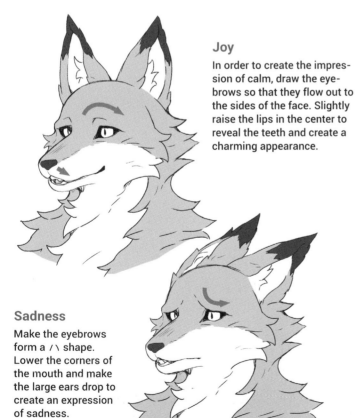

Joy

In order to create the impression of calm, draw the eyebrows so that they flow out to the sides of the face. Slightly raise the lips in the center to reveal the teeth and create a charming appearance.

Rage

When a real fox is angered or threatens another creature, the wrinkles don't mostly form in the muzzle, as they would on a dog. Draw wrinkles between the eyebrows and narrow the eyes to express rage.

Sadness

Make the eyebrows form a / \ shape. Lower the corners of the mouth and make the large ears drop to create an expression of sadness.

Surprise

Make the large ears stand completely upright, open the eyes wide and make the mouth gape. As this is a wild animal, reference its senses, especially smell, sight and hearing. This creates the expression of alertness or surprise.

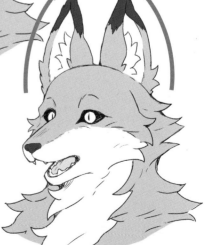

Lesson 02

Feline-Based Furries

Feline furries elicit a deep familiarity and mysteriousness at the same time. Their agile movements often lead to them being portrayed as cool, cute or without a care in the world as this is a creature that lends itself to a variety of personalities. Your character can tap into the full range of cat behaviors, moods and modes: feisty, cerebral, slinky, aloof. You decide! What kind of cat person are you?

Male Furry

The cat is characterized by a slight and supple physique

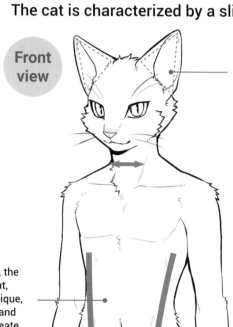

Front view

Ears

The ears are triangular and are positioned on both sides of the top of the head, facing forward and slightly opened out. Have large triangles in mind as you draw them.

Neck

The masculine neck is thick and sturdy, lending strength to an otherwise streamlined physique.

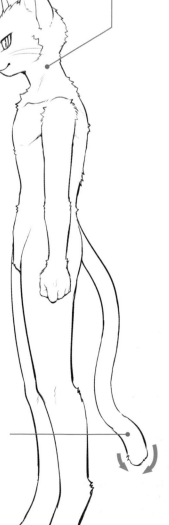

Side view

Body

In order to express the lean, agile look of a cat, the male cat furry has a taut, well-proportioned physique, with compact pectoral and abdominal muscles. Create tapering in the body just above the navel area.

Thighs

Cat thighs are slender but muscular. There's little fat covering them, so the legs are slim and the form of the muscles stands out even more clearly on the insides of the thighs. The knee and shin bones protrude and there's a gap between the thighs.

Joints

Unlike humans, the whole foot does not come into contact with the ground. The tarsus, which equates to the heel on a human, remains separated from, elevated above, the ground. In human terms, it's as if the character were constantly walking on tiptoes.

Tail

Tapering toward the tip, the tail grows from the base of the tailbone and is roughly as long as the length of the torso.

40

Female Furry Cute and commanding

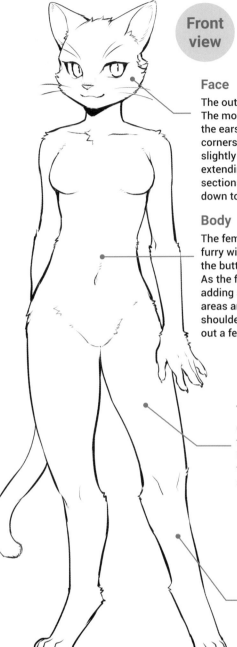

Front view

Face

The outline is like a horizontal oval. The mouth and eyes are rounded and the ears are large cones. The inner corners of the eyes are positioned slightly to the outside of the lines extending from where the inner sections of the ear join the head down to the sides of the nose.

Body

The female has less fat than a male furry with an average physique, and the buttocks and breasts are small. As the figure is slender overall, adding shadow to the prominent areas around the collarbone, knees, shoulder blades and muscles brings out a feminine look.

Thighs

Cats' unique flexibility makes their thighs both slender and muscular. Making the thighs thicker than those of male furries creates a softer, more rounded form.

Legs

Below the tarsus is the metatarsus, which joins to bones called phalanges. These equate to the soles of the feet in humans. In order for cats to walk silently, the claws are usually sheathed inside the toes.

🐾 Expert Tip ❶: Cat Furries

Distinguishing male and female

Bring out a feminine look by making the line from the forehead to the nose softer than that of a male. The eyes should also be larger than male eyes.

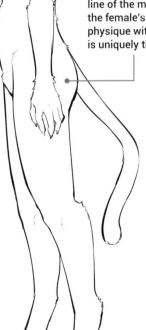

Side view

Neck

The neck is thinner than that of a male furry. This creates a lean, neat impression and gives it greater definition.

Buttocks

In comparison with the flat, even line of the male furry's buttocks, the female's swell out to create a physique with a rounded line that is uniquely their own.

🐾 Expert Tip ❷: Cat Furries

Don't forget the whiskers

For cats, the whiskers are important nerve-filled sensory organs in addition to a unique flourish you must add when finishing your character. Emphasizing the whiskers above the eyes in the same way as eyebrows allows for the creation of various expressions and moods.

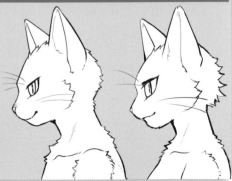

Bone Structure Explore the commonalities between feline and human bone structure

Cat furry bone structure

The bone structure of the torso is practically the same as a human's. As on a human body, the shoulder blades are at the back and the ribs are supported by the clavicle. The arms are in proportion to the body in nearly the same way as for a human. The biggest difference is in the lower legs, where the phalanges equate to the soles of the feet in a human and make contact with the ground to support the body.

Cat bone structure

In an actual cat skeleton, the clavicle isn't connected to other bones but floats. There are 13 sets of ribs, each connected to the thoracic spine. As the fore and hind legs are always bent at the knee, the forelegs appear to be performing push-ups and the hind legs appear to be seated in an imaginary chair.

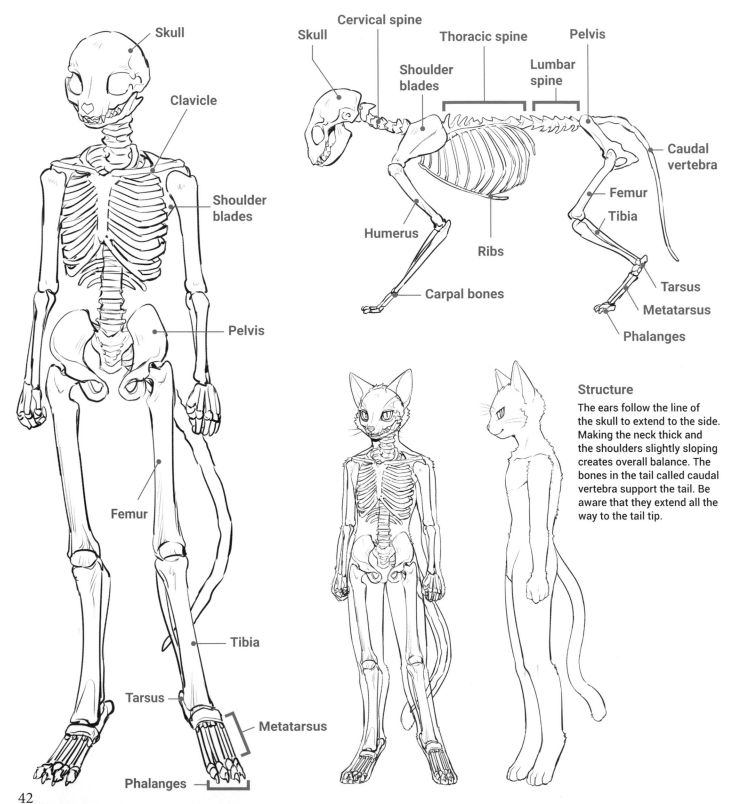

Structure

The ears follow the line of the skull to extend to the side. Making the neck thick and the shoulders slightly sloping creates overall balance. The bones in the tail called caudal vertebra support the tail. Be aware that they extend all the way to the tail tip.

How to Draw the Body Try drawing a cool black-and-white feline furry

① Blocking-in

Divide the cat furry's body into blocks for the head, neck, shoulders, arms, torso and belly to create the blocking-in. Divide them as much as possible for accuracy.

Within the torso, the chest is the widest area, followed by the stomach and waist. Think of it in terms of an inverted triangle.

Divide the legs into thighs, knees, shins and the area from the ankles down in order to create a result that appears more solid.

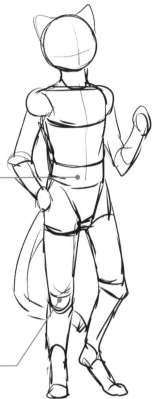

② Rough sketch

Using the blocking-in as a base, draw in the muscles. The figure is designed to be slim, so don't make it too muscular.

When the legs are extended, they're straight with no protrusions, but for furry-like joints, keep in mind that the bones of the knees and heels are defined and the backs of the knees are gently rounded.

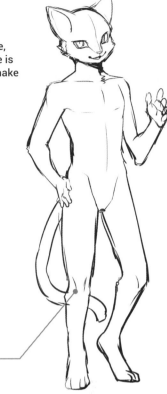

③ Line drawing

Make a clean copy of the rough sketch to create a line drawing, adding the tail, whiskers, tufts of fur and other beastlike elements.

Don't draw fur over the entire body for a short-haired breed, but add it to areas such as the throat and undersides to give the figure dimension.

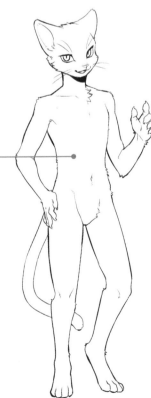

④ Completion

Apply color to complete the drawing. Rather than using straight lines to apply color in the areas where black and white meet, keep the direction of the fur in mind as you work. This allows the differences in color to be shown.

Muscled thighs and the tufts of hair along the joint add realism to the exterior and the sleek coat.

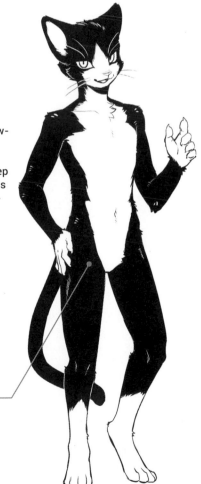

43

How to Draw the Face

The position of the eyes is key

Blocking-in the face
Block-in a circle to form the base outline. Draw a horizontal line halfway down the center line and draw in basic eyes and eyebrows.

Blocking-in markings
Draw ovals to block-in the positioning for the ears. Add a muzzle below the center line.

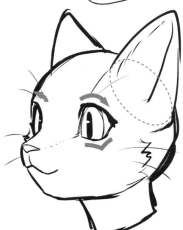

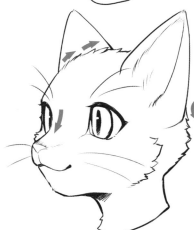

Draw the outline
Follow the blocking-in for the eyes and eyebrows to draw in the eyes and use the blocking-in for the ears to draw in cone-shaped ears. When drawing the eyes, use a smooth curved line for the upper eyelids and an inverted < shape for the lower lids.

Make a clean copy
Draw in the details. As the line for the muzzle overlaps with the corner of the eye, the right eye (which is farthest from the viewer) is hardly visible. Add tufts of fur to follow the contours of the face and complete the drawing.

Adding Expressions

Express emotions through the angle of the ears

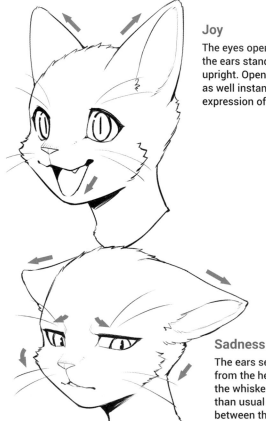

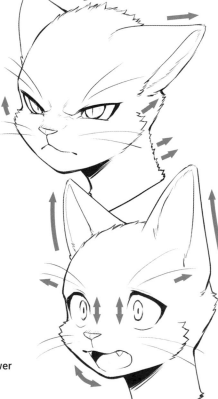

Joy
The eyes open wide and the ears stand completely upright. Opening the mouth as well instantly creates the expression of joy.

Rage
Tension forms between the eyebrows, pulling the insides of the eyebrows together and narrowing the eyes. Additionally, the ears flatten out horizontally. Making the fur stand up the wrong way on the top of the head and around the neck makes for an even angrier look.

Sadness
The ears seem to flop down from the head. Additionally, the whiskers point down lower than usual and a gap forms between the eyebrows.

Surprise
The ears point straight to the front and strain to stand up. The eyes are similarly directed forward. A gentle arch shape defines both the upper and lower parts of the eyes.

Angles of the Face Approaches from various directions

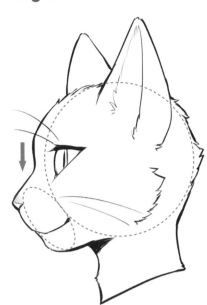

Side
A cat's face is rounded, so the head resembles a large oval, while the muzzle can be thought of as a small oval. There's a sharp drop from the brow down to the muzzle.

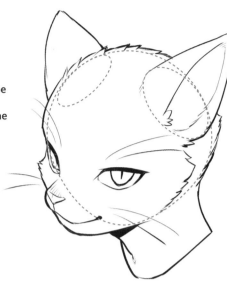

Diagonal
Viewed from above on a diagonal angle, a cat's face is slightly oval in shape. The ears appear conical. The whites of the eyes are visible, creating a white rim around the iris.

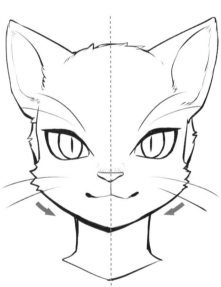

Front view
From the front, the cheeks puff out slightly to make the outline more circular in shape. The muzzle is positioned on the center line of the face.

🐾 Expert Tip ❸: Cat Furries

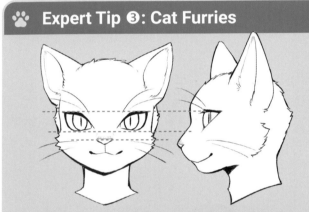

Get a clear understanding of the lines of the eyes and nose

A cat's face is rounded and the muzzle doesn't protrude far. Connect the lines that position the eyes and nose on the front and side views in order to understand where these features are positioned on the face.

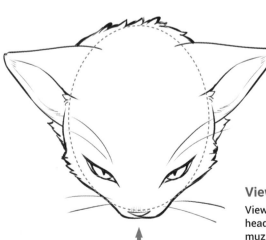

View from above
Viewed from overhead, the head is an elongated oval. The muzzle doesn't protrude from the outline of the face but rather sits within it.

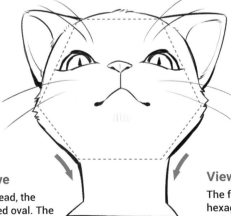

View from below
The facial outline resembles a hexagon. There are no protrusions and the outline from the face to the neck flows smoothly.

45

Beastly Hands Paw pad size is key

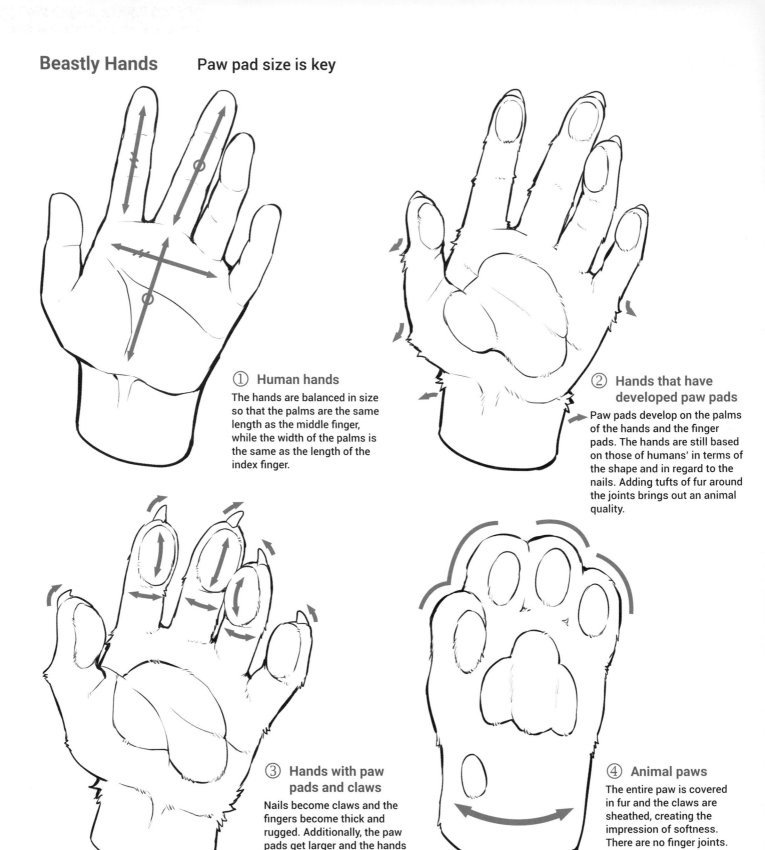

① Human hands

The hands are balanced in size so that the palms are the same length as the middle finger, while the width of the palms is the same as the length of the index finger.

② Hands that have developed paw pads

Paw pads develop on the palms of the hands and the finger pads. The hands are still based on those of humans' in terms of the shape and in regard to the nails. Adding tufts of fur around the joints brings out an animal quality.

③ Hands with paw pads and claws

Nails become claws and the fingers become thick and rugged. Additionally, the paw pads get larger and the hands take on a more beast-like appearance.

④ Animal paws

The entire paw is covered in fur and the claws are sheathed, creating the impression of softness. There are no finger joints. A paw pad known as a carpal ball forms on the area equating to the wrist.

☀ The true nature of paw pads

The springy feel of cats' paw pads fascinates us. It's fat that makes them this way. The surface layer of skin is thin and constructed to resist abrasion. Beneath the skin there are many layers of fat, which is the secret to the uniquely soft springiness of the paw pads.

Beastly Feet The angle of the heel also determines how beastly the feet seem.

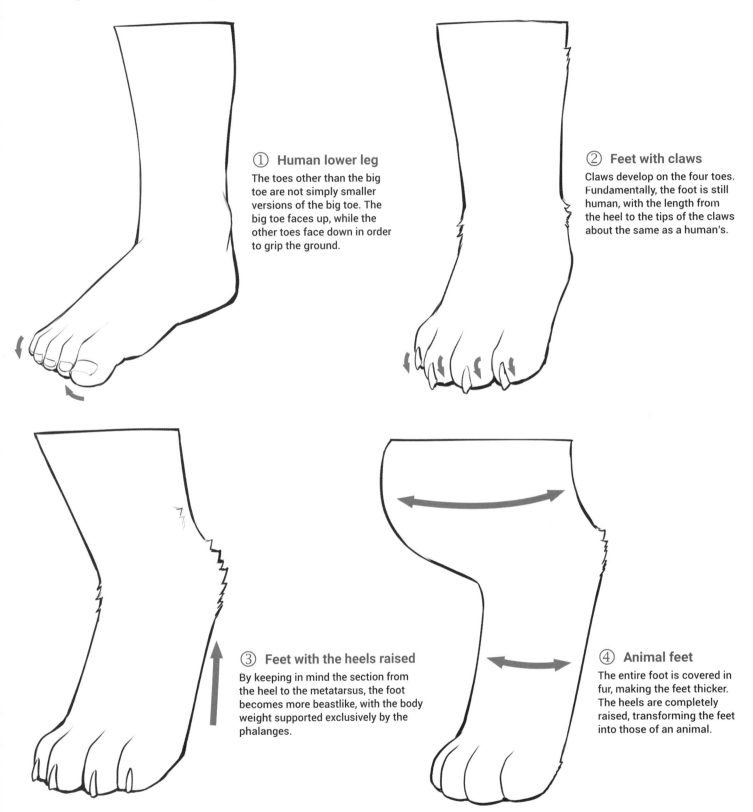

① **Human lower leg**
The toes other than the big toe are not simply smaller versions of the big toe. The big toe faces up, while the other toes face down in order to grip the ground.

② **Feet with claws**
Claws develop on the four toes. Fundamentally, the foot is still human, with the length from the heel to the tips of the claws about the same as a human's.

③ **Feet with the heels raised**
By keeping in mind the section from the heel to the metatarsus, the foot becomes more beastlike, with the body weight supported exclusively by the phalanges.

④ **Animal feet**
The entire foot is covered in fur, making the feet thicker. The heels are completely raised, transforming the feet into those of an animal.

👣 The role of the paw pads

The paw pads don't exist just for us to enjoy their springy touch. For cats that are hunters, they're invaluable in absorbing shock when jumping down from high places, preventing slipping when pouncing on something and silencing noise when stalking prey.

Cat Furries' Physiques Use fat and muscle distribution to show differences

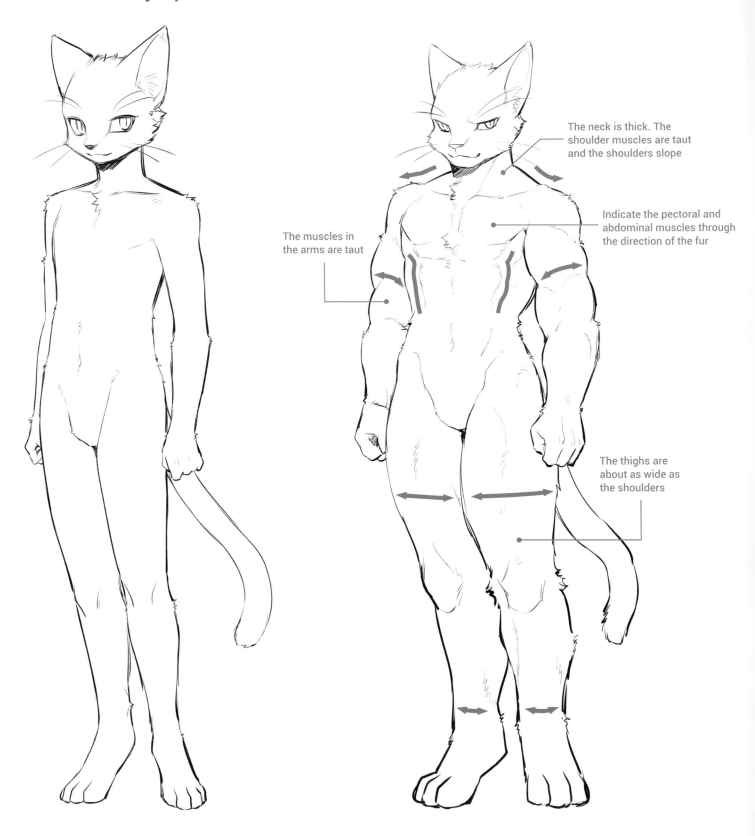

The neck is thick. The shoulder muscles are taut and the shoulders slope

Indicate the pectoral and abdominal muscles through the direction of the fur

The muscles in the arms are taut

The thighs are about as wide as the shoulders

Average

For a cat furry of average physique, keep in mind a symmetrical, slim build. It's not a particularly muscular physique.

Muscular

A defined, muscular build. Make the chest thick and sturdy and add in pectoral and abdominal muscles. The limbs should also be large, with the bulges of the muscles in the arms particularly emphasized.

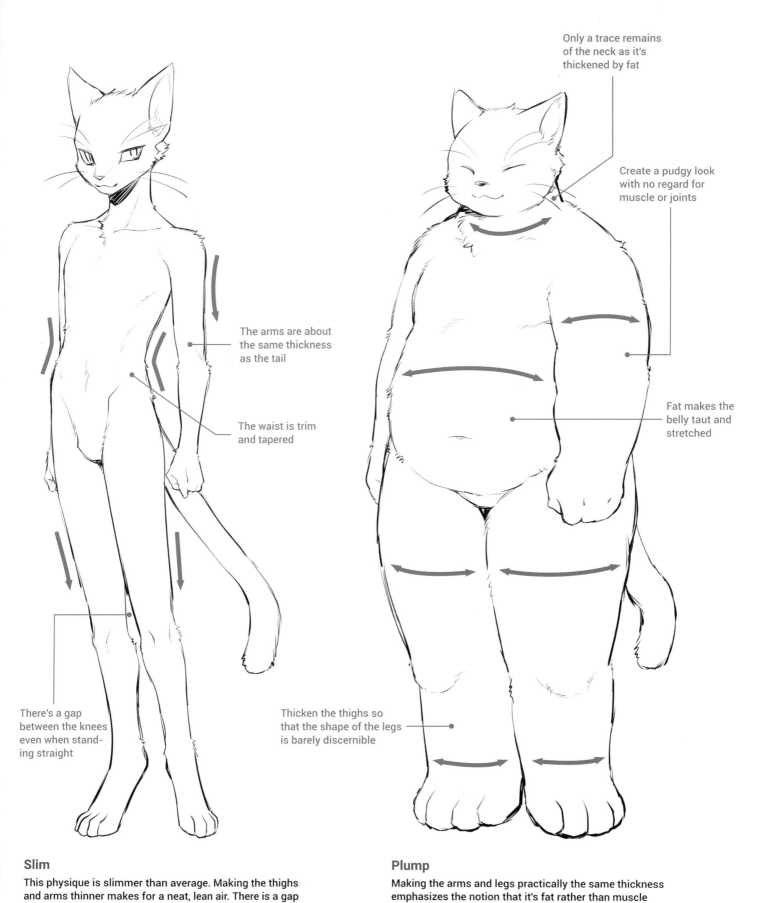

Only a trace remains of the neck as it's thickened by fat

Create a pudgy look with no regard for muscle or joints

The arms are about the same thickness as the tail

The waist is trim and tapered

Fat makes the belly taut and stretched

There's a gap between the knees even when standing straight

Thicken the thighs so that the shape of the legs is barely discernible

Slim

This physique is slimmer than average. Making the thighs and arms thinner makes for a neat, lean air. There is a gap between the knees.

Plump

Making the arms and legs practically the same thickness emphasizes the notion that it's fat rather than muscle making the creature so stout. As both legs are so thick, there's no gap between them.

Cat Furries' Ages — Draw features to show age differences

🐾 Expert Tip ❹: Cat Furries

Droopy ears and upright ears

At the kitten stage, the ears droop, but start to stand upright as the cat gets older. The fur also changes from being soft to having more body to it.

🐾 Expert Tip ❺: Cat Furries

Use the size of the eyes to distinguish ages

A commonality in all young creatures is that drawing them with big, wide eyes makes them more adorable. The key point when doing this is to use a smooth, mountain-shaped arch for the eyelids. Alternately, make the eyes small and slitted for a mature air.

Youth (6–14 years)

Making the body small, rounded in form and with an even surface creates a childlike physique. The knees and ankle joints don't stand out and the arms and legs are about the same thickness. The muzzle isn't yet well-defined, and using a ω shape for the mouth brings out a cute, immature look.

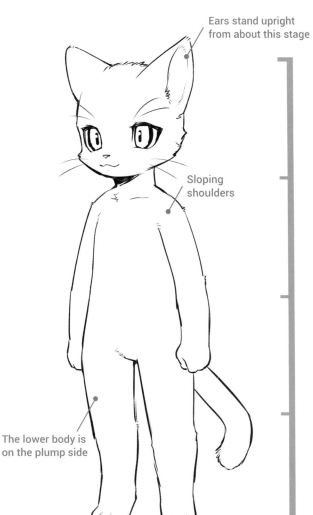

Ears stand upright from about this stage

Sloping shoulders

The lower body is on the plump side

Infancy (0–5 years)

The style of this design closely resembles a cat. The head is large, with the body measuring about two heads in height. The neck is short and appears absent when viewed from the front. The outline of the face is round overall and the chin isn't pointed.

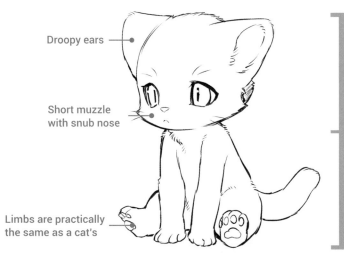

Droopy ears

Short muzzle with snub nose

Limbs are practically the same as a cat's

The ages indicated are based on human ages.

Adolescence (15–19 years)

The outline of the face is no longer a circle and the chin starts to become pointed. As the tapering around the waist and knee joints becomes more defined, the body line becomes more dynamic. The ankle joints also become more defined, making for a more furry-like figure.

Adulthood (20 years and over)

The chest thickens and the physique becomes more muscular, so add muscle to the neck and chest. The neck also thickens, so making the shoulders slope creates overall physical balance. Small eyes give the impression of maturity.

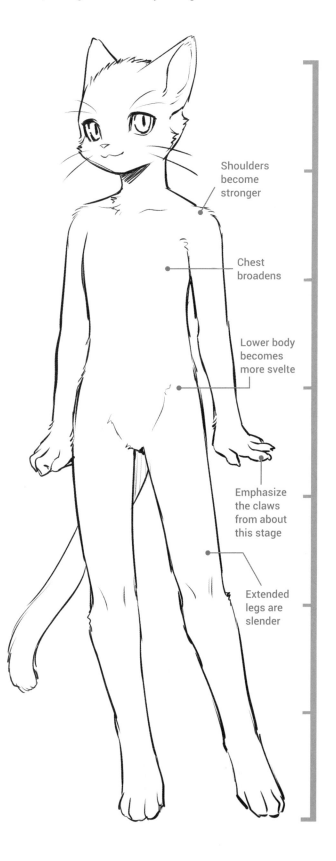

Shoulders become stronger

Chest broadens

Lower body becomes more svelte

Emphasize the claws from about this stage

Extended legs are slender

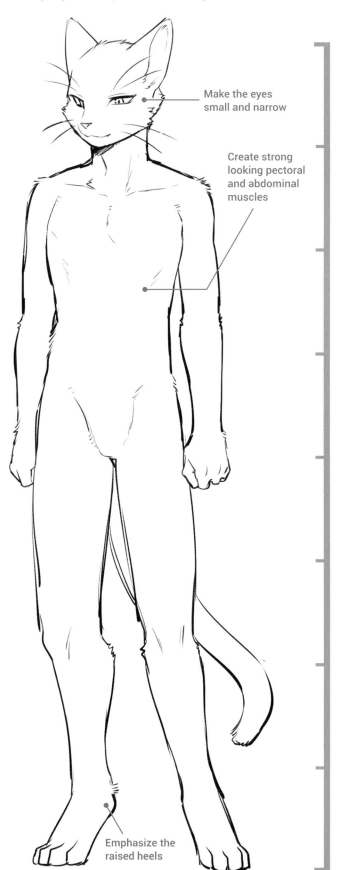

Make the eyes small and narrow

Create strong looking pectoral and abdominal muscles

Emphasize the raised heels

Variation ❶ Siamese Cat

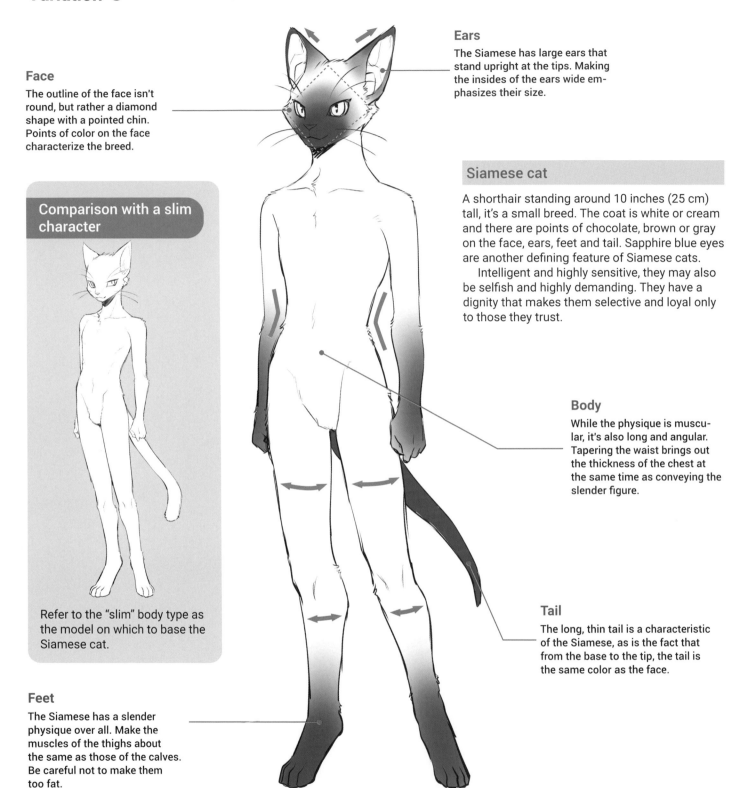

Face

The outline of the face isn't round, but rather a diamond shape with a pointed chin. Points of color on the face characterize the breed.

Ears

The Siamese has large ears that stand upright at the tips. Making the insides of the ears wide emphasizes their size.

Siamese cat

A shorthair standing around 10 inches (25 cm) tall, it's a small breed. The coat is white or cream and there are points of chocolate, brown or gray on the face, ears, feet and tail. Sapphire blue eyes are another defining feature of Siamese cats.

Intelligent and highly sensitive, they may also be selfish and highly demanding. They have a dignity that makes them selective and loyal only to those they trust.

Comparison with a slim character

Refer to the "slim" body type as the model on which to base the Siamese cat.

Body

While the physique is muscular, it's also long and angular. Tapering the waist brings out the thickness of the chest at the same time as conveying the slender figure.

Tail

The long, thin tail is a characteristic of the Siamese, as is the fact that from the base to the tip, the tail is the same color as the face.

Feet

The Siamese has a slender physique over all. Make the muscles of the thighs about the same as those of the calves. Be careful not to make them too fat.

💡 Siamese cats: Running the world

In Thailand, Siamese cats were treasured and not allowed to be exported out of the kingdom. They first traveled out of the country when a pair were presented by the palace to British consul general Owen Gould. They won ribbons at a cat show in England in 1885 and began to be imported to America in the 1890s.

Variation ❷ British Shorthair

Ears

Compared with the size of the head, the ears are small and shaped like equilateral triangles. Making the insides of the ears the same color as the rest of the fur conveys the density of the fur.

Face

There's a sense of solidity in the face, with the outline like that of a mountain. Softening the angles of the outline makes for a sweet facial expression.

British Shorthair

A shorthaired cat breed of British origin, with a height of about 20 inches (50 cm). Due to much cross-breeding, there's a diverse range of coat colors, with characteristic colors including dark gray, silver tabby and tortoiseshell. Contrary to their appearance, they have delicate natures and don't like loud places. They have a very quiet temperament despite being cast as calm and laidback. Although obedient, they have a tendency to dislike being touched or held.

Body

The body is characteristically short and stout. As the short fur covering the body is dense, the muscles and line of the navel can be omitted.

Comparison with a plump character

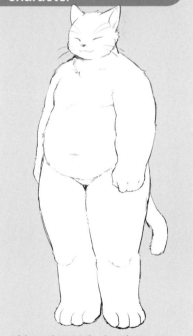

Although British shorthairs are not quite plump, the size and form of the plump character's body and legs serve as a reference.

Legs

In order to support the stout body, the legs are sturdily built. Keep in mind that they're not fat, but muscular.

Tail

Make the tail thick to match the body. Show the flow of the fur by making outward-facing strokes.

💡 England's oldest cat

The ancient Romans brought the British shorthair's ancestors, the European mountain cat, to Britain as a measure against mice and vermin. Later, around 1900, the prototype of the current British shorthair was created by a breeder who focused on English cats, which is why the breed is considered to be the oldest in England.

Face

The tiger's face is catlike, with a plump, rounded muzzle. Ornamental fur covers the area over the cheeks from the ears to the jaw.

Ears

Tigers' ears are not triangular but rather round in shape. They are different from those of pet cats. Keep a slightly elliptical shape in mind as you draw.

Tiger

A carnivorous species, the tiger can reach lengths up to 8 feet (around 250 cm) and sports a tail up to 3.5 feet (about 110 cm) long. Weighing up to 650 pounds (about 300 kg), it's the largest member of the cat family. Its characteristic striped markings obscure the body's outline, allowing it to blend into thickets and to go unnoticed when stalking and ambushing prey. Tigers don't form groups and live as solitary animals except during the mating season.

Arms

The arms are muscular with a log-like thickness. As they are covered in long fur, there is no need to emphasize the bulges in the muscles.

Body

The characteristic striped markings vary in thickness and brightness depending on the type of tiger. Make both the upper and lower body solid to form a muscular physique.

Tail

Thick and supple, the tail is about half the length of the body. Think of it being similar to a cat's as you draw.

Feet

The thighs are taut and rounded like those of a professional cyclist. From the thighs down, rather than creating bulges in the line of the leg, emphasize strength.

♨ Take a closer look: Tigers love water!

Most members of the cat family hate water. However, the tiger does not share this common trait. Inhabiting hot, tropical regions, the tiger bathes to cool down and to eliminate its own smell before hunting. It is a good swimmer and can pursue prey along a watercourse.

How to Draw a Tiger's Face

Pay attention to creating eyes and ears that are in proportion to the face

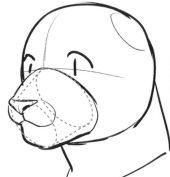

① **Blocking-in**

Block-in the face and add the blocking-in for the muzzle. The muzzle is shaped like an upturned bucket.

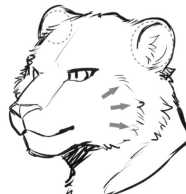

② **Rough sketch**

Follow the blocking-in to draw the oval-shaped ears. Before drawing in the striped markings, add in the ornamental fur around the cheeks.

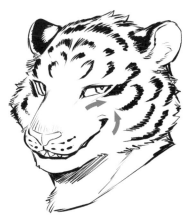

③ **Overall rough sketch**

Block-in the striped markings that are significant features of a tiger. Draw them to radiate out along the cheeks and surround the eyes.

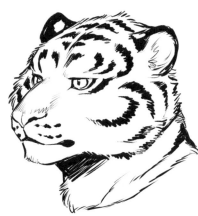

④ **Make a clean copy**

Draw in the plump, rounded muzzle. Follow the blocking-in for the stripes and rather than making solid lines, work with the direction of the fur in mind to complete the piece.

Tigers' expressions

Expression can be created even in the way the teeth are shown

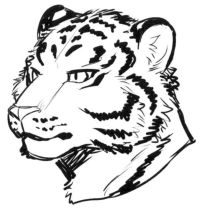

Joy

Draw the line of the lips back to below the outer corners of the eyes and angle them up to create a smile. Showing the teeth at the front of the mouth makes the expression easy to read.

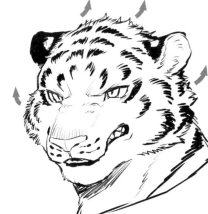

Anger

Not revealing the teeth at the front but rather showing a glimpse of them from the side conjures a growl. Roughen up the striped markings to show that the fur is standing on end.

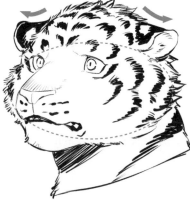

Sadness

The ears sit flat in the same way as those of a cat. Pulled back by the ears, the facial outline goes from being a circle to a horizontally elongated oval shape.

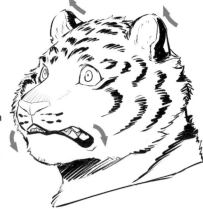

Surprise

Depict the mouth hanging down and slight gaps between the upper and lower teeth to create the look of being taken aback. Like those of a cat, the ears face forward.

55

Face

The facial outline is round and covered by the mane. Think of a conical shape when drawing the muzzle.

Mane

When drawing the mane, think of it in blocks made up of the top of the head, cheeks and jawline. Note that there are also short hairs growing in front of the ears.

Lion

The lion's main habitat is the savannah and grasslands in the southern part of Africa. Males can weigh more than 550 pounds (250 kg), making them the second-largest members of the cat family after the tiger. Unusual in cat species, lions are social animals, forming prides composed of small numbers of males and large numbers of females and cubs. Characteristic of lions is the way that females work together in groups to hunt.

Arms

The arms are strong, as they should be for a carnivorous animal. The fur is short, meaning it doesn't cover up the body, so emphasize the bulges in the muscles and the form of the joints when drawing.

Tail

Compared with the size of the body, the tail is thin. It's characterized by a tuft of fur at the end. Extend the line of the tail to draw it.

Body

The body is muscular and covered in short fur. Make the area from the waist down taut and lean compared with the upper body.

Legs and feet

The legs are sturdy and muscular. Make the thighs a squarish shape to differentiate lions from tigers, which are also muscular.

💡 **The secret of the mane**

There are two theories regarding the role of the male lion's mane: that it's a symbol of strength and that it protects the neck. The symbol of strength theory holds that an impressive mane is proof of health and power, attracting females and leading to many offspring. The second theory of the mane protecting the neck relates to males frequently having to fight off intruders in order to safeguard members of their pride. During these attacks, the mane protects the particularly vulnerable neck area.

How to Draw a Lion's Face Decide on the facial structure before drawing the mane

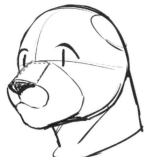

① **Blocking-in**

Block-in a circle for the outline and add the muzzle below the center line. The upper section of the muzzle is a squarish shape.

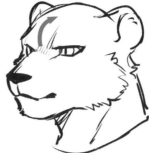

② **Rough sketch**

Using the blocking-in as a base, draw in the facial structure. Think of the line of the cheeks as being smooth and fluid.

③ **Overall rough sketch**

Keeping in mind the flow of the fur, draw the mane around the outline of the face. Make it cover the neck and make the facial outline stand out.

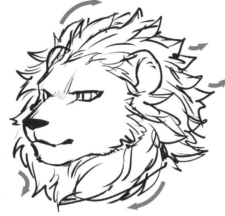

④ **Make a clean copy**

Make the muzzle a solid rectangular form that protrudes slightly beyond the facial outline. Clearly define the flow of the fur in the mane to complete the work.

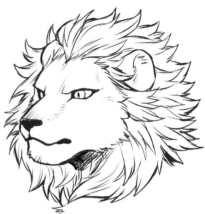

Lions' Expressions Make maximum use of the mane and teeth

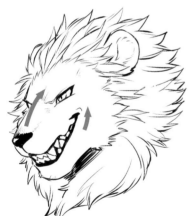

Joy

Direct the muzzle downward and extend the lips to around the outer corners of the eyes. Make the line from the forehead to the muzzle smooth and fluid.

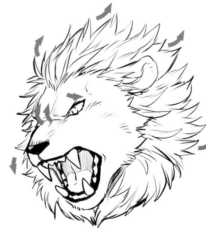

Rage

Depicting the mane spreading out expresses rage. As the area around the eyebrows bulges, the inner corners of the eyes are compressed from above, creating a sharp, glaring look.

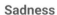

Sadness

Make the mouth closed with the corners of the mouth facing down. Directing the gaze downward indicates a deep sorrow beyond words.

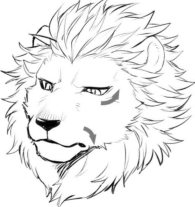

Surprise

The mouth opens to be more than half the face in size, but the teeth in the upper jaw are not particularly exposed. This expresses surprise rather than rage.

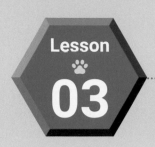

Furries with Hooves: Bighorn Sheep

Hooved furries include goats, sheep and cows. Their characteristic eyes give them something of a mysterious look. Many share similar features, but a grip of the key points distinguishing the individual animals will allow to particularize your character and render it right.

Male Furry

High rock walls are of no concern for this surefooted furry

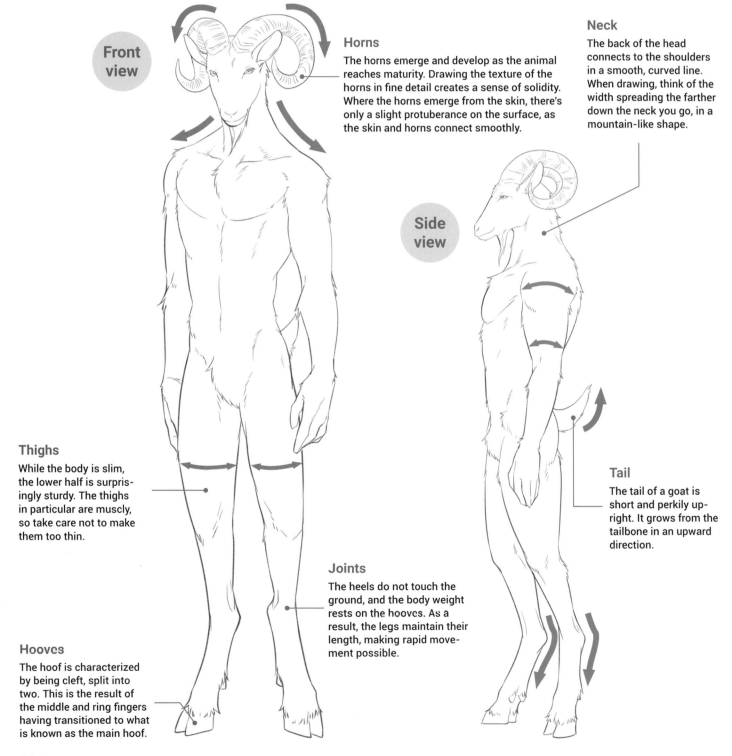

Front view

Side view

Horns

The horns emerge and develop as the animal reaches maturity. Drawing the texture of the horns in fine detail creates a sense of solidity. Where the horns emerge from the skin, there's only a slight protuberance on the surface, as the skin and horns connect smoothly.

Neck

The back of the head connects to the shoulders in a smooth, curved line. When drawing, think of the width spreading the farther down the neck you go, in a mountain-like shape.

Thighs

While the body is slim, the lower half is surprisingly sturdy. The thighs in particular are muscly, so take care not to make them too thin.

Joints

The heels do not touch the ground, and the body weight rests on the hooves. As a result, the legs maintain their length, making rapid movement possible.

Tail

The tail of a goat is short and perkily upright. It grows from the tailbone in an upward direction.

Hooves

The hoof is characterized by being cleft, split into two. This is the result of the middle and ring fingers having transitioned to what is known as the main hoof.

Female Furry Highlight the curves and slenderness

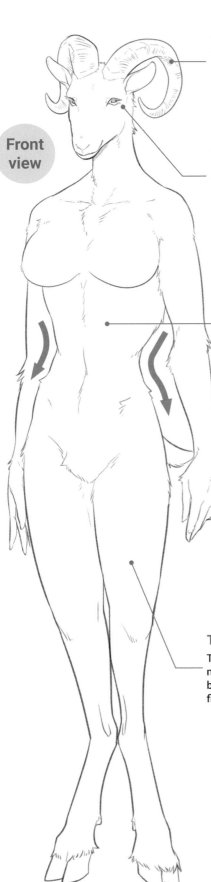

Front view

Horns

The horns are longer and thinner than the male's. If the horns are symmetrical, make sure they're the same height on either side, regardless of their shape.

Face

Thinking of the facial outline as an inverse triangle makes it easier to create the shape. The pupils are rectangular and can take in a wide field of view.

Body

The body is even more slender than that of the slim male furry, but there's more volume in the bust and buttocks. Emphasizing the narrowing of the waist brings out the slim figure.

Thighs

Thicken the section of the thighs near the crotch. Closing the gap between the thighs creates a filled-out, rounded impression.

🐾 Expert Tip ❶: Hooved Furries

Dew claw

At the base of the foot is a small hoof called a dew claw that serves to support the body and prevent it from slipping on cliffs. Adding a detail such as this biological characteristic makes for a more realistic result.

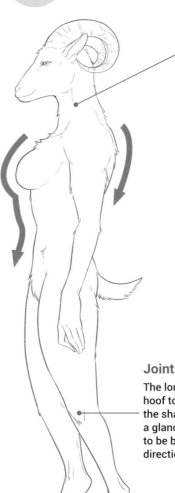

Side view

Neck

The neck is slightly slimmer than a male furry's. This allows for the creation of a sweeping line from the neck down to the shoulders.

Joints

The long section from the hoof to the heel connects to the shank and the knee. At a glance, the joints appear to be bending in the wrong direction.

Bone Structure Mixing the bone structures of goats and humans

Furry bone structure

As in a human, the clavicle joins the shoulder blades at the back to the breastbone. The upper body is also the same as a human's. In the lower body, the bone structure is such that the tibia is short and the metatarsus is long.

Animal bone structure

In an actual goat skeleton, there are 13 sets of ribs, all of which join to the breast bone. As the dew claws are atrophied or shriveled digits, there's a small bone in each.

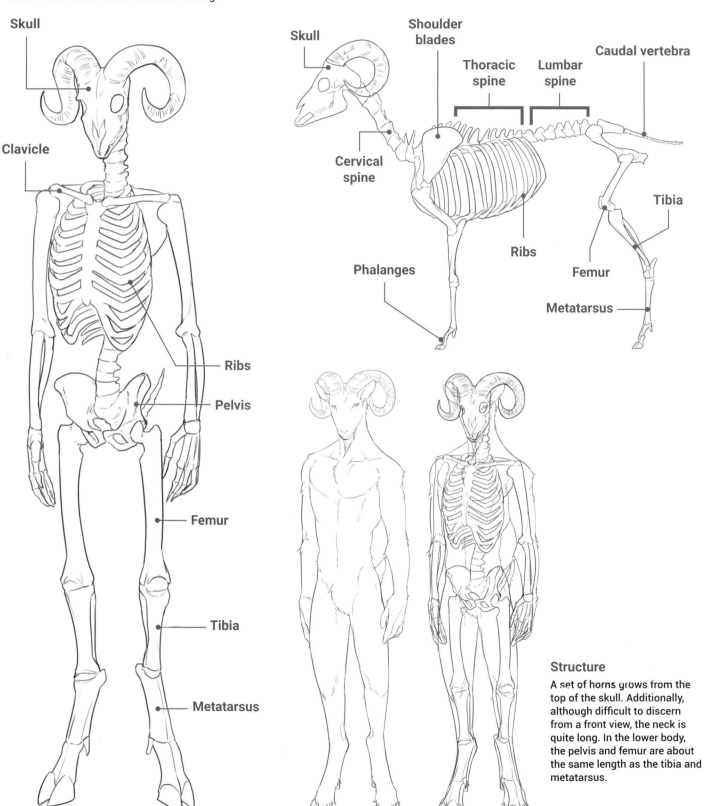

Skull

Clavicle

Ribs

Pelvis

Femur

Tibia

Metatarsus

Skull

Shoulder blades

Thoracic spine

Lumbar spine

Caudal vertebra

Cervical spine

Tibia

Phalanges

Ribs

Femur

Metatarsus

Structure

A set of horns grows from the top of the skull. Additionally, although difficult to discern from a front view, the neck is quite long. In the lower body, the pelvis and femur are about the same length as the tibia and metatarsus.

How to Draw the Body Divide the body into blocks to draw

① Blocking-in

Block-in the body of the hoofed furry, making circles to indicate the joints. The upper body tapers from the shoulders through the torso and down to the waist. Think of a rectangle as you draw.

From the thighs down, use lines rather than blocks. This way, it's possible to clearly indicate the angle of the joints that are characteristic of hoofed animals.

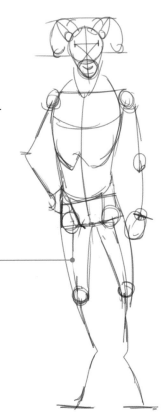

② Rough sketch

Follow the blocking-in to add the clavicle and the lines of muscles. Goats are quite muscular, so make the muscles thick.

As the length of the legs is important, note the line from the heels down as you draw. Add the blocking-in for the hooves at this stage.

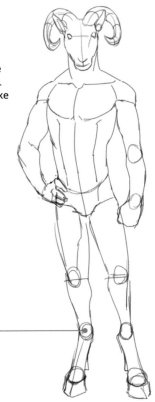

③ Line drawing

Clean up the rough sketch and make a line drawing, adding the animal elements such as horns, eyes and body hair. When drawing the horns, take care with the positioning and angle.

Add bulges to the shoulder and chest muscles and draw in tufts of fur around the crotch and joints. This creates the sense of the fur's texture even if it's short.

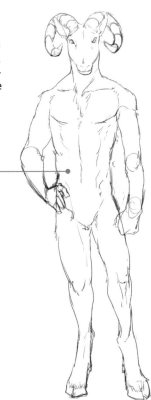

④ Completion

Adding tendons around the joints in the lower body makes the joints stand out more. Add fine lines to the horns to bring out texture and add a beard to complete the work.

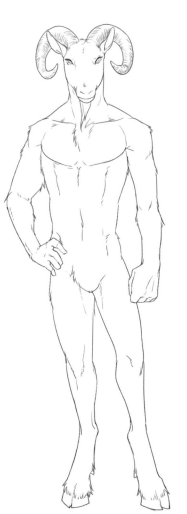

How to Draw the Face Understanding the look of the head and horns

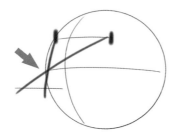

Blocking-in the face

Block-in the circle that forms the foundation for the facial outline. Draw the lines that block-in the muzzle. As a guide, make the starting point below the center line, under the right eye, at a distance about half the length from the eyes to the center line.

Think of a cross section of horn

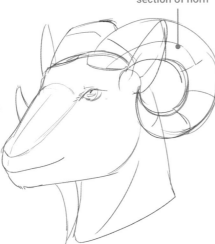

Draw the outline

The eyes are not on the front of the face but on the sides, so the right eye is not visible. Draw in the ears to the sides of the eyes.

Blocking-in markings

Follow the blocking-in to draw the muzzle. Think of the muzzle as being shaped like a plant pot. Block-in the ears and horns also.

Keep the base of the horn near the hairline smooth

Make a clean copy

Fill in the texture of the horns, the hairline and other fine details. Use light and shade to create a slight swelling in the hairline area on the head for a realistic look.

Adding expression Express emotion through the angle of the ears

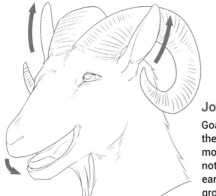

Joy

Goats don't have teeth in their upper jaw, so even if the mouth is open, front teeth are not visible. Additionally, the ears are perpendicular to the ground.

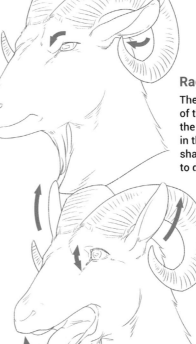

Rage

The ears flatten to the back of the head and the backs of the ears face forward. Tension in the eyebrows changes the shape of the eyes from circles to diamonds.

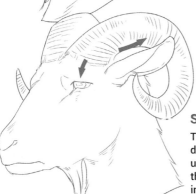

Sadness

The ears lose firmness and droop out to the sides. The upper parts of the eyes lose their circular shape, flattening out to give the eyes a semicircle shape.

Surprise

The eyes open wide to form circles and the ears stand straight up. While goats don't have front teeth, they do have molars (back teeth) so make sure to show them.

Angles of the Face Capture the sense of solidity from various angles

Side view

Think of the outline of the face in profile as a large triangle. The gaze does not follow the direction of the face, but rather the eyes look out to both sides.

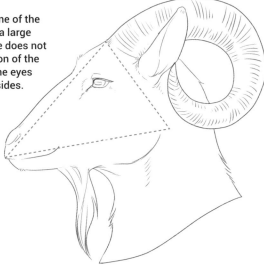

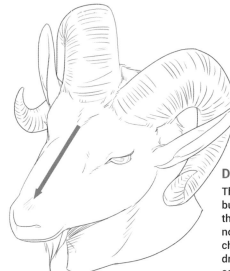

Diagonal angle

There are few lumps and bumps in the line from the head to the tip of the nose. The line from the cheeks to the muzzle drops slightly but is basically smooth and straight.

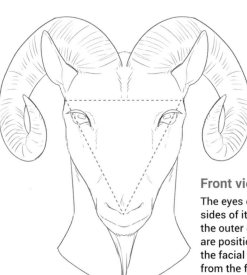

Front view

The eyes of a goat are on the sides of its face. This is why the outer corners of the eyes are positioned barely within the facial outline when viewed from the front. The outline forms an inverse triangle from the eyes down to the apex at the tip of the nose.

🐾 Expert Tip ❷: Hooved Furries

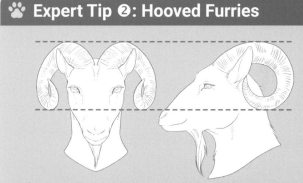

Make sure the position and angle of the horns match

Match the highest and lowest parts and the tips of the horns to achieve a symmetrical look. Take care that the horns are angled to fall between the parallel lines on either sides of the eyes when the front and side views are placed next to each other.

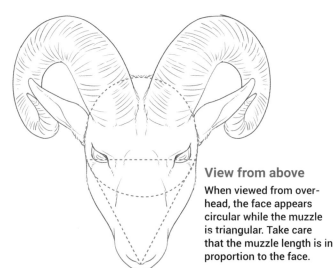

View from above

When viewed from overhead, the face appears circular while the muzzle is triangular. Take care that the muzzle length is in proportion to the face.

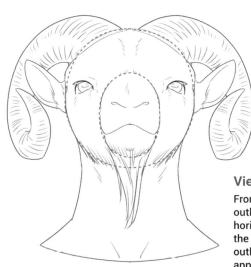

View from below

From below, the facial outline resembles a long horizontal oval. Within the facial outline, the outline of the muzzle appears as another oval.

Beastly Hands Add parts as you go

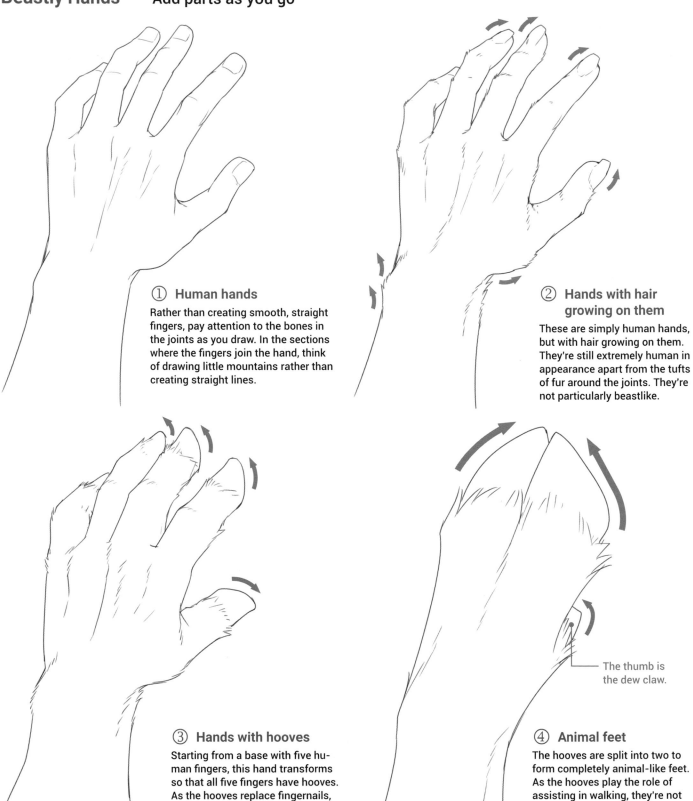

① Human hands

Rather than creating smooth, straight fingers, pay attention to the bones in the joints as you draw. In the sections where the fingers join the hand, think of drawing little mountains rather than creating straight lines.

② Hands with hair growing on them

These are simply human hands, but with hair growing on them. They're still extremely human in appearance apart from the tufts of fur around the joints. They're not particularly beastlike.

③ Hands with hooves

Starting from a base with five human fingers, this hand transforms so that all five fingers have hooves. As the hooves replace fingernails, take care not to make them too big.

④ Animal feet

The hooves are split into two to form completely animal-like feet. As the hooves play the role of assisting in walking, they're not suited to grasping objects.

The thumb is the dew claw.

🐾 Hooves are specialized for running

In human terms, hooves are the equivalent of nails. While human nails play the role of protecting the digits, the hooves are used to kick the ground and are ideally suited for striking the ground to run fast. However, they cannot be used for detailed tasks.

Beastly Feet The bone structure approaches that of a goat

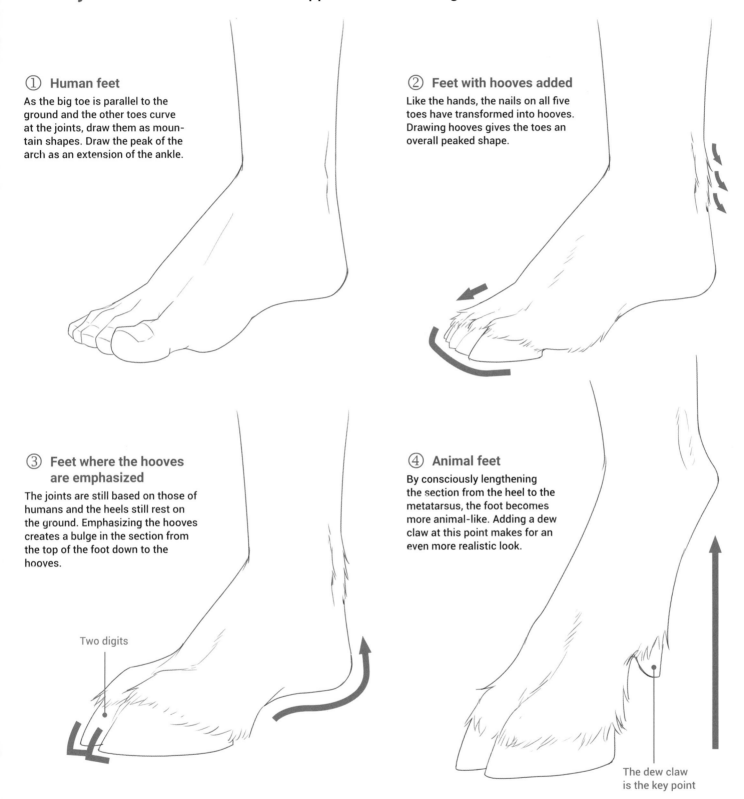

① **Human feet**
As the big toe is parallel to the ground and the other toes curve at the joints, draw them as mountain shapes. Draw the peak of the arch as an extension of the ankle.

② **Feet with hooves added**
Like the hands, the nails on all five toes have transformed into hooves. Drawing hooves gives the toes an overall peaked shape.

③ **Feet where the hooves are emphasized**
The joints are still based on those of humans and the heels still rest on the ground. Emphasizing the hooves creates a bulge in the section from the top of the foot down to the hooves.

Two digits

④ **Animal feet**
By consciously lengthening the section from the heel to the metatarsus, the foot becomes more animal-like. Adding a dew claw at this point makes for an even more realistic look.

The dew claw is the key point

🐾 Standing on tiptoes forms the foundation

The "animal foot," in Step 4, above, is long in the metatarsus from the tiptoes to the heel and the heel is raised significantly off the ground. As this section then connects to the knee, the joints appear to be bent backward. These are known as "reverse joints" because the heel section is mistakenly seen as the knee. In reality, the animal is standing on its tiptoes, so the joint is not bent backward at all.

Hooved Furries' Physiques Use fat and muscle distribution to show differences

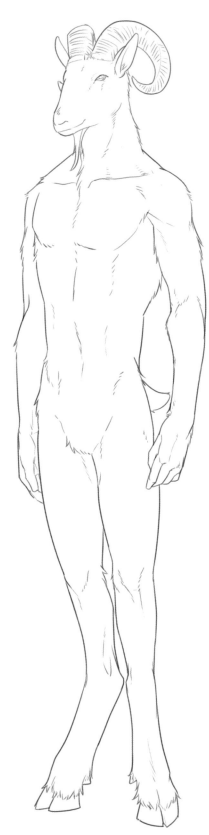

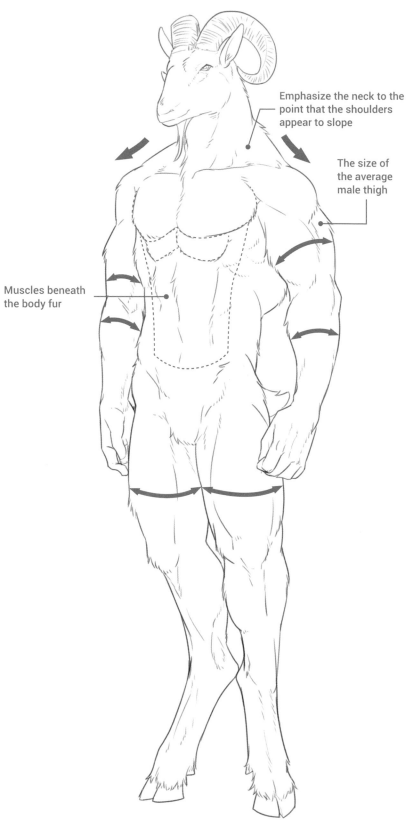

Emphasize the neck to the point that the shoulders appear to slope

The size of the average male thigh

Muscles beneath the body fur

Average

The physique is surprisingly muscular. Create a lean line for the body and add tendons to the muscles in the pectoral, oblique and thigh areas to indicate a muscular physique.

Muscular

Thickening the neck and making the shoulders slope allows for the expression of bulges in the shoulder muscles, creating a still more massive physique.

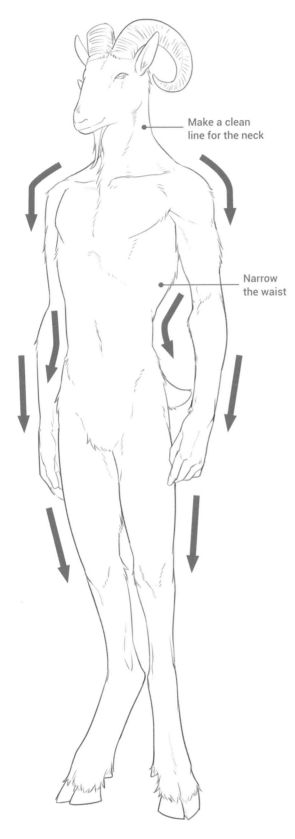

Make a clean
line for the neck

Narrow
the waist

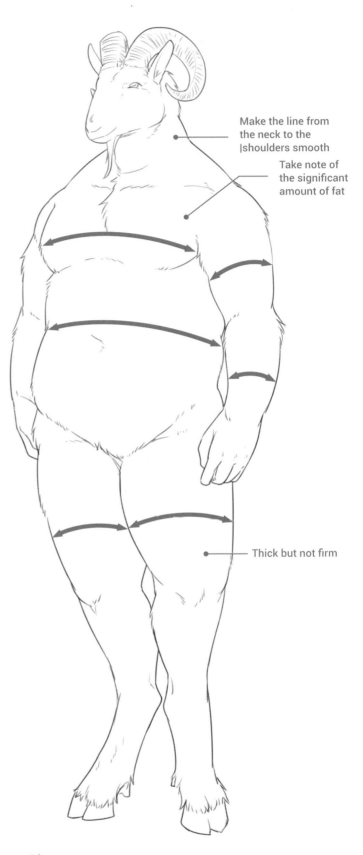

Make the line from
the neck to the
|shoulders smooth

Take note of
the significant
amount of fat

Thick but not firm

Slim

As there's little muscle, the line from the neck to
the shoulders is relatively even, so use a smooth,
curved line to draw it. The legs are also not very
muscly, meaning that the length of the legs is
easiest to convey in this body type.

Plump

Make the neck short and lengthen the line of the
shoulders. This broadens the shoulders and makes
the body seem larger.

Hooved Furries' Ages Draw features to show age differences

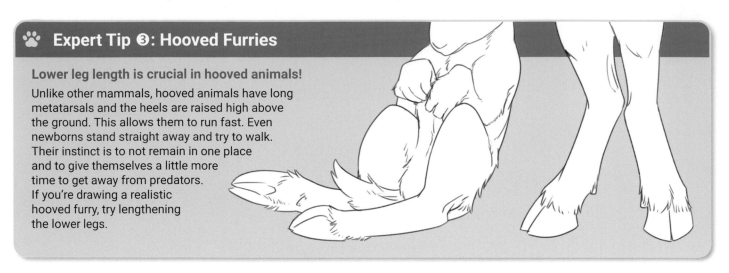

Expert Tip ❸: Hooved Furries

Lower leg length is crucial in hooved animals!

Unlike other mammals, hooved animals have long metatarsals and the heels are raised high above the ground. This allows them to run fast. Even newborns stand straight away and try to walk. Their instinct is to not remain in one place and to give themselves a little more time to get away from predators. If you're drawing a realistic hooved furry, try lengthening the lower legs.

Youth (6–14 years)

The muzzle lengthens and the entire face takes on a rounded outline and structure. The horns start to emerge. Draw the base of the horns as slightly bulging to make them blend in with the skin rather than simply sitting on top of the head.

Infancy (0–5 years)

The lower legs are long in proportion to the body, so the body is not balanced for walking on two legs. The horns have not yet grown. The face is small and the ears are long compared with the head. Make the ears droopy.

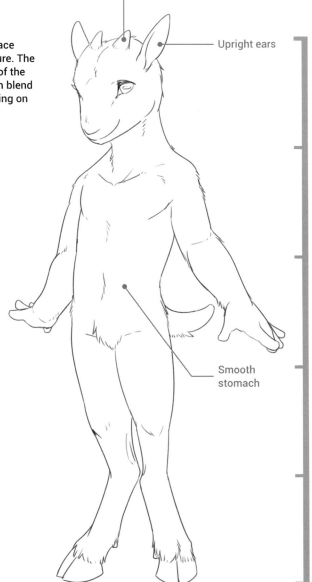

Horns emerge

Upright ears

Smooth stomach

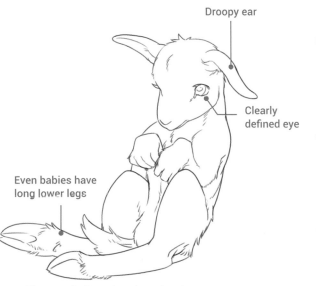

Droopy ear

Clearly defined eye

Even babies have long lower legs

The ages indicated are based on human ages.

68

Adolescence (15–19 years)

The muzzle becomes clearly defined emerging from the rounded facial outline and the horns grow and begin to curve. The area from the hooves to the heels and the knee joints becomes more defined and the lower legs lengthen.

Adulthood (20 years and over)

Add muscle to the lower body to form a sturdy physique. Add muscle to the neck and chest also. Make sure the height of the tips of the curling horns is symmetrical when drawing them.

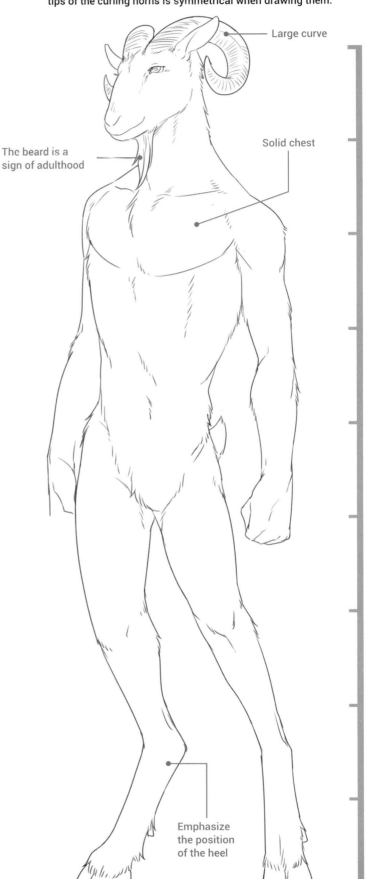

Large curve

Solid chest

The beard is a sign of adulthood

Emphasize the position of the heel

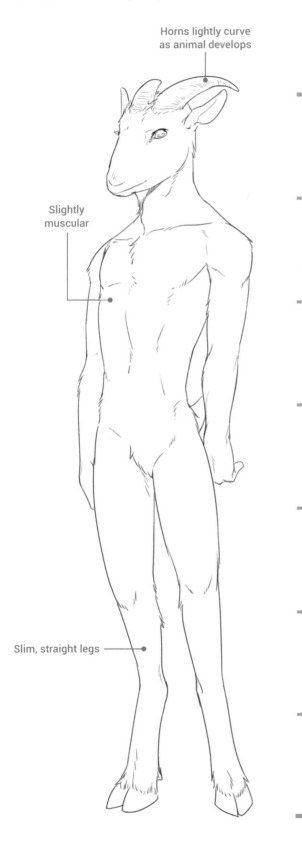

Horns lightly curve as animal develops

Slightly muscular

Slim, straight legs

Variation ❶　Goat

Face

For the facial outline, think of the chin as the pivot point in a right-angled triangle. The line of the muzzle is relatively straight and even.

Horns

Most of these goats don't have horns, but if they do, they're not curled.

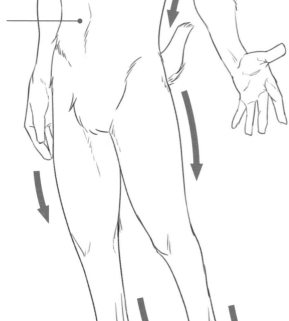

Body

Although it's a domestic animal, the goat fundamentally has a sturdy physique so don't make the body too thin.

Goats

Goats are kept all over the world. The prevailing image of goats being white comes from this breed. Males are about 190 pounds (85 kg) and females are about 120 pounds (55 kg), but some large males can weigh more than 225 pounds (100 kg). Their coats are white and females have well-developed udders.

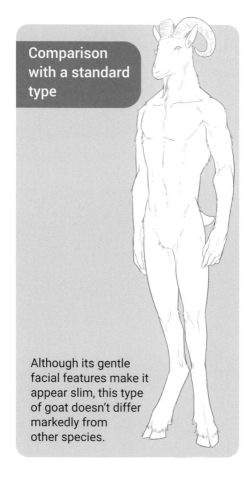

Comparison with a standard type

Although its gentle facial features make it appear slim, this type of goat doesn't differ markedly from other species.

Feet

As this is a milking breed, don't make the lower body particularly muscular. Define the joints in the characteristic line from the heels to the hooves.

🐾 Think goat, think saanen

Most goats raised in Japan are the standard breed or Japanese saanens, which are a hybrid. Japanese saanens were refined in Japan in 1949. They are a result of cross breeding the native Japanese shibayagi, which came mainly from the Kyushu region, in the 15th century with the saanen, which was imported from Europe. The females are raised for milking while the males are bred for meat, mainly in the Okinawa region.

Variation ❷ Mountain Goat

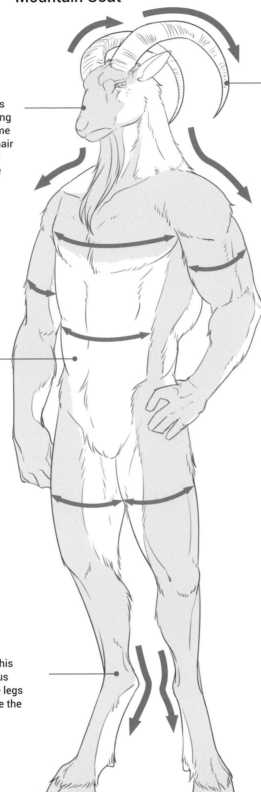

Face

The adult male animal has extremely long hair growing from the jawline, with some older individuals having hair so long that it completely covers the area below the jaw.

Body

The body is characterized by brown fur covering the face, shoulders, chest and front of the limbs, while the stomach and inner thighs are white.

Feet

Unlike a domestic goat, this type inhabits mountainous regions, which is why the legs are so sturdily built. Make the thighs muscular.

Horns

The horns form a crescent moon shape with the tips curving inward like an archer's bow. The surface of the horns is not smooth, but rather is covered in faint horizontal lines.

Mountain Goat

The mountain goat inhabits the forested rocky areas, wetlands and grasslands. Its coat is a reddish brown in summer and a grayish brown in winter, with long hair growing around the neck and shoulders in the winter months. The males are solitary, with only young males joining herds.

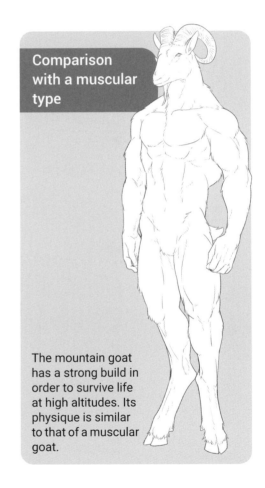

Comparison with a muscular type

The mountain goat has a strong build in order to survive life at high altitudes. Its physique is similar to that of a muscular goat.

💡 Hailing from ancient ruins

Bones presumed to be from domesticated goats have been excavated from ruins in Jericho, Jordan, which is said to be one of the world's oldest agrarian settlements. These domesticated goat bones estimated as dating from 6000–7000 B.C.E. are consistent with those of the mountain goat. For this reason, it is thought that the mountain goat was domesticated and became the goat that we know today.

Other Species ❶ Sheep

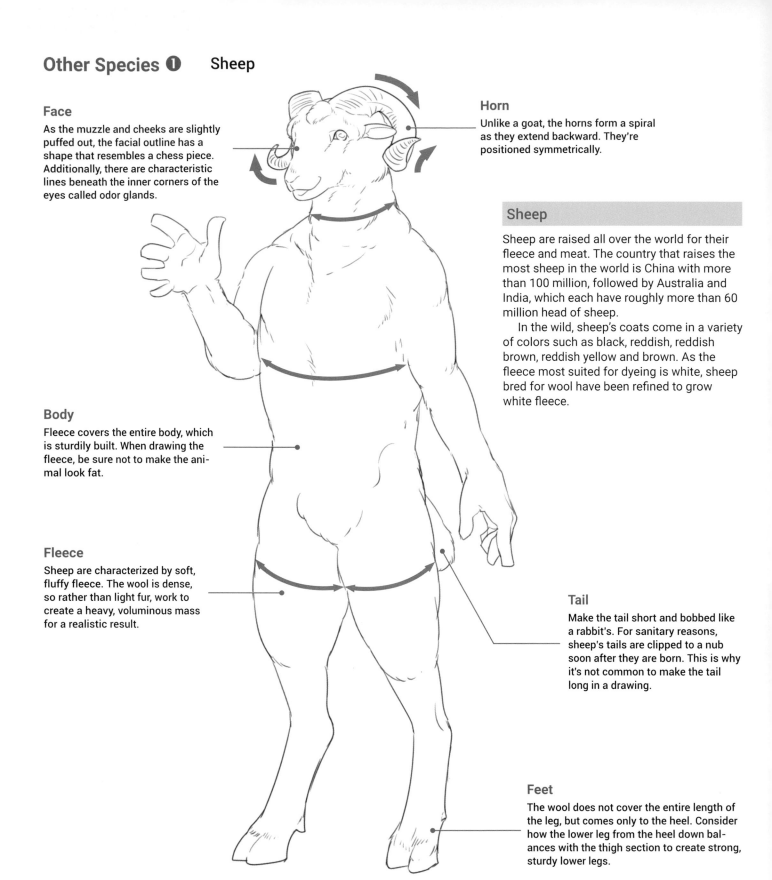

Face

As the muzzle and cheeks are slightly puffed out, the facial outline has a shape that resembles a chess piece. Additionally, there are characteristic lines beneath the inner corners of the eyes called odor glands.

Horn

Unlike a goat, the horns form a spiral as they extend backward. They're positioned symmetrically.

Sheep

Sheep are raised all over the world for their fleece and meat. The country that raises the most sheep in the world is China with more than 100 million, followed by Australia and India, which each have roughly more than 60 million head of sheep.

In the wild, sheep's coats come in a variety of colors such as black, reddish, reddish brown, reddish yellow and brown. As the fleece most suited for dyeing is white, sheep bred for wool have been refined to grow white fleece.

Body

Fleece covers the entire body, which is sturdily built. When drawing the fleece, be sure not to make the animal look fat.

Fleece

Sheep are characterized by soft, fluffy fleece. The wool is dense, so rather than light fur, work to create a heavy, voluminous mass for a realistic result.

Tail

Make the tail short and bobbed like a rabbit's. For sanitary reasons, sheep's tails are clipped to a nub soon after they are born. This is why it's not common to make the tail long in a drawing.

Feet

The wool does not cover the entire length of the leg, but comes only to the heel. Consider how the lower leg from the heel down balances with the thigh section to create strong, sturdy lower legs.

💡 Personality differences between sheep and goats

Sheep are mild-mannered and gentle and are also said to be cowardly and indecisive. In contrast, goats are found to be extremely inquisitive, lively and self-centered. These traits are sometimes utilized by installing a goat as the leader in a herd of sheep. This method allows the entire herd to be controlled by the goat, which is then controlled by a human.

How to Draw a Sheep's Face Watch the distance between the forehead and muzzle

① Blocking-in

Block-in the circles for the facial outline and muzzle. Draw the muzzle to sit below the center line, slightly beyond the facial outline.

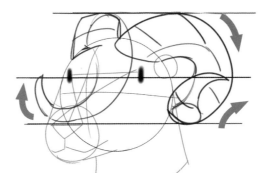

② Rough sketch

Block-in the ears and horns. The horns don't extend up like a goat's, but rather curve in a direction just behind the ears.

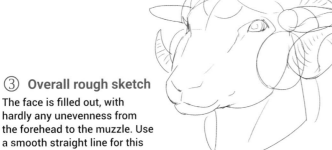

③ Overall rough sketch

The face is filled out, with hardly any unevenness from the forehead to the muzzle. Use a smooth straight line for this section.

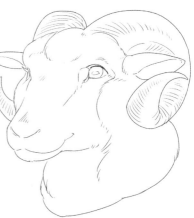

④ Make a clean copy

Characteristic fleece covers the forehead, cheeks and neck. In contrast, the skin is bare from the eyes inward. Make fine horizontal lines over the horns to complete the work.

Sheep's Expressions Exaggerate the eyes and mouth

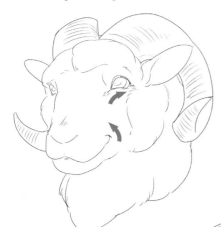

Joy

The top lip of a sheep is divided in two. Make sure each side of the mouth is raised equally, keeping in mind a ω shape spreading out horizontally as you draw.

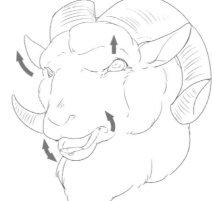

Rage

It may be due to the fleece covering the entire face, but sheep have a mild-mannered appearance. Try to exaggerate the expression by making the eyes triangular and showing the teeth bared.

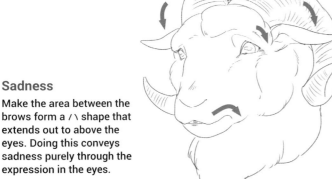

Sadness

Make the area between the brows form a / \ shape that extends out to above the eyes. Doing this conveys sadness purely through the expression in the eyes.

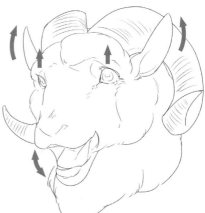

Surprise

Both the upper and lower jaw open up wide to create the expression of surprise. Don't alter the size of the pupils as the eyes grow big and round.

Other Species ❷ Cow

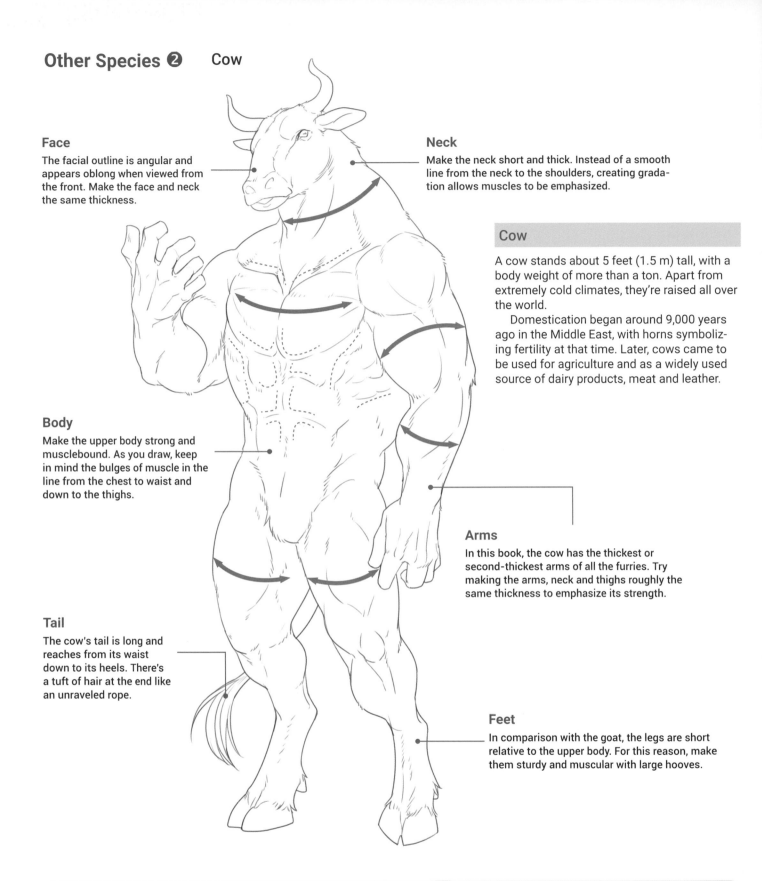

Face

The facial outline is angular and appears oblong when viewed from the front. Make the face and neck the same thickness.

Neck

Make the neck short and thick. Instead of a smooth line from the neck to the shoulders, creating gradation allows muscles to be emphasized.

Cow

A cow stands about 5 feet (1.5 m) tall, with a body weight of more than a ton. Apart from extremely cold climates, they're raised all over the world.

 Domestication began around 9,000 years ago in the Middle East, with horns symbolizing fertility at that time. Later, cows came to be used for agriculture and as a widely used source of dairy products, meat and leather.

Body

Make the upper body strong and musclebound. As you draw, keep in mind the bulges of muscle in the line from the chest to waist and down to the thighs.

Arms

In this book, the cow has the thickest or second-thickest arms of all the furries. Try making the arms, neck and thighs roughly the same thickness to emphasize its strength.

Tail

The cow's tail is long and reaches from its waist down to its heels. There's a tuft of hair at the end like an unraveled rope.

Feet

In comparison with the goat, the legs are short relative to the upper body. For this reason, make them sturdy and muscular with large hooves.

💡 The cow's four stomachs

The cow is the stereotypical ruminant animal, bringing food that has been partially digested in its stomach back to its mouth to chew. Repeating this process allows the cow to digest food effectively. Cows have four stomachs, but only the fourth stomach, the abomasum, has the function of secreting gastric juice as a stomach usually would. Positioned near the mouth, the first to third stomachs are actually esophagi that have changed form.

How to Draw a Cow's Face Make the face tough and squarish

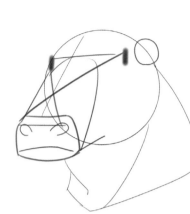

① Blocking-in

Think of the facial outline as a circle, with the muzzle an oblong shape. Draw the blocking-in line of the neck not from below the face but rather from below the muzzle.

② Rough sketch

Think of the horns as an oval shape that sits across the top of the head. Draw in the tips of the horns to match the oval shape, making the horns the same height on both sides.

③ Overall rough sketch

Draw in the facial outline to follow the blocking-in. Connect the back of the head to the line of the neck in order to emphasize the thickness of the neck.

④ Make a clean copy

Draw in the nostrils as horizontal ovals and add the outer lines of the muzzle around the nostrils. Add the bulge of muscles to the neck to complete the work.

Cows' Expressions Create expression within a rigidly defined face

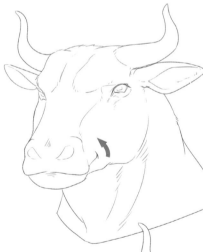

Joy

Raising the ends of the mouth creates the appearance of smiling. At the same time, be aware that over-exaggerating this expression will negate the cow's powerful image.

Rage

The area between the eyebrows tenses and bulges form in the muscles. Define the lines of the eyebrows to emphasize rage and make the ears turn out to the sides.

Sadness

Draw the eyes with the outer corners lowered and make the ears fold down. This creates the sense of sadness.

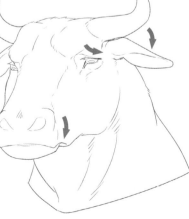

Surprise

Allowing the mouth to gape open sloppily creates a look of surprise. Like goats, cows have no teeth in their upper jaws, so only those in the lower jaw are visible.

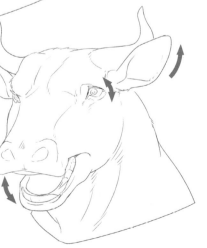

Plumped-Up Furries

Plump furries have a fluffy, puffy silhouette. Although their bone structure is unchanged from that of a regular furry, the areas around the stomach, legs and even face are plumper, altering the face itself. When a regular human puts on weight, the entire body swells; but in the case of furries, their covering of fur makes them appear even fluffier.

Their puffed-up facial features, soft appearance, large bodies and strong limbs have established them as an increasingly popular character type.

Their rounded figures would seem to be simple to draw, however as their skeletons and joints are covered in flesh, there's actually a high level of difficulty involved.

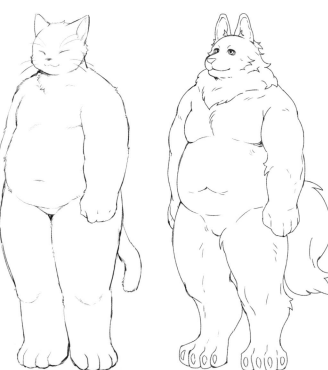

Feathered Furries and Flying Beasts

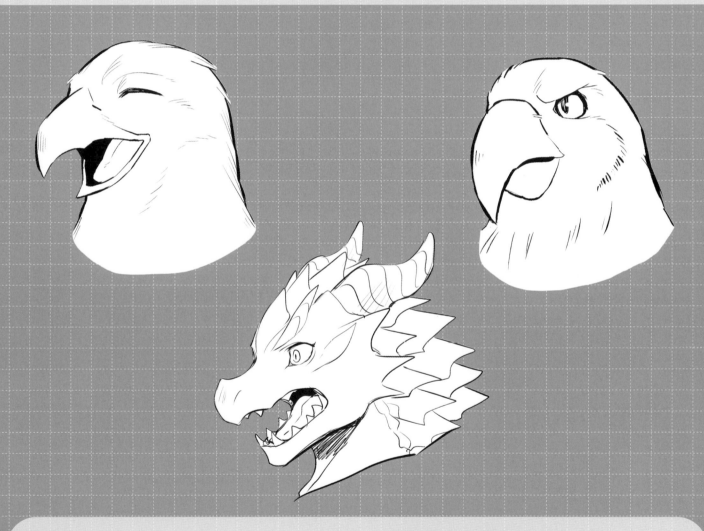

How to Draw Bird Furries

Birds present a range of motion options, flying, walking and their beak structures present the artist with unique challenges and rewards. Birds are said to have evolved from dinosaurs, becoming highly compact and airborne. There's a huge variety of types, ranging from adorable birds such as sparrows to ferocious predators such as eagles and hawks. Embrace the range of choices these winged wonders offer.

Male Furry The bald eagle: the most powerful bird of prey with a sharp, straight beak

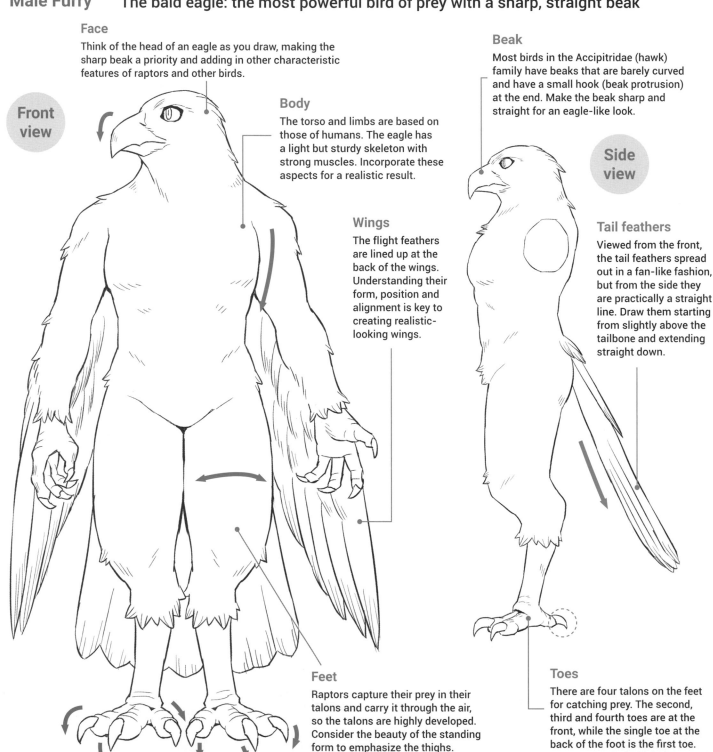

Face

Think of the head of an eagle as you draw, making the sharp beak a priority and adding in other characteristic features of raptors and other birds.

Front view

Body

The torso and limbs are based on those of humans. The eagle has a light but sturdy skeleton with strong muscles. Incorporate these aspects for a realistic result.

Wings

The flight feathers are lined up at the back of the wings. Understanding their form, position and alignment is key to creating realistic-looking wings.

Beak

Most birds in the Accipitridae (hawk) family have beaks that are barely curved and have a small hook (beak protrusion) at the end. Make the beak sharp and straight for an eagle-like look.

Side view

Tail feathers

Viewed from the front, the tail feathers spread out in a fan-like fashion, but from the side they are practically a straight line. Draw them starting from slightly above the tailbone and extending straight down.

Feet

Raptors capture their prey in their talons and carry it through the air, so the talons are highly developed. Consider the beauty of the standing form to emphasize the thighs.

Toes

There are four talons on the feet for catching prey. The second, third and fourth toes are at the front, while the single toe at the back of the foot is the first toe.

Female Furry Use rounded forms of a human to express the line of the body

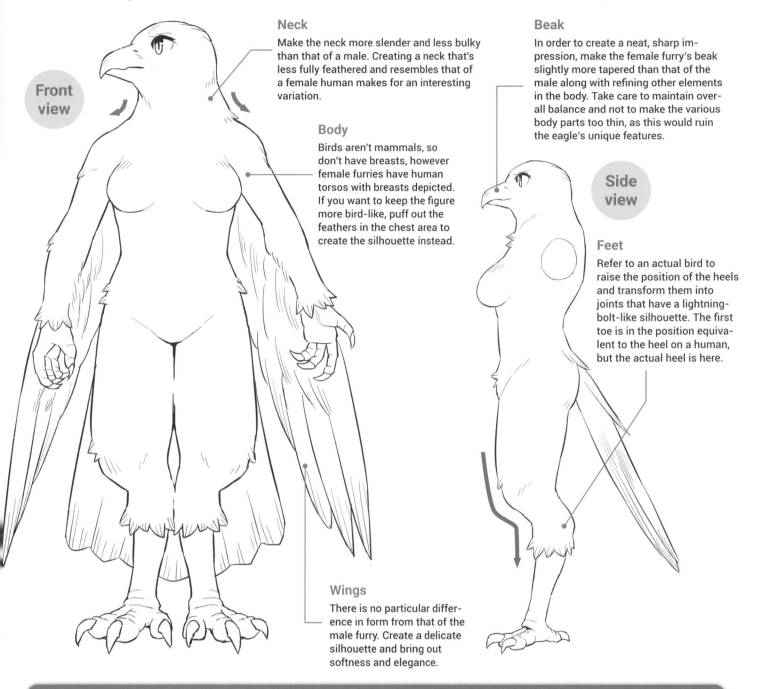

Neck

Make the neck more slender and less bulky than that of a male. Creating a neck that's less fully feathered and resembles that of a female human makes for an interesting variation.

Body

Birds aren't mammals, so don't have breasts, however female furries have human torsos with breasts depicted. If you want to keep the figure more bird-like, puff out the feathers in the chest area to create the silhouette instead.

Beak

In order to create a neat, sharp impression, make the female furry's beak slightly more tapered than that of the male along with refining other elements in the body. Take care to maintain overall balance and not to make the various body parts too thin, as this would ruin the eagle's unique features.

Feet

Refer to an actual bird to raise the position of the heels and transform them into joints that have a lightning-bolt-like silhouette. The first toe is in the position equivalent to the heel on a human, but the actual heel is here.

Wings

There is no particular difference in form from that of the male furry. Create a delicate silhouette and bring out softness and elegance.

Front view

Side view

🐾 Expert Tip ❶: Flying Furries

Basic structure of bird wings

Within a bird's wing, three types of "flight feathers" are used, with the primary feathers producing thrust, the secondary feathers producing lift and the tertiary feathers filling the area between the torso and wings. Covering these, as the name suggests, are the "coverts." The alula works to prevent stalling during low-speed flight. The exact number of each is also important, but a grasp of how the coverts and flight feathers are arranged is top priority. Furthermore, the flight feathers are large and stiff with a thick line called a rachis running through them. Incorporating this into your drawing increases the level of expression and accuracy.

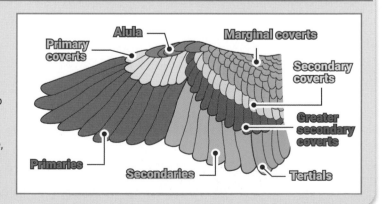

Bone Structure Mixing a bird's bone structure into a human's

Furry bone structure

The bone structure of the torso is the same as a human's. As birds have only three digits and humans have five, furries split the difference by having four. The legs are also depicted with reference to a real bird, with the tarsus elongated. In order to balance when standing, the tibia has been shortened.

Animal bone structure

The large wings are supported by the bone structure of the arms. Within the wings there are actually bone structures for the first, second and third digits. The humerus and other parts are the same bone structure as those of humans, and the form resembles a human with outstretched arms.

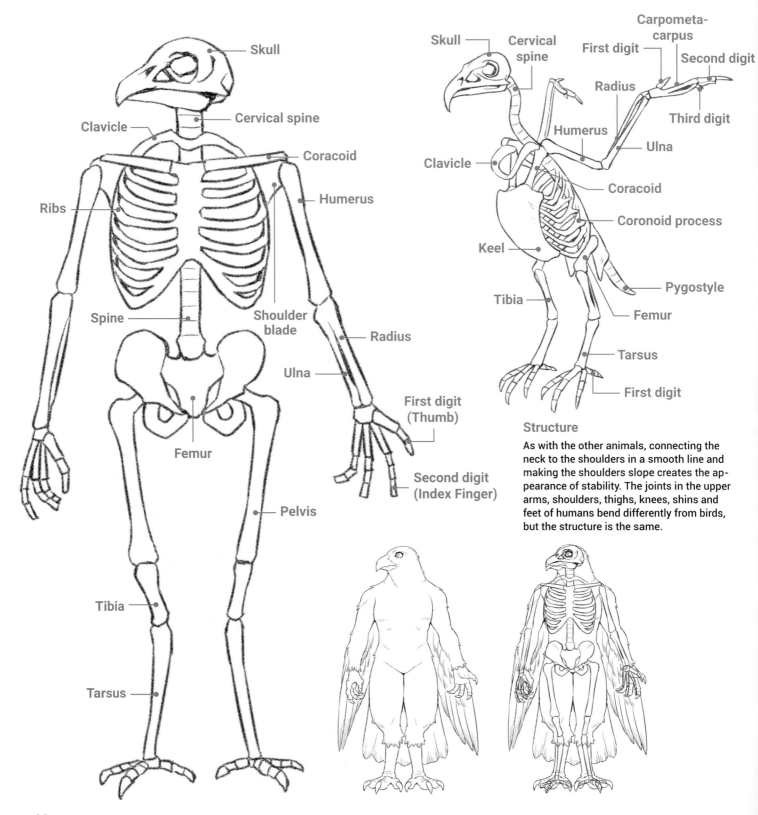

Structure

As with the other animals, connecting the neck to the shoulders in a smooth line and making the shoulders slope creates the appearance of stability. The joints in the upper arms, shoulders, thighs, knees, shins and feet of humans bend differently from birds, but the structure is the same.

How to Draw the Body Tweaking the bird-like qualities alters the look

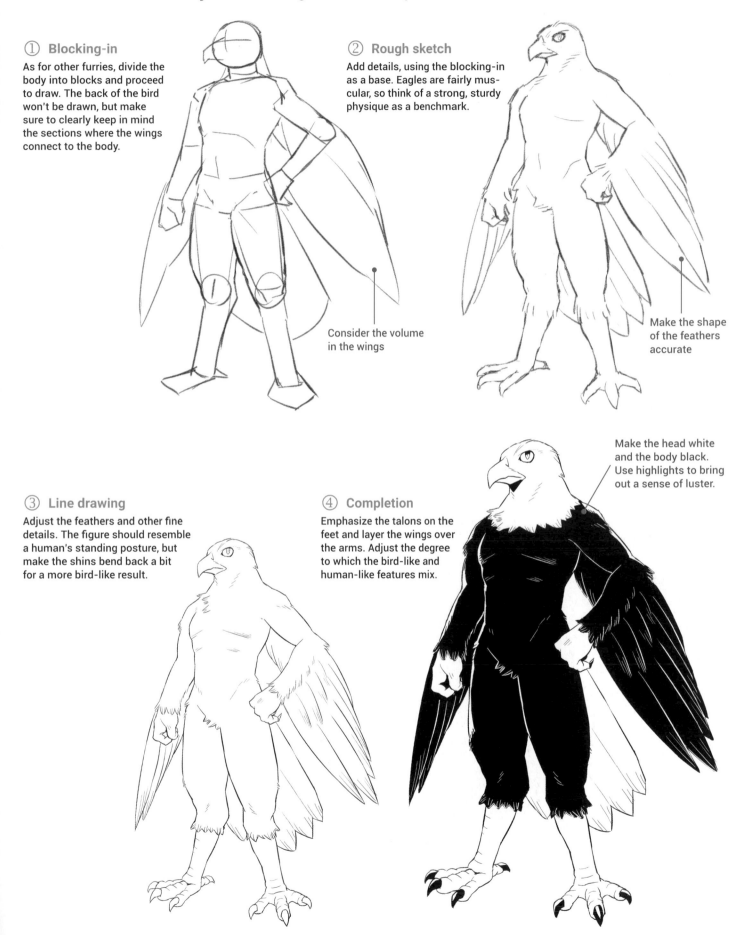

① **Blocking-in**

As for other furries, divide the body into blocks and proceed to draw. The back of the bird won't be drawn, but make sure to clearly keep in mind the sections where the wings connect to the body.

Consider the volume in the wings

② **Rough sketch**

Add details, using the blocking-in as a base. Eagles are fairly muscular, so think of a strong, sturdy physique as a benchmark.

Make the shape of the feathers accurate

③ **Line drawing**

Adjust the feathers and other fine details. The figure should resemble a human's standing posture, but make the shins bend back a bit for a more bird-like result.

④ **Completion**

Emphasize the talons on the feet and layer the wings over the arms. Adjust the degree to which the bird-like and human-like features mix.

Make the head white and the body black. Use highlights to bring out a sense of luster.

How to Draw the Face Emphasize a bird-like appearance in the face

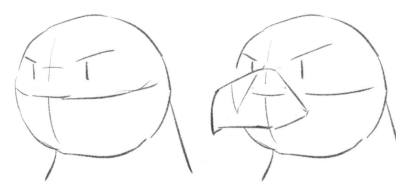

Blocking-in the face

Structure the face with an oval and use a thick cylinder for the neck. Make a cross over the circle that forms the base for the face and decide on the basic position for the large eyes.

Blocking-in the muzzle

This is the most characteristic feature of bird furries. Draw the lines for the beak, keeping in mind its sharpness and how the texture differs from that of the head.

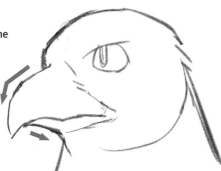

Draw the outline

Determine the shape of the lower beak at this point. Keeping the eagle's beak straight makes it look realistic.

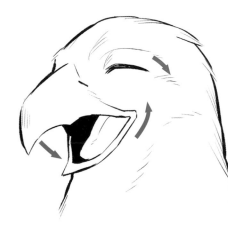

Make a clean copy

Fine-tune the position and size of the eyes to complete the work. As birds' eyes are usually close to the nose (the part where the upper beak emerges), position them in the same way as for a human face.

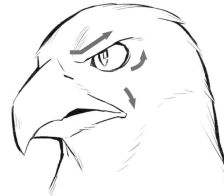

Adding Expression Make good use of the upper and lower beak

Joy

Open the beak wide and curve the lower section in particular to express a smile. Adding lines like curved eyebrows above the eyes further expresses joy.

Rage

Lower the ends of the mouth and add deep wrinkles in the eyebrows. This expresses the level of extreme rage.

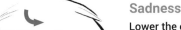

Sadness

Lower the eyebrows and ends of the beak to express sadness. Further lowering the ends of the beak—the corners of the mouth on a human—increases the range of expression.

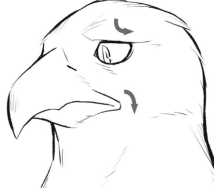

Surprise

Open the beak to its very limit. Make the eyes perfect circles with shrunken pupils. Add a drop of sweat on the side of the eyes, just like for a human.

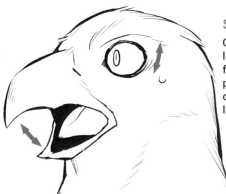

Angles of the Face Retain the fearless appearance regardless of the angle

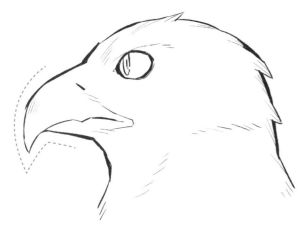

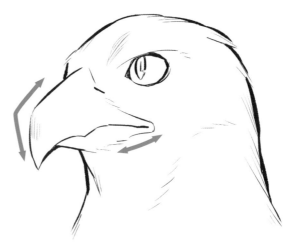

Side view

Refer to actual eagles and birds to see how the upper and lower sections of the beak fit together.

Diagonal

At this angle, there will be a conspicuous change in perspective for drawing the beak. Bring out depth by creating a well-rounded curve.

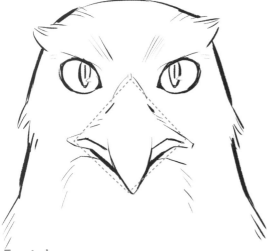

Front view

The firm outline and direct gaze are key points. Make the upper beak by forming a long diamond and positioning it in the center of the face for a balanced look.

🐾 Expert Tip ❷: Flying Furries

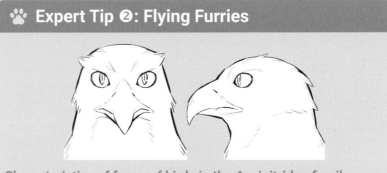

Characteristics of faces of birds in the Accipitridae family

In addition to the characteristic beak, the long, rounded nostrils with no protrusion in the center are also key to the character's development. Known as the cere, the exposed section over the base of the upper beak is also a characteristic of birds in the Accipitridae family (in parrots and other birds it's covered with feathers). Keep in mind that the irises are yellow or brown to create variety through the colors of the eyes.

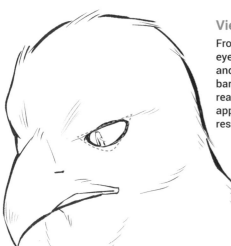

View from above

From this angle, the eyes become triangular and the lower beak is barely visible. For this reason, the expression appears thoughtful and restrained.

View from below

This expression creates a look of intimidation. Depending on how the line for the upper beak is drawn, various expressions can be created.

Beastly Hands Use feathers and claws to achieve an avian look

Think of a human wearing clothes

① Human arms

In order to draw bird furries, first of all draw human arms. The upper and lower arms are about the same length. Keep this in mind to create a realistic look.

② Arms sprouting feathers

Soft feathers add a birdlike touch. If you can draw human arms well, there will be no problem.

Use fine feathers to make a smooth joint

Femur

③ Arms with talons and feathers

Depict sharp talons on the hands and add wings to the arms for an even more avian appearance. Use sharp lines to create the outline of the wings. Add fine feathers to adjust the area where the wings join the arms.

④ Bird wings

The wings are covered in feathers to enable flight, and the bone structure has also altered for this reason. The fingers are not able to grasp objects.

Radius + Ulna

Digits

🐾 Missing links?

An interesting theory showing the relationship between dinosaurs and birds posits that dinosaurs are the closest relative to birds. The view is that birds are creatures that have survived until now after having evolved from particular dinosaurs (the theropods introduced in the chapter on dinosaurs). Furthermore, dinosaurs sported body hair like birds. However, the exact link between birds and dinosaurs has not been proved. Even so, there's a sense of romance in the theory that dinosaurs, extinct for millennia, have altered and disguised their appearance and continue to live among us to this day.

Beastly Feet From human feet to bird feet

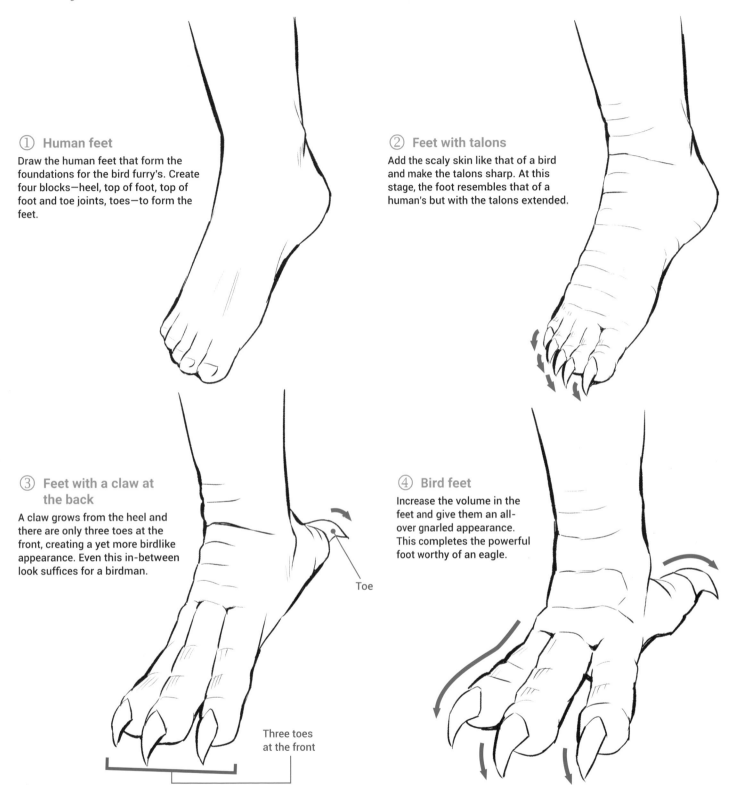

① **Human feet**

Draw the human feet that form the foundations for the bird furry's. Create four blocks—heel, top of foot, top of foot and toe joints, toes—to form the feet.

② **Feet with talons**

Add the scaly skin like that of a bird and make the talons sharp. At this stage, the foot resembles that of a human's but with the talons extended.

③ **Feet with a claw at the back**

A claw grows from the heel and there are only three toes at the front, creating a yet more birdlike appearance. Even this in-between look suffices for a birdman.

Toe

Three toes at the front

④ **Bird feet**

Increase the volume in the feet and give them an all-over gnarled appearance. This completes the powerful foot worthy of an eagle.

💡 How birds grip branches depending on their species

Most birds have three digits in front and one behind. This is known as an anisodactyl foot, as in the illustration, and is suited for gripping branches. Parrots and budgerigars have only two digits in front and two at the back (known as a zygodactyl foot). Owls are unique in that their feet are zygodactyl when gripping branches but on flat surfaces, one digit pivots so that they have three digits in front. In this book, the feet are depicted as anisodactyl, but depending on the type of bird, it's fine to change the form of the digits on the feet to suit your needs or inspiration.

Use fat and muscle distribution to show the differences

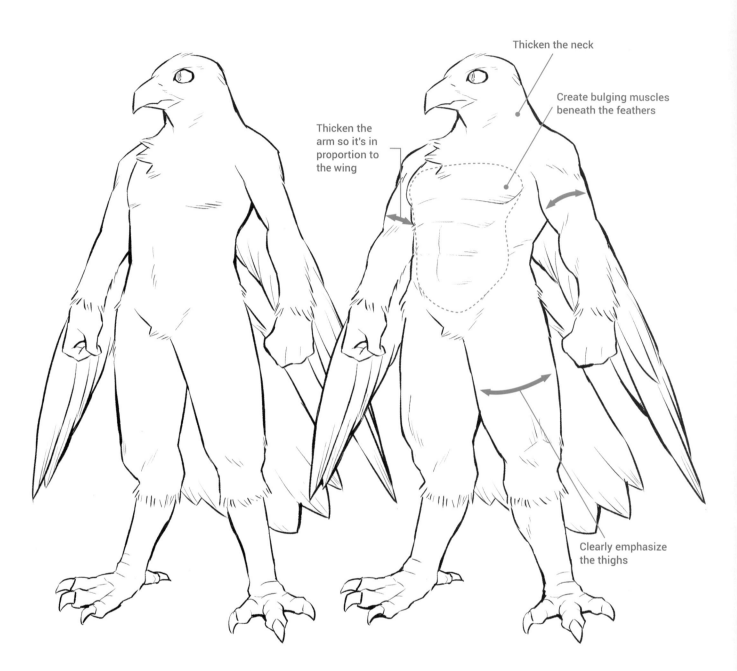

Thicken the neck

Create bulging muscles beneath the feathers

Thicken the arm so it's in proportion to the wing

Clearly emphasize the thighs

Average

In the case of a bird furry based on an eagle, the average physique resembles that of an actual eagle but is slightly more muscular.

Muscular

Add muscles such as the abdominals, firm up the contours of the body and thicken the limbs. Adding volume all over the body makes for a strong physique.

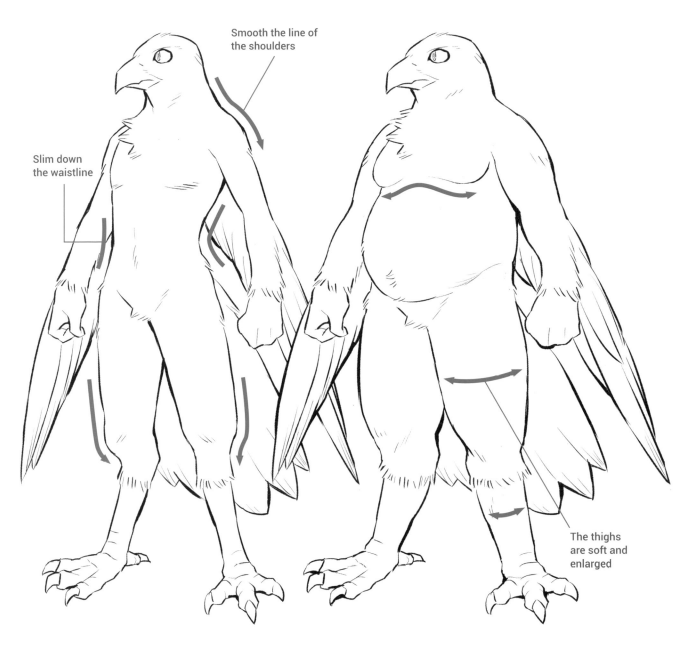

Smooth the line of the shoulders

Slim down the waistline

The thighs are soft and enlarged

Slim

Make the shoulders narrower and sloped. Tighten the area around the waist and buttocks. If you don't change the volume in the wings, the figure will retain its fearless look.

Plump

Add volume to the entire figure without showing muscle. Bring out the look of roundness from fat in the plump belly and thick neck.

Bird Furries' Ages Draw features to show age differences

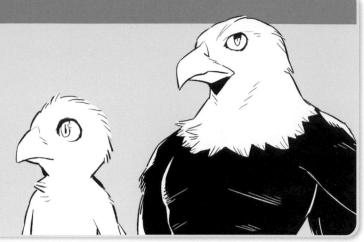

Youth (6–14 years)

A human would be about 6–7 heads tall at this stage, and a bird furry is similar in terms of proportion. Make the arms and limbs more defined.

Infancy (0–5 years)

As the bird is not very old, keep an infant in mind to create a rounded facial outline and beak.

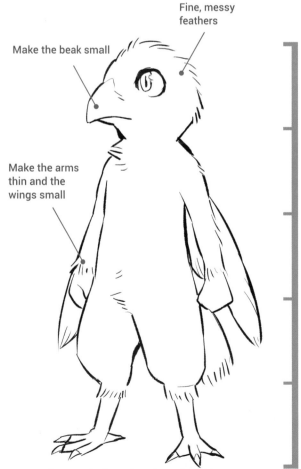

Fine, messy feathers

Make the beak small

Make the arms thin and the wings small

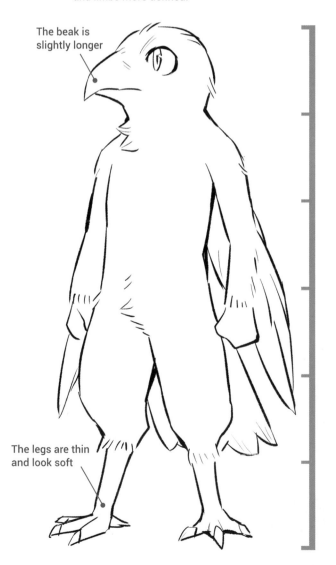

The beak is slightly longer

The legs are thin and look soft

The ages indicated are based on human ages.

88

Adulthood (20 years and over)

Compared with an adult human, the head-to-body ratio is a lot higher, making for a fearless-looking figure. Use the size and shape of the eyes to bring out a more adult look.

Adolescence (15–19 years)

In a human, the average height would be seven heads tall at this age, but as birds' heads are flat, make the height closer to eight heads tall. The limbs, however, are basically at their finished proportion at this stage.

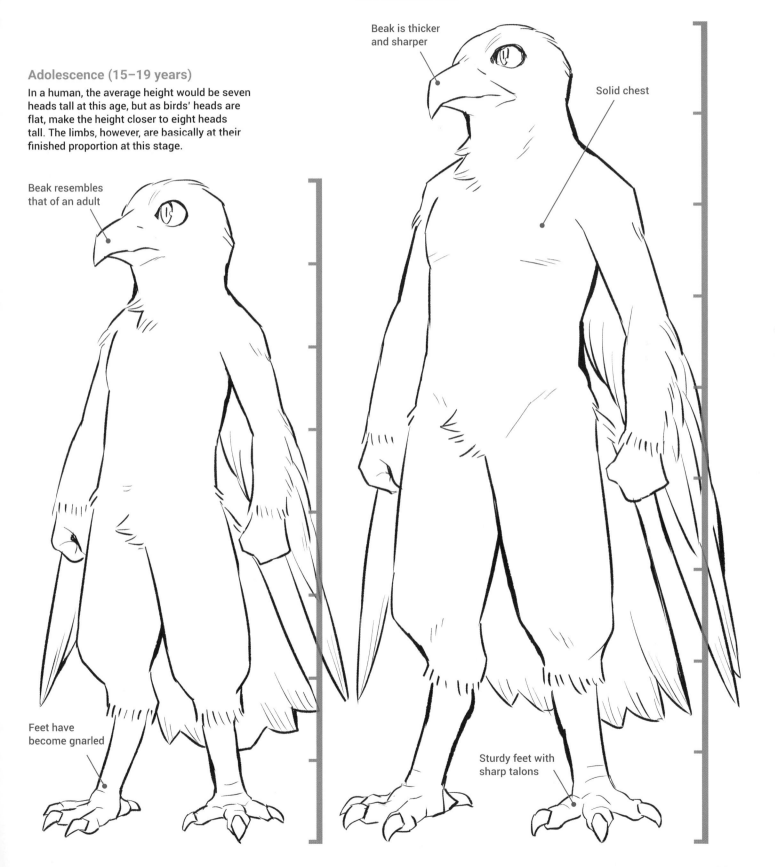

Beak is thicker and sharper

Solid chest

Beak resembles that of an adult

Feet have become gnarled

Sturdy feet with sharp talons

Variation ❶ Hawk

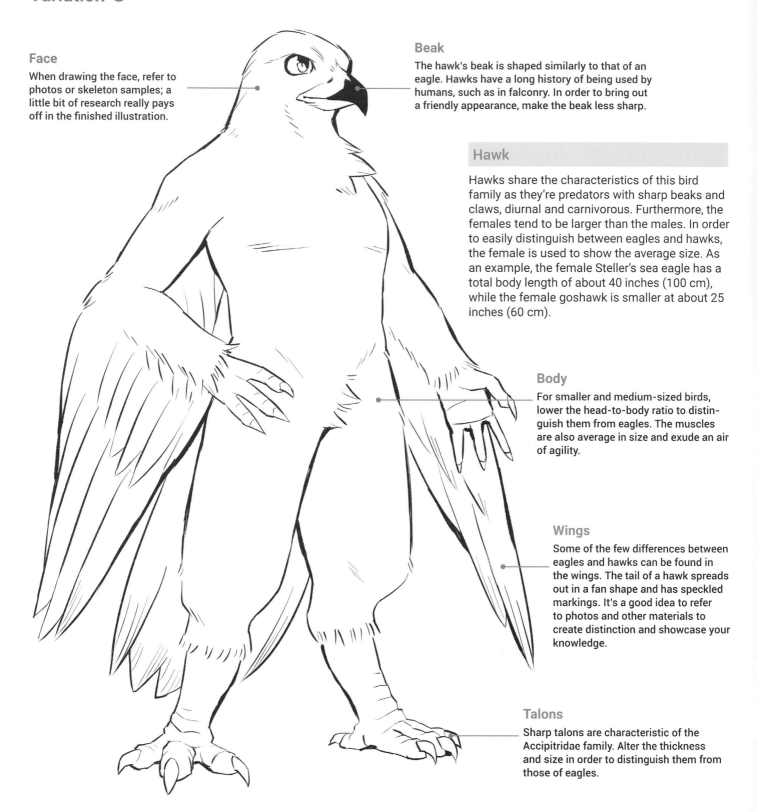

Face

When drawing the face, refer to photos or skeleton samples; a little bit of research really pays off in the finished illustration.

Beak

The hawk's beak is shaped similarly to that of an eagle. Hawks have a long history of being used by humans, such as in falconry. In order to bring out a friendly appearance, make the beak less sharp.

Hawk

Hawks share the characteristics of this bird family as they're predators with sharp beaks and claws, diurnal and carnivorous. Furthermore, the females tend to be larger than the males. In order to easily distinguish between eagles and hawks, the female is used to show the average size. As an example, the female Steller's sea eagle has a total body length of about 40 inches (100 cm), while the female goshawk is smaller at about 25 inches (60 cm).

Body

For smaller and medium-sized birds, lower the head-to-body ratio to distinguish them from eagles. The muscles are also average in size and exude an air of agility.

Wings

Some of the few differences between eagles and hawks can be found in the wings. The tail of a hawk spreads out in a fan shape and has speckled markings. It's a good idea to refer to photos and other materials to create distinction and showcase your knowledge.

Talons

Sharp talons are characteristic of the Accipitridae family. Alter the thickness and size in order to distinguish them from those of eagles.

💡 The relationship between humans and birds of prey

Hawks tend to be solitary birds. However, falconry, the culture of training birds of prey, brings these loners into the human fold. In Japan, falconry has existed since ancient times, referred to in the *"Nihon Shoki"* (*chronicles of Japan dating back* 1,700 years). Falconry is still practiced in Asia, Europe and the Middle East, with a range of birds used including hawks, eagles and peregrine falcons. In Japan, it's mainly goshawks and peregrine falcons that are used.

Variation ❷ Owl

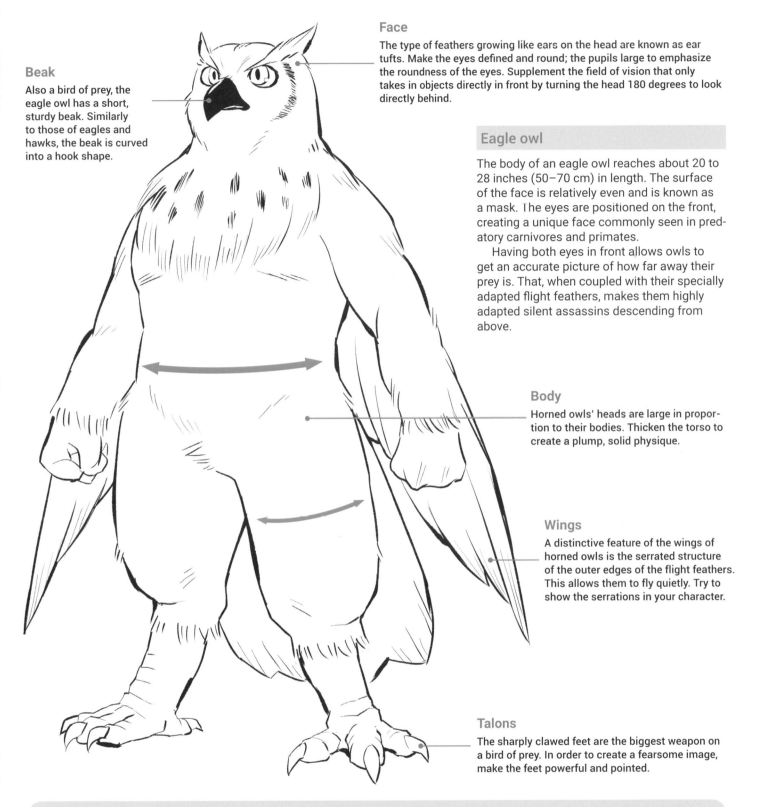

Beak

Also a bird of prey, the eagle owl has a short, sturdy beak. Similarly to those of eagles and hawks, the beak is curved into a hook shape.

Face

The type of feathers growing like ears on the head are known as ear tufts. Make the eyes defined and round; the pupils large to emphasize the roundness of the eyes. Supplement the field of vision that only takes in objects directly in front by turning the head 180 degrees to look directly behind.

Eagle owl

The body of an eagle owl reaches about 20 to 28 inches (50–70 cm) in length. The surface of the face is relatively even and is known as a mask. The eyes are positioned on the front, creating a unique face commonly seen in predatory carnivores and primates.

 Having both eyes in front allows owls to get an accurate picture of how far away their prey is. That, when coupled with their specially adapted flight feathers, makes them highly adapted silent assassins descending from above.

Body

Horned owls' heads are large in proportion to their bodies. Thicken the torso to create a plump, solid physique.

Wings

A distinctive feature of the wings of horned owls is the serrated structure of the outer edges of the flight feathers. This allows them to fly quietly. Try to show the serrations in your character.

Talons

The sharply clawed feet are the biggest weapon on a bird of prey. In order to create a fearsome image, make the feet powerful and pointed.

💡 The wings of owls were incorporated into the bullet train

The reason that owls can fly so quietly and silently swoop down on their prey is that the serrations on the wings diffuse the air. In the 1990s, this quality was applied to pantographs as a measure against noise when the Shinkansen 500 series was being developed. When serrations similar to those of flight feathers were applied to the pantograph, noise was reduced by about 30 percent. Incidentally, at this time, the shape of a kingfisher's beak was also incorporated to reduce wind resistance. Birds are useful to humans in unexpected ways.

Different Species ❶ Parakeet

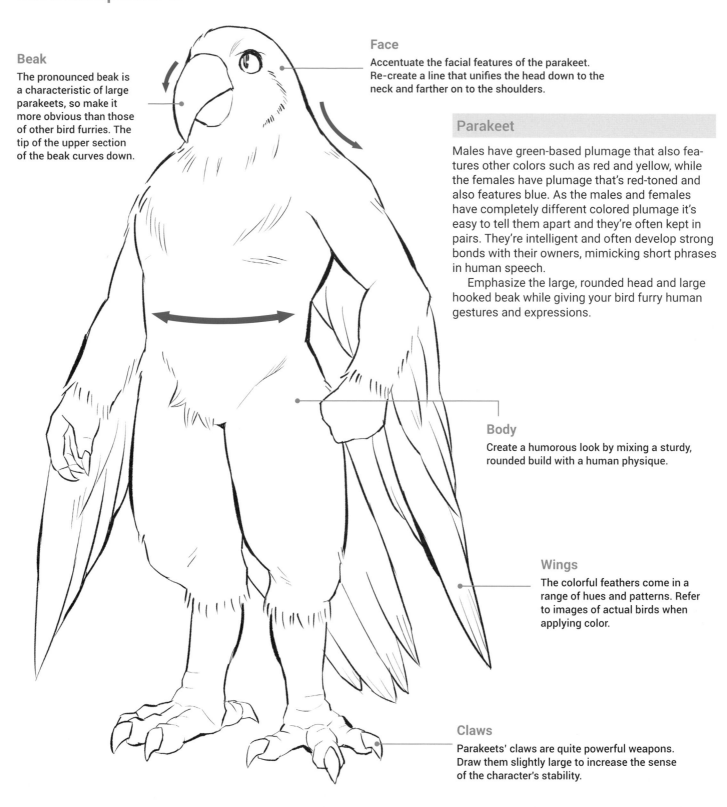

Beak

The pronounced beak is a characteristic of large parakeets, so make it more obvious than those of other bird furries. The tip of the upper section of the beak curves down.

Face

Accentuate the facial features of the parakeet. Re-create a line that unifies the head down to the neck and farther on to the shoulders.

Parakeet

Males have green-based plumage that also features other colors such as red and yellow, while the females have plumage that's red-toned and also features blue. As the males and females have completely different colored plumage it's easy to tell them apart and they're often kept in pairs. They're intelligent and often develop strong bonds with their owners, mimicking short phrases in human speech.

Emphasize the large, rounded head and large hooked beak while giving your bird furry human gestures and expressions.

Body

Create a humorous look by mixing a sturdy, rounded build with a human physique.

Wings

The colorful feathers come in a range of hues and patterns. Refer to images of actual birds when applying color.

Claws

Parakeets' claws are quite powerful weapons. Draw them slightly large to increase the sense of the character's stability.

💡 Differences between parakeets and parrots

Parakeets are often confused with parrots. Both belong to the parrot family and share traits such as the shape of their beaks and their ability to mimic human speech. The difference is that parrots have a crest and parakeets do not. Cockatiels have "parakeet" in their Japanese name, but as they are crested, they are actually parrots.

How to Draw Parakeets' Faces Reflect the short, stout build in the bird's face

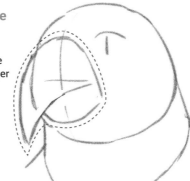

① **Blocking-in for the face**

Make a cross over a circle to prepare for positioning the facial elements. The parakeet's eyes are big and bright, so make them larger than those of other birds.

② **Blocking-in for the muzzle**

Consider the position and shape of the beak. Along with the eyes, this is an element that determines the facial expression, so consider various options.

③ **Draw the outline**

Decide on the shape of each facial element. It's fine to make the beak larger. As with the real bird, make the beak rounded at the tip.

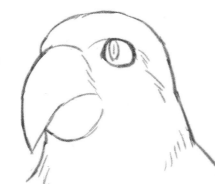

④ **Make a clean copy**

This is the completed result. Take note of the air of intelligence that a parakeet exudes, more so than other birds.

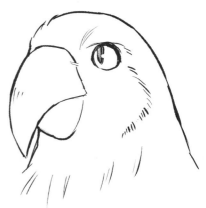

Parakeets' Expressions Use the beak and eyes to differentiate between emotions

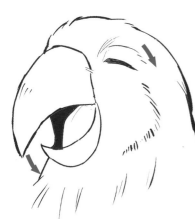

Joy

Curve the lines that equate to the eyebrows, make the eyes an arched shape and open the mouth to create a standard expression of joy.

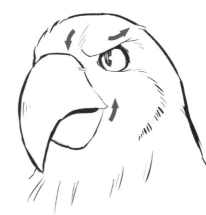

Rage

Lower the parts that are equivalent to the corners of the mouth even further to create a still stronger expression of rage.

Sadness

Make the eyes half closed and lower the eyebrows to create an expression of sadness. Opening the beak makes for an even more disappointed look.

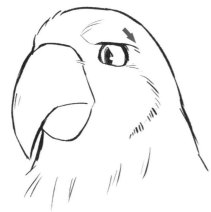

Surprise

The basic expression of surprise is wide-open eyes and a gaping beak. Parakeets have a developed tongue, so use chibi techniques to make it stick out.

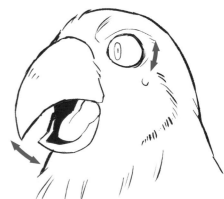

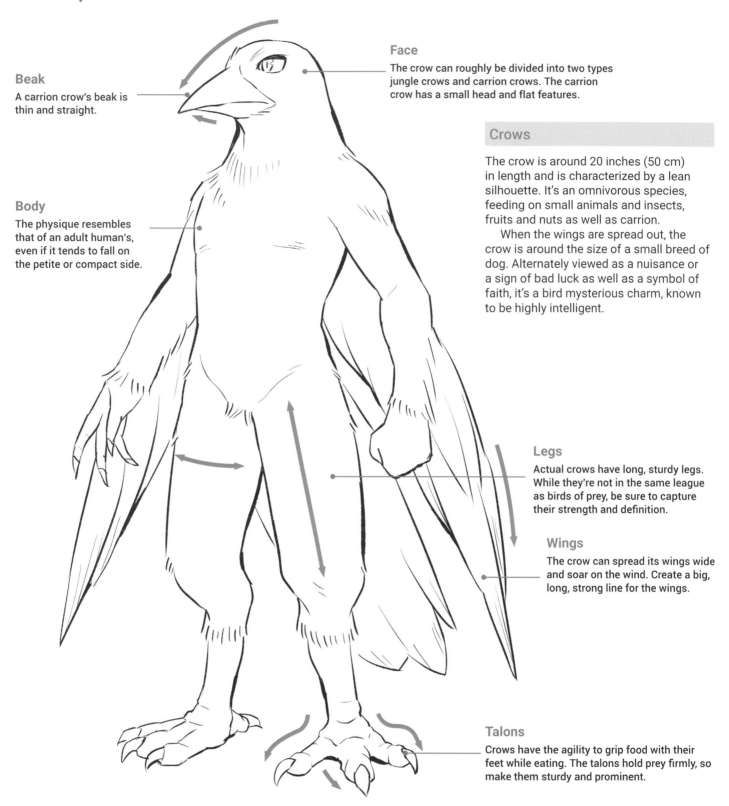

Beak

A carrion crow's beak is thin and straight.

Face

The crow can roughly be divided into two types jungle crows and carrion crows. The carrion crow has a small head and flat features.

Crows

The crow is around 20 inches (50 cm) in length and is characterized by a lean silhouette. It's an omnivorous species, feeding on small animals and insects, fruits and nuts as well as carrion.

When the wings are spread out, the crow is around the size of a small breed of dog. Alternately viewed as a nuisance or a sign of bad luck as well as a symbol of faith, it's a bird mysterious charm, known to be highly intelligent.

Body

The physique resembles that of an adult human's, even if it tends to fall on the petite or compact side.

Legs

Actual crows have long, sturdy legs. While they're not in the same league as birds of prey, be sure to capture their strength and definition.

Wings

The crow can spread its wings wide and soar on the wind. Create a big, long, strong line for the wings.

Talons

Crows have the agility to grip food with their feet while eating. The talons hold prey firmly, so make them sturdy and prominent.

💡 The crow is an ancient ally

Since ancient times, crows have appeared in folklore and myths all over the world, even emerging as objects of worship in some regions. In Japan, too, crows are seen as being messengers of the mountain gods, and there are Shinto fortune-telling rituals that involve crows. The best-known crow worship in Japan is that of Yatagarasu, the three-legged crow that's considered to be the incarnation of the sun.

How to Draw Crows' Faces Acccentuate the angular features

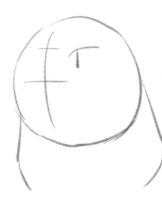

① Blocking-in the face

This face is based on the crow. Make a vertical line with two short hatches across it to mark out the position of the eyes.

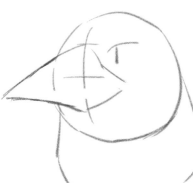

② Blocking-in the muzzle

Block-in the muzzle in the same order as for the eagle. On a crow, the line from the beak to the cheeks forms a gentle curve, making it an interesting feature to incorporate.

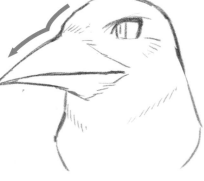

③ Draw the outline

Without making any major changes, draw in the outline of the face. Lightly draw in the flow of the feathers to follow the facial structure.

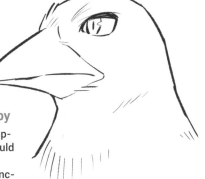

④ Make a clean copy

Although the whole body appears glossy black, you could try using other colors too. Coloring will create differences between crows.

Crows' Expressions Channel crows' friendliness

Joy

Use the eyes and beak to create a human smile that easily expresses joy. Make the eyes nearly closed and open the beak wide.

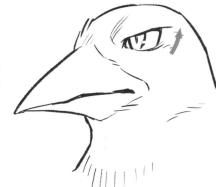

Rage

Actual crows often threaten people when nesting. Raise the eyes and slightly sharpen the beak.

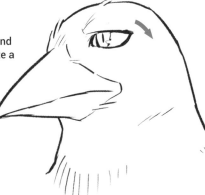

Sadness

Make the eyes droop and close the beak to create a lonely expression.

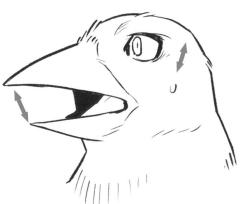

Surprise

The detail of wrinkles around the eyes aids in expressing emotions of all kinds, so pay attention to this point.

Fearsome Dragon Furries

Dragons are fantasy creatures that factor prominently in myths and legends. Most dragons' physiques and physical features combine the hybrid parts of various animals, which is what makes them an ideal furry candidate and so much fun to draw.

Male Furry · A Western dragon covered in armor-like scales

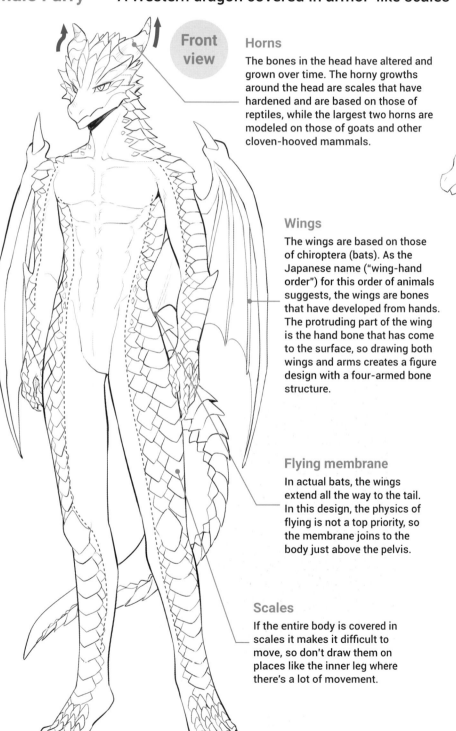

Front view

Horns

The bones in the head have altered and grown over time. The horny growths around the head are scales that have hardened and are based on those of reptiles, while the largest two horns are modeled on those of goats and other cloven-hooved mammals.

Wings

The wings are based on those of chiroptera (bats). As the Japanese name ("wing-hand order") for this order of animals suggests, the wings are bones that have developed from hands. The protruding part of the wing is the hand bone that has come to the surface, so drawing both wings and arms creates a figure design with a four-armed bone structure.

Flying membrane

In actual bats, the wings extend all the way to the tail. In this design, the physics of flying is not a top priority, so the membrane joins to the body just above the pelvis.

Scales

If the entire body is covered in scales it makes it difficult to move, so don't draw them on places like the inner leg where there's a lot of movement.

Neck

The neck is covered in armor-like scales shaped like horizontally elongated hexagons that form curved layers. From a skeletal point of view, the head protrudes forward and the neck is slender.

Side view

Tail

Draw scales on the upper facing part of the tail and reveal soft skin on the underside. To create a natural look, draw the layers of scales so that they're large at the base and get smaller toward the tip of the tail.

Female Furry A dignified, fearless female dragon

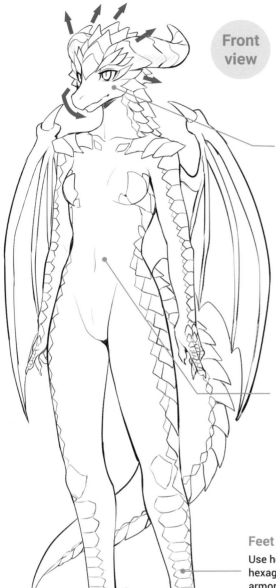

Front view

Face

In reptilian terms, the nose of a dragon furry most resembles that of a turtle, with a bulging tip. The mouth is positioned slightly below and back. Draw the scales fanning out on an angle toward the back. As there's a strongly demonic air to this character, make the pupils long and vertical.

Body

In contrast to the muscular body of the male dragon furry, use a soft line for the navel and chest. In the same way as for the male, draw scales along the side of the body but keep them within a confined area in order to show the softer side of the skin.

Feet

Use horizontally elongated hexagons to cover the feet in armor-like scales. Slightly raise the heels off the ground.

🐾 Expert Tip ❶: Dragon Furries

The shapes of scales

The scales are made up of diamond and hexagon shapes in about four different sizes. The shape is up to you, but distribute them in a consistent and regular fashion for a more accurate look.

Neck

The overall build is slim so the neck is slender. To create a powerful dragon-like appearance, create a dense growth of large scales on the neck.

Side view

🐾 Expert Tip ❷: Dragon Furries

Connecting the face and body

In most animals, including dogs, the head and neck form one unit. When drawing furries, think about whether to depict them this way or with the head resting on the neck like that of a human. The body of an animal from the head down to the back also tends to form one unit, so not only in dragon furries, but in others too, making the neck thick and the shoulders sloping creates a more animal-like appearance. Keep this in mind to create distinctions when drawing to create variation in your work.

Bone Structure Adding human bone structure to a creature that combines various animals

Furry bone structure

The wings on the back are the biggest feature of the dragon furry's bone structure. The wings join to the body at the edges of the shoulder blades, with the joint of the humerus adjacent. Just as the wings of bats are equivalent to evolved hands in human terms, dragon wings look to the bone structures of hands as their base. However, the regular bones of the arm are also included in the structure, making for four arms in total.

Animal bone structure

Here, the skull of the imaginary dragon is modeled on the skull of a dog, with just the tip derived from the bone structure of a lizard. However, you may prefer to try basing the skull on that of a horse to create a different impression. The scales give the dragon a strongly reptilian impression, but the bone structure actually resembles a cat or other mammal.

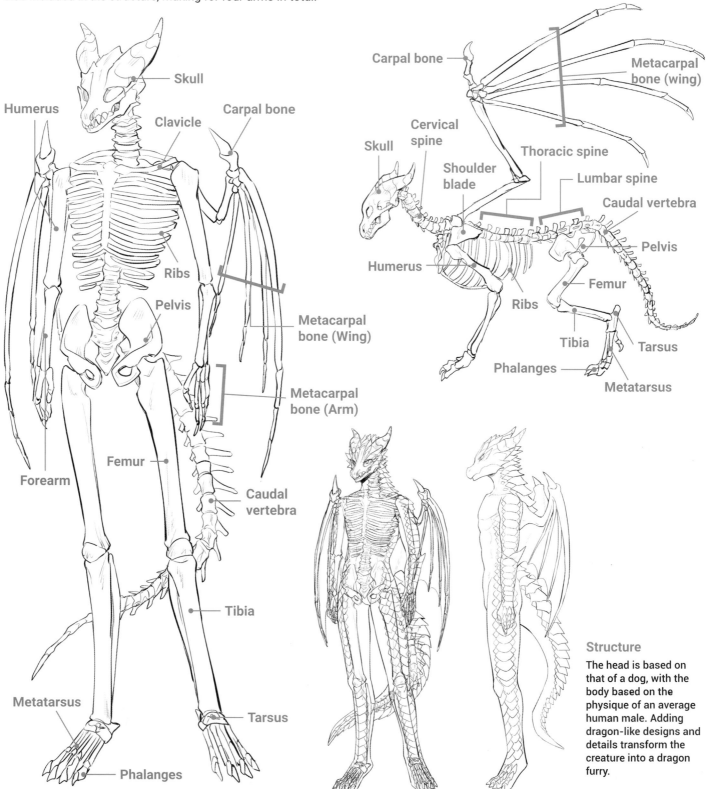

Skull

Humerus

Clavicle

Carpal bone

Ribs

Pelvis

Metacarpal bone (Wing)

Metacarpal bone (Arm)

Femur

Forearm

Caudal vertebra

Tibia

Metatarsus

Phalanges

Tarsus

Carpal bone

Metacarpal bone (wing)

Skull

Cervical spine

Shoulder blade

Thoracic spine

Lumbar spine

Caudal vertebra

Pelvis

Humerus

Ribs

Femur

Tibia

Tarsus

Phalanges

Metatarsus

Structure

The head is based on that of a dog, with the body based on the physique of an average human male. Adding dragon-like designs and details transform the creature into a dragon furry.

How to Draw the Body Making the human form resemble a dragon

① Blocking-in

Use blocks to create the head, neck, torso, shoulders, arms and legs to roughly block-in a human figure.

The body is slightly twisted in this pose. This is achieved in the same way as for a human—by altering the angle of the lumbar spine, which determines posture.

Roughly decide on the position and sweep of the tail at this stage. Most tails grow from just above where the buttocks divide.

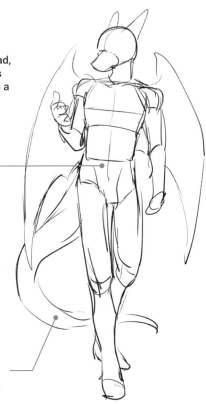

② Rough sketch

Join the blocks together and flesh out the wings and head. At this stage, take care to make the physique fairly average rather than creating a massive build.

When creating a more muscular physique, it's fine to add more volume to the legs and arms.

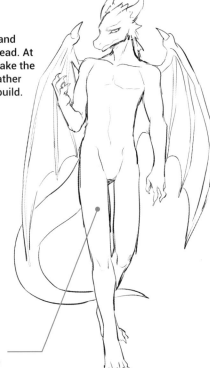

③ Line drawing

Make a clean copy and create a line drawing. If there are several lines on top of one another that make connecting the parts difficult, use blue pencil to make a clean copy of the rough sketch drawn in black pencil as this allows the lines to connect smoothly. Have a go at using these kinds of manual techniques.

If creating a female dragon character, make necessary adjustments to details at this stage such as altering the amount of skin covered by scales and changing the line of the navel for a softer appearance.

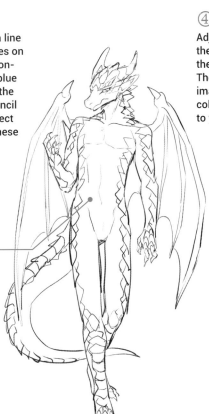

④ Completion

Adjust details to complete the work, keeping in mind the solid build of the figure. The creature is of course imaginary, so as long as the coloring is attractive, it's up to you.

Altering the length and volume of limbs and the balance of the torso makes for a different physique, so try various looks.

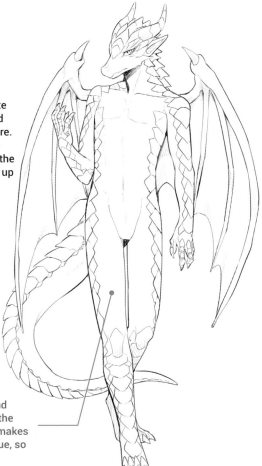

How to Draw the Face

Keep in mind the features of a dog

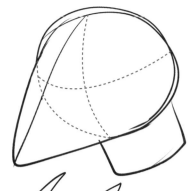

Blocking-in the face

Combine a cylinder for the neck and a cone for the face, picturing a dog as you work. Make the end of the cone parallel to the cylinder for a balanced result.

Blocking-in markings

Draw the center line and add in the horizontal line across it to form the facial outline. Add the line for the muzzle (nose and mouth) as well.

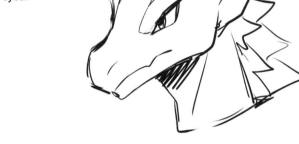

Draw the outline

Use the blocked-in markings to add the dragon's details, tidying up the overall outline at the same time. Keep in mind adjusting the position of the eyes.

Make a clean copy

Adjust the details of the scales and firm up fine details. Pay particular attention to changes in the contour around the tip of the nose, the line of the neck and the size of the eyes.

Adding Expression

Rely on the eyes to conjure a range of emotions

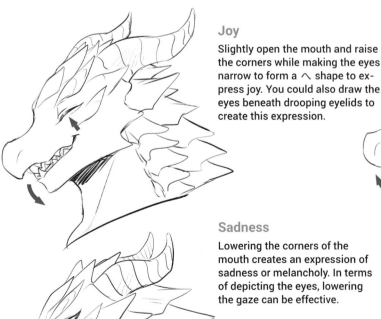

Joy

Slightly open the mouth and raise the corners while making the eyes narrow to form a ∧ shape to express joy. You could also draw the eyes beneath drooping eyelids to create this expression.

Rage

Open the mouth wide and draw the eyes as ∧ shapes to express rage. It's possible to create variation by opening the mouth still wider, making the fangs thicker and longer.

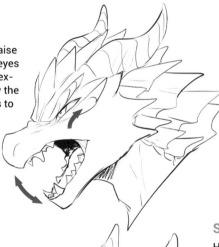

Sadness

Lowering the corners of the mouth creates an expression of sadness or melancholy. In terms of depicting the eyes, lowering the gaze can be effective.

Surprise

Having the mouth open is the same as for the expression of rage, but tone it down slightly to express natural emotion. Widen the eyes as for a human.

Angles of the Face Pay attention to the angles of the horns

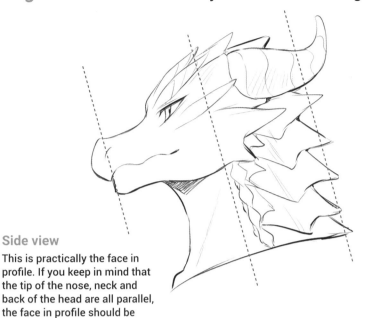

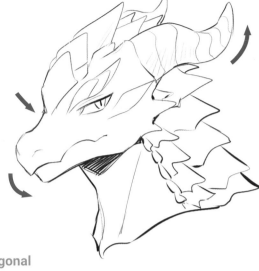

Side view

This is practically the face in profile. If you keep in mind that the tip of the nose, neck and back of the head are all parallel, the face in profile should be well-balanced.

Diagonal

Variation can be achieved not only via the angle of the face but also through the line and form of the horns. Depending on the direction in which the face is pointing, the right eye may be visible beyond the muzzle.

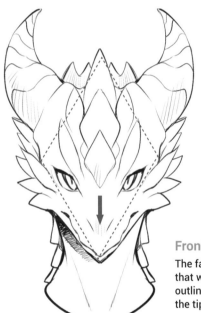

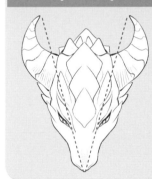

> 🐾 **Expert Tip ❸: Dragon Furries**
>
> **The line of the nose, eyes and horns**
>
> Viewed from overhead, a single line connects the nose to the eye and through to the horn. Use this chain of positions as the foundation for the face. Tweaking the positioning, shape and degree of spread between the horns allows for the creation of an even more appealing face.

Front view

The face is based on that of a dog. Keep in mind that when viewed from the front, a dog's facial outline is a diamond shape, and if facing forward the tip of the nose is lowered.

View from below

In comparison with the upper jaw, the lower jaw is narrower and smaller. It's possible to capture and convey even details such as this. Drawing in the line that would equate to the sternocleidomastoid muscle in humans makes a fantasy creature more realistic.

View from above

The face is based on the dog, a carnivorous animal. For this reason, the eyes are on the front of the face in order to easily seek out prey. The eyes of herbivores are on the sides of their heads.

Beastly Hands Alter human hands to create variations

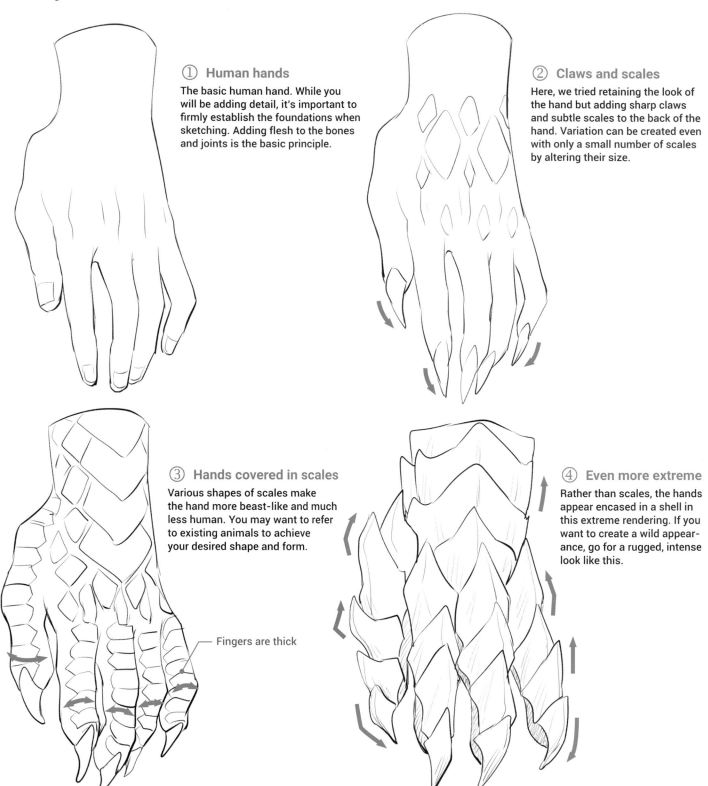

① Human hands
The basic human hand. While you will be adding detail, it's important to firmly establish the foundations when sketching. Adding flesh to the bones and joints is the basic principle.

② Claws and scales
Here, we tried retaining the look of the hand but adding sharp claws and subtle scales to the back of the hand. Variation can be created even with only a small number of scales by altering their size.

③ Hands covered in scales
Various shapes of scales make the hand more beast-like and much less human. You may want to refer to existing animals to achieve your desired shape and form.

Fingers are thick

④ Even more extreme
Rather than scales, the hands appear encased in a shell in this extreme rendering. If you want to create a wild appearance, go for a rugged, intense look like this.

🐾 Various animals combined

Apart from dogs, which form the base for making a dragon furry, other animals can also serve as references. When it comes to the hands, look to mammals such as cats and bears that have paws that can grasp objects. In this respect, other unexpected species are helpful as a reference for drawing dragon furries. Using a dog as the base, incorporate parts of various other animals into the figure. This is one of the pleasures involved in drawing a furry derived from a dragon, a creature that already doesn't exist in reality.

Beastly Feet Try bold variations

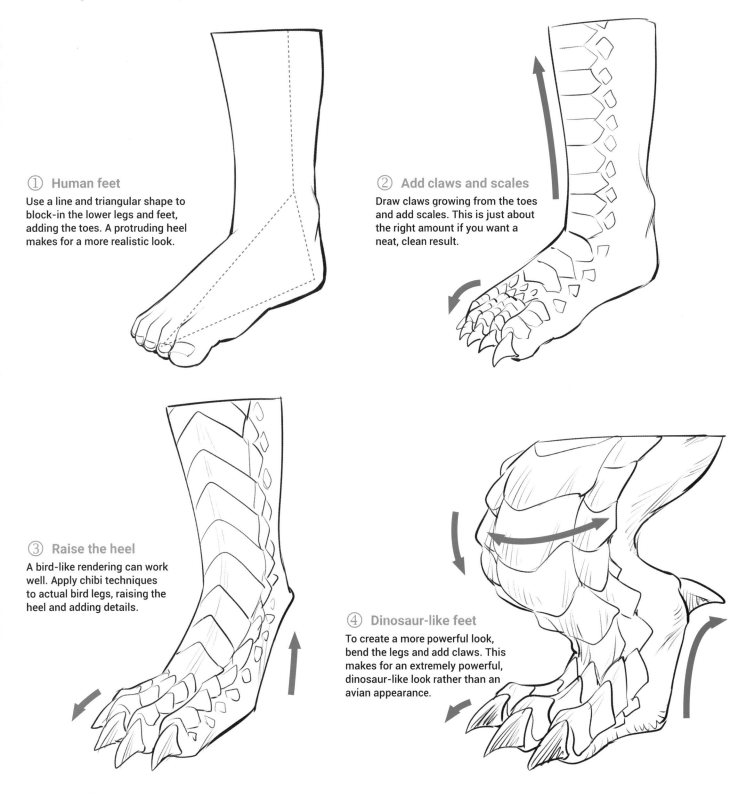

① **Human feet**
Use a line and triangular shape to block-in the lower legs and feet, adding the toes. A protruding heel makes for a more realistic look.

② **Add claws and scales**
Draw claws growing from the toes and add scales. This is just about the right amount if you want a neat, clean result.

③ **Raise the heel**
A bird-like rendering can work well. Apply chibi techniques to actual bird legs, raising the heel and adding details.

④ **Dinosaur-like feet**
To create a more powerful look, bend the legs and add claws. This makes for an extremely powerful, dinosaur-like look rather than an avian appearance.

💡 Consider the function of claws

Animals such as cats generally have claws so that when they run, the claws function as spikes on the surface of the ground. This is why they're rounded at the end and aren't used for hunting. Contrastingly, most birds use their claws as weapons. If incorporating characteristics such as claws into dragons' feet, consider their function in order to determine their direction and shape at the ends of the claws.

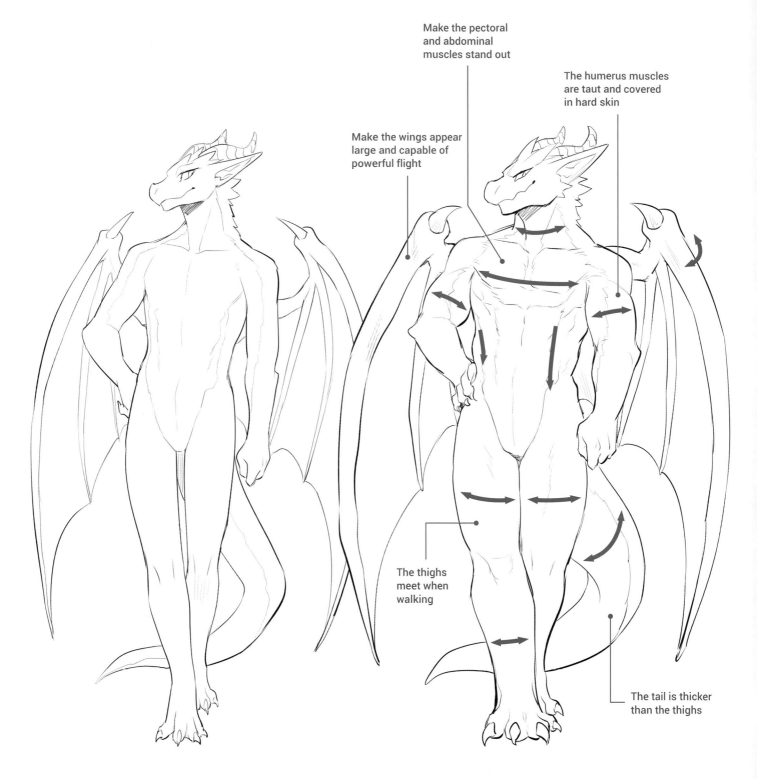

Make the pectoral and abdominal muscles stand out

The humerus muscles are taut and covered in hard skin

Make the wings appear large and capable of powerful flight

The thighs meet when walking

The tail is thicker than the thighs

Average

The average physique corresponds to a medium build in a human. Have an accurate understanding of human structure in order to correctly depict the body's uneven surfaces.

Muscular

For a powerful appearance, create more volume in the wings as well as adding muscle to the limbs. Delineating the stomach muscles makes for a more massive look.

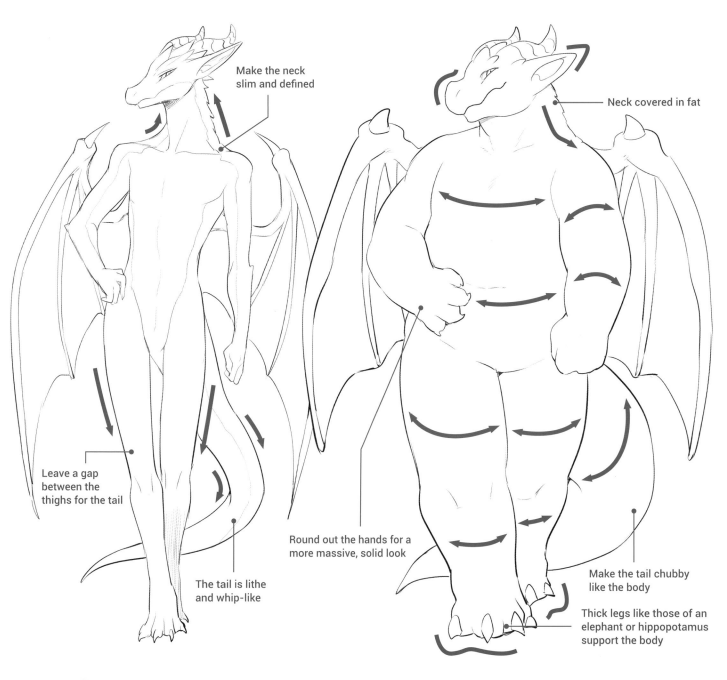

Make the neck slim and defined

Neck covered in fat

Leave a gap between the thighs for the tail

Round out the hands for a more massive, solid look

The tail is lithe and whip-like

Make the tail chubby like the body

Thick legs like those of an elephant or hippopotamus support the body

Slim

Slim down the torso and limbs but make sure the form of the joints remains defined. Pay attention to details such as widening the gap between the thighs when they're crossed.

Plump

Enlarge the face, torso and limbs and make the body rounder all over to indicate fat. As the body is covered in hard skin, don't create a flabby look.

Dragon Furries' Ages Draw features to show age differences

💡 Dragons: egg layers or live birth?

Animals can broadly be categorized into those that lay eggs (oviparous) and those that give birth to live young (viviparous). In general, the former are reptiles while the latter are mammals. So which category do dragons fit into? In movies and games, there are many scenes where dragons hatch from eggs, and "dragon egg" toys are available on the market. It would seem that dragons are thought of as being oviparous.

Youth (6–14 years)

Create a child-like look by making the figure 3 heads tall and bring out more sharpness in facial details than for the infant. Make the horns, wings, tail and other dragon characteristics more defined than for those of the infant. This is an effective way to show development.

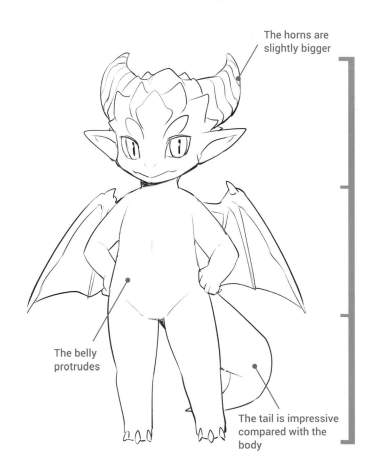

The horns are slightly bigger

The belly protrudes

The tail is impressive compared with the body

Infancy (0–5 years)

For the infancy period, picture a puppy walking on four legs. Make the face, body and limbs short and rounded for an adorable look. Making the eyes large and round gives the impression of immaturity. In order to convey dragon-like traits, draw horns, wings and a tail, even if they're small.

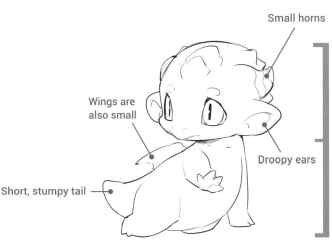

Small horns

Wings are also small

Droopy ears

Short, stumpy tail

The ages indicated are based on human ages.

🐾 Expert Tip ❹: Dragon Furries

Pay attention to ratios in the body to make drawing easy

When drawing dragon furries, it's helpful to keep the proportion and ratios of the human body in mind. The head and hands are roughly the same size, and the fingertips should reach to about halfway down the thighs. Paying attention even to these two points creates a sense of stability for the viewer. When drawing dragon furries, keep these rules in mind to a certain extent.

Adulthood (20 years and over)

The balance of various parts of the body is relatively unchanged from adolescence, however making the limbs and neck thicker creates a mature male appearance. The scales, horns, claws, wings, tail and other parts that create the characteristic look of a dragon also become more defined in the adult dragon furry.

Adolescence (15–19 years)

The figure stands around 6–7 heads tall and the limbs lengthen as the physique approaches that of an adult. The claws also lengthen and the wings become functional. Make the face longer and thinner and the ears and horns larger to give the young creature a masculine appearance.

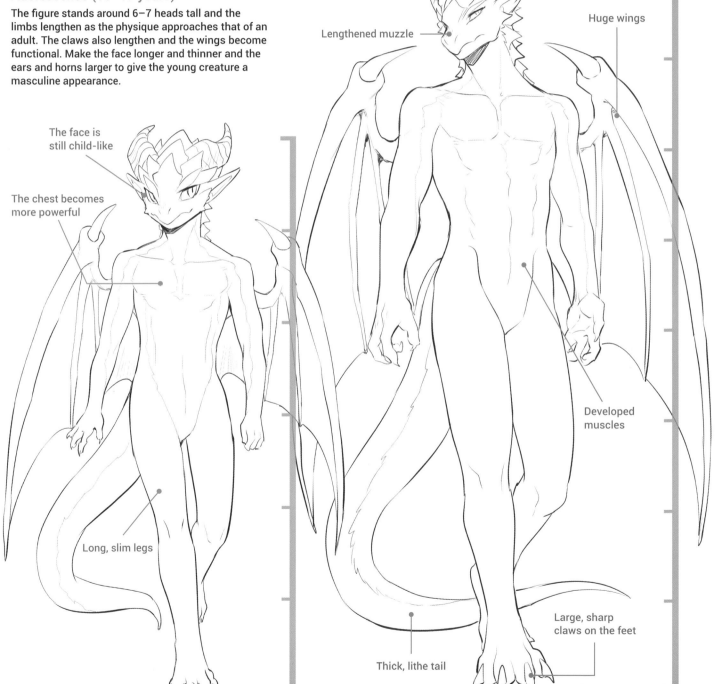

The face is still child-like

The chest becomes more powerful

Long, slim legs

Lengthened muzzle

Huge wings

Developed muscles

Thick, lithe tail

Large, sharp claws on the feet

Variation ❶ Japanese Dragon

Whiskers

Along with the horns, the long, fine whiskers growing from the tip of the nose and the short tufts around the tip of the nose and the chin are the major features of a Japanese dragon. Color prints from the past are useful references when drawing.

Horns

In ancient Chinese texts, the horns are recorded as being those of deer. Therefore, rather than the thick, short horns of Western dragons, oriental dragons tend to have long, thin antler-like horns.

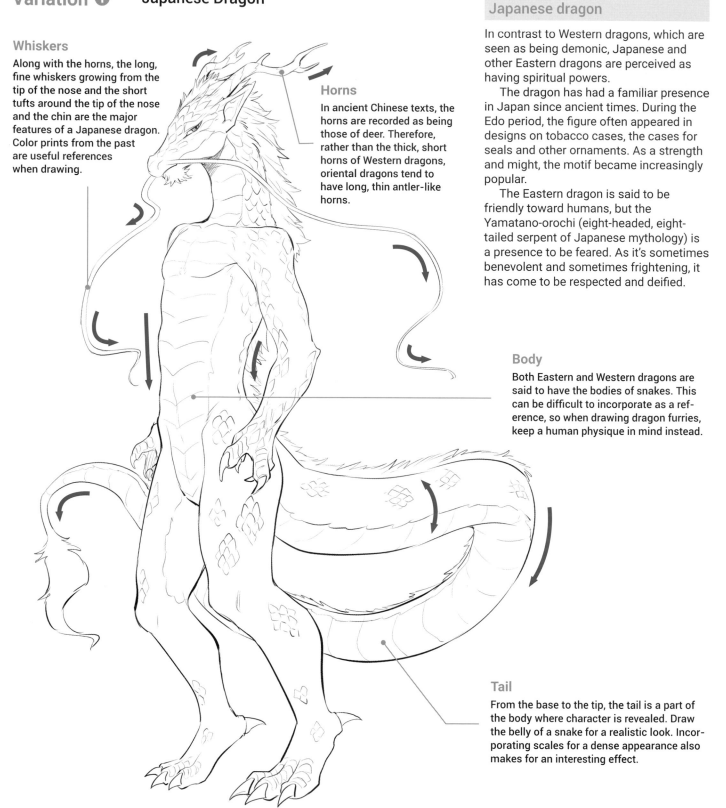

Body

Both Eastern and Western dragons are said to have the bodies of snakes. This can be difficult to incorporate as a reference, so when drawing dragon furries, keep a human physique in mind instead.

Tail

From the base to the tip, the tail is a part of the body where character is revealed. Draw the belly of a snake for a realistic look. Incorporating scales for a dense appearance also makes for an interesting effect.

Japanese dragon

In contrast to Western dragons, which are seen as being demonic, Japanese and other Eastern dragons are perceived as having spiritual powers.

The dragon has had a familiar presence in Japan since ancient times. During the Edo period, the figure often appeared in designs on tobacco cases, the cases for seals and other ornaments. As a strength and might, the motif became increasingly popular.

The Eastern dragon is said to be friendly toward humans, but the Yamatano-orochi (eight-headed, eight-tailed serpent of Japanese mythology) is a presence to be feared. As it's sometimes benevolent and sometimes frightening, it has come to be respected and deified.

💡 The dragon as devil

The reason that dragons are thought of as demonic in the West is because in Christianity, they're portrayed as enemies of God. In Christianity, leviathan is a sea monster defeated by God. For these reasons, in the west, particularly in Christian Europe, dragons became established as demons and evil presences. In contrast, in the East, dragons are revered and often worshiped as gods.

Variation ❷ Wyvern

Face

The wyvern's face resembles a crocodile's as it has a long, thin mouth with sharp teeth. However, there's no need to draw it exactly that way. This illustration takes the face of a mammal as its base and emphasizes the horns.

Tail

The tip of the tail is extremely poisonous, and in some illustrations it resembles the tip of an arrow. Here a standard tail is used, but keep it in mind as a body part that can be used to differentiate between figures.

Wings

Among the dragons, the wyvern boasts fast flight speeds and a high degree of mobility. The shape of the wings resembles those of bats. When drawing, refer to photos and images of bats.

Wyvern

The wyvern is a two-legged dragon that originated in England. It has the wings of a bat and a long, thin tail with a poisonous spur at its tip. Like a dragon, its body is covered in scales, and some types live on land while others live underwater or in swamps. Its ability for agile, high-speed flight puts it in the top class among dragons.

Legs

The main point of difference between a wyvern and a dragon is that a wyvern stands upright on two legs. In a dragon furry, this difference disappears, so work on the webbing (a characteristic of the sea wyvern) and the shape of the horns instead.

💡 A wide variety of wyverns

A wyvern is a variation of a dragon and includes the specialized creature known as the sea wyvern (or sea dragon). Wyverns are sometimes referred to as flying dragons and pterosaurs. Apart from this, there are also examples of two-headed or multi-headed wyverns on coats of arms, and its ferocious impression has led to it also being used on coats of arms in the military.

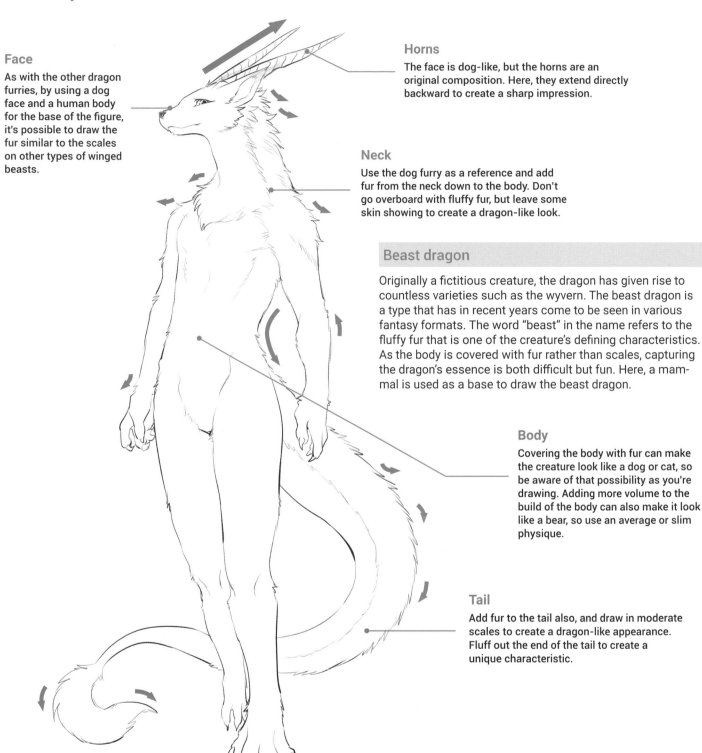

Face

As with the other dragon furries, by using a dog face and a human body for the base of the figure, it's possible to draw the fur similar to the scales on other types of winged beasts.

Horns

The face is dog-like, but the horns are an original composition. Here, they extend directly backward to create a sharp impression.

Neck

Use the dog furry as a reference and add fur from the neck down to the body. Don't go overboard with fluffy fur, but leave some skin showing to create a dragon-like look.

Beast dragon

Originally a fictitious creature, the dragon has given rise to countless varieties such as the wyvern. The beast dragon is a type that has in recent years come to be seen in various fantasy formats. The word "beast" in the name refers to the fluffy fur that is one of the creature's defining characteristics. As the body is covered with fur rather than scales, capturing the dragon's essence is both difficult but fun. Here, a mammal is used as a base to draw the beast dragon.

Body

Covering the body with fur can make the creature look like a dog or cat, so be aware of that possibility as you're drawing. Adding more volume to the build of the body can also make it look like a bear, so use an average or slim physique.

Tail

Add fur to the tail also, and draw in moderate scales to create a dragon-like appearance. Fluff out the end of the tail to create a unique characteristic.

💡 Bits and pieces about beast dragons

In this book, beast dragons are presented covered in fur, but they're more derived from dinosaurs, particularly the theropods. Their characteristics include long, thin bodies, walking upright on two legs, and having sharp teeth, so among the dinosaurs they'd most closely correspond to the tyrannosaurus and allosaurus.

In recent years, a derivation called a white dragon has entered the scene, spearheaded by Falcor, the dragon that appeared in the 1995 film "The NeverEnding Story."

How to Draw Beast Dragons' Faces

Start with a dog as the basis for the face

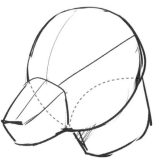

① **Blocking-in**

As for the dragon furry, rework a dog's face to create a beast dragon's face. Combine a sphere and a cylinder and draw in the muzzle (nose and mouth sections).

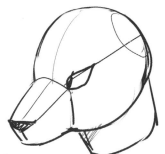

② **Blocking-in the muzzle**

At the same time as deciding on the shape of the nose, work out where to position the eyes, which should be on the front of the face as they would be for a dog or other carnivore. Block-in the position of the ears also.

③ **Overall rough sketch**

Define the ears and horns. The horns, which are original creations, are positioned on the line running from the nose to the eyes. It gives the creature a sharp, defined look.

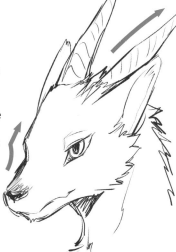

④ **Make a clean copy**

Alter lines to complete the work. On this angle, the right ear should be concealed, so corrections have been made to reveal only a glimpse of it.

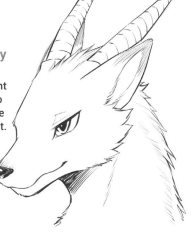

Beast Dragons' Expressions

Use not only the mouth and eyes, but also the expressive ears

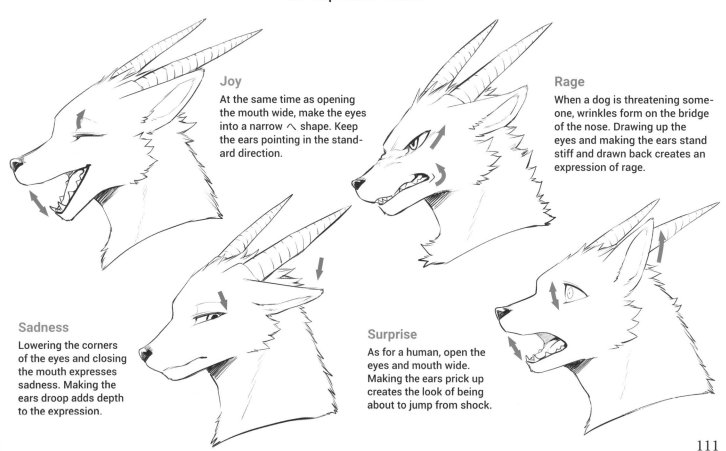

Joy

At the same time as opening the mouth wide, make the eyes into a narrow ∧ shape. Keep the ears pointing in the standard direction.

Rage

When a dog is threatening someone, wrinkles form on the bridge of the nose. Drawing up the eyes and making the ears stand stiff and drawn back creates an expression of rage.

Sadness

Lowering the corners of the eyes and closing the mouth expresses sadness. Making the ears droop adds depth to the expression.

Surprise

As for a human, open the eyes and mouth wide. Making the ears prick up creates the look of being about to jump from shock.

111

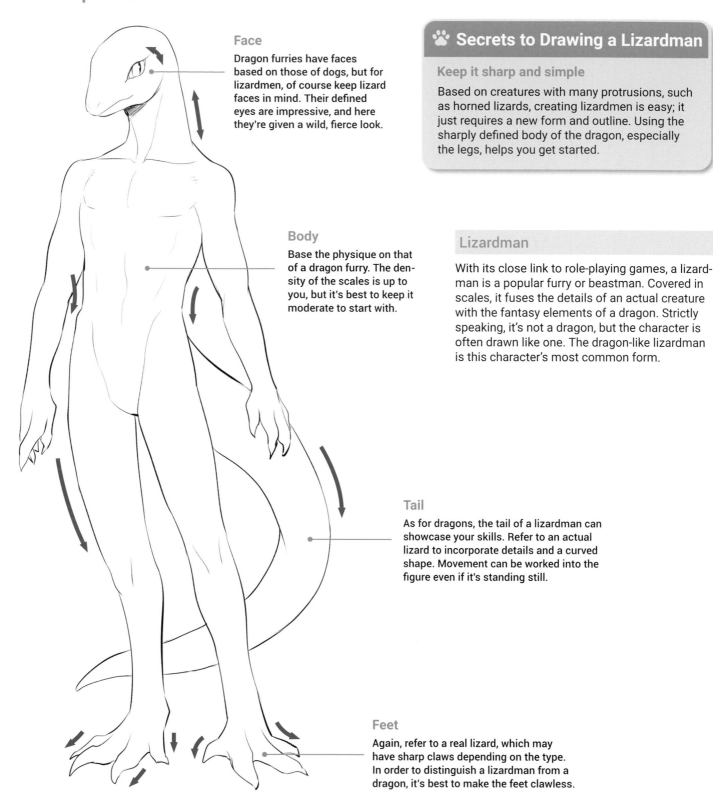

Face

Dragon furries have faces based on those of dogs, but for lizardmen, of course keep lizard faces in mind. Their defined eyes are impressive, and here they're given a wild, fierce look.

🐾 Secrets to Drawing a Lizardman

Keep it sharp and simple

Based on creatures with many protrusions, such as horned lizards, creating lizardmen is easy; it just requires a new form and outline. Using the sharply defined body of the dragon, especially the legs, helps you get started.

Body

Base the physique on that of a dragon furry. The density of the scales is up to you, but it's best to keep it moderate to start with.

Lizardman

With its close link to role-playing games, a lizardman is a popular furry or beastman. Covered in scales, it fuses the details of an actual creature with the fantasy elements of a dragon. Strictly speaking, it's not a dragon, but the character is often drawn like one. The dragon-like lizardman is this character's most common form.

Tail

As for dragons, the tail of a lizardman can showcase your skills. Refer to an actual lizard to incorporate details and a curved shape. Movement can be worked into the figure even if it's standing still.

Feet

Again, refer to a real lizard, which may have sharp claws depending on the type. In order to distinguish a lizardman from a dragon, it's best to make the feet clawless.

💡 A fantasy regular

Lizardmen are associated with dragons because of their similar appearance and how they've been intergrated into pop culture. In Kumo Kagyu's novella "Goblin Slayer," a lizard priest transforms into a dragon in order to raise his rank. In that world, dragons are higher ranking than lizards. In the popular game series Dragon Quest, the lizardman is established as being a dragon-style monster, and its wings make it look exactly like a dragon.

How to Draw a Lizardman's Face

Making a lizard's face into a human's

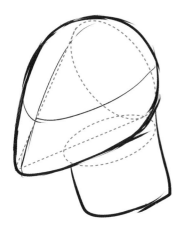

① Blocking-in

Stack a conical form onto a cylinder and make a cross over the face to determine the position of the eyes and mouth. Think of it as drawing a human face.

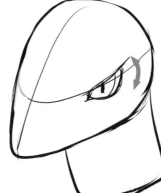

② Blocking-in the muzzle

Decide on the form and position of the eyes. Lizards' eye can be roughly divided into those with vertical and those with round pupils. Here, they're vertical to create a more piercing appearance.

③ Overall rough sketch

Lizards have eyelids that slide over the eye from the bottom lid upward. While this is subtle, it's a point that differentiates them from dragons, so it's a good idea to incorporate this detail into a drawing.

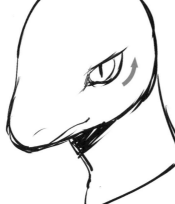

④ Make a clean copy

This is the finished work. The mouth and bridge of the nose on a lizard are clearly different from those of a human. Here, the nose has been made extremely low.

Lizardmen's Expressions

Use the mouth and eyes to differentiate among emotions

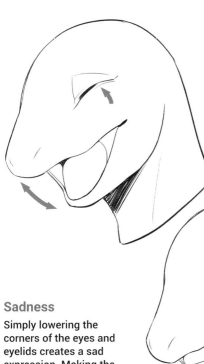

Joy

As for dragons, make the eyes a ∧ shape and open the mouth wide to indicate joy. Note the human-like depiction of the eyelid.

Rage

The vertical pupils are effective for showing expression. Make them smaller than usual and curve the corners of the mouth.

Sadness

Simply lowering the corners of the eyes and eyelids creates a sad expression. Making the mouth open halfway adds to the depth of emotion.

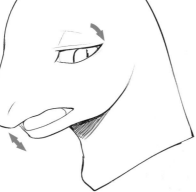

Surprise

The nose does not affect facial expression, so open the eyes and mouth wide and change the direction in which the face is pointing. It would seem one could even hear the creature's surprised voice.

Furry Babies

Let's compare the forms of different species' babies. Excluding baby birds that resemble bipedals and killer whales that only have tails, mammals don't walk on two legs as babies. Human babies crawl on all fours, and the bone structures of all types of furries in infancy take the original quadrupeds as their models. Looking at the illustrations below, you'll see that most furry babies have large heads and eyes. This is because, in contrast to the body, which gets bigger, the head and in particular the size of the eyeballs remain the same. On the other hand, the muzzle in most furries is short in infancy and gets longer as the creature matures.

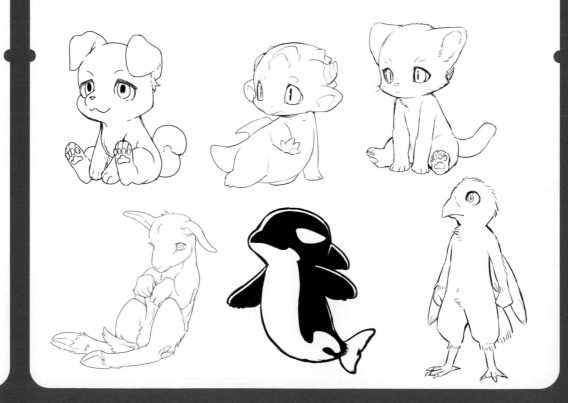

Finned Furries and Sea Creatures

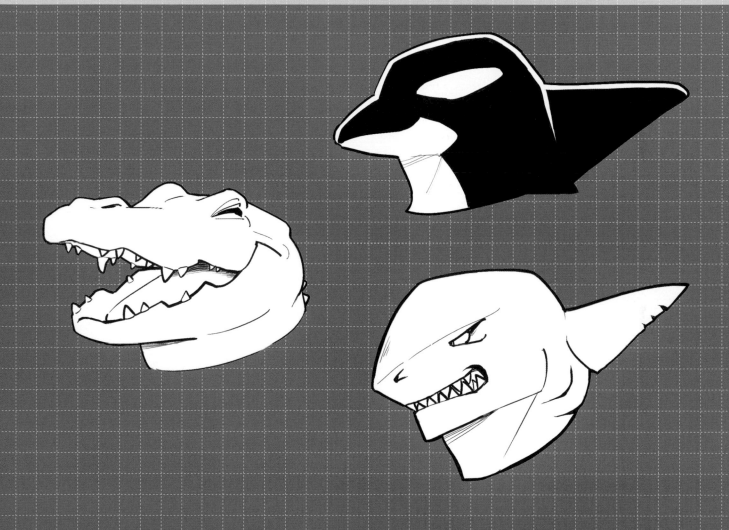

Marine-Based Furries: Killer Whale

Finally, the most unusual of the unusual, the marine mammals that have returned to the ocean from the land. Their bodies are similar in form to those of fish, but there are parts within their bone structure that are the same as those of humans. We'll look at other underwater creatures as well.

Male Furry Killer whale: the sea's massive mammal

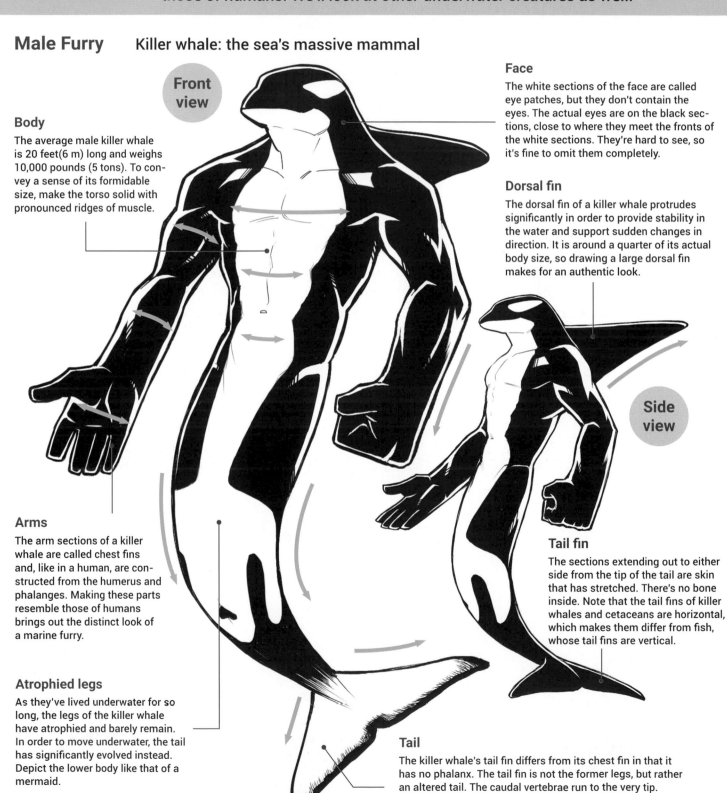

Front view

Side view

Body

The average male killer whale is 20 feet(6 m) long and weighs 10,000 pounds (5 tons). To convey a sense of its formidable size, make the torso solid with pronounced ridges of muscle.

Face

The white sections of the face are called eye patches, but they don't contain the eyes. The actual eyes are on the black sections, close to where they meet the fronts of the white sections. They're hard to see, so it's fine to omit them completely.

Dorsal fin

The dorsal fin of a killer whale protrudes significantly in order to provide stability in the water and support sudden changes in direction. It is around a quarter of its actual body size, so drawing a large dorsal fin makes for an authentic look.

Arms

The arm sections of a killer whale are called chest fins and, like in a human, are constructed from the humerus and phalanges. Making these parts resemble those of humans brings out the distinct look of a marine furry.

Tail fin

The sections extending out to either side from the tip of the tail are skin that has stretched. There's no bone inside. Note that the tail fins of killer whales and cetaceans are horizontal, which makes them differ from fish, whose tail fins are vertical.

Atrophied legs

As they've lived underwater for so long, the legs of the killer whale have atrophied and barely remain. In order to move underwater, the tail has significantly evolved instead. Depict the lower body like that of a mermaid.

Tail

The killer whale's tail fin differs from its chest fin in that it has no phalanx. The tail fin is not the former legs, but rather an altered tail. The caudal vertebrae run to the very tip.

Female Furry A sleek and lithe figure

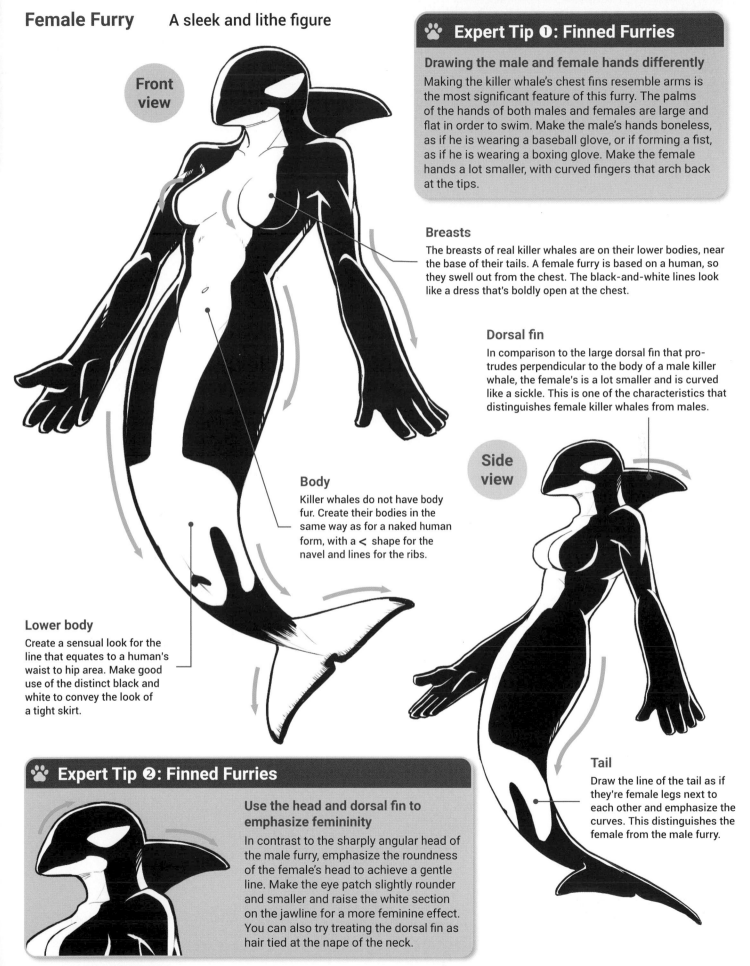

Front view

🐾 Expert Tip ❶: Finned Furries

Drawing the male and female hands differently

Making the killer whale's chest fins resemble arms is the most significant feature of this furry. The palms of the hands of both males and females are large and flat in order to swim. Make the male's hands boneless, as if he is wearing a baseball glove, or if forming a fist, as if he is wearing a boxing glove. Make the female hands a lot smaller, with curved fingers that arch back at the tips.

Breasts

The breasts of real killer whales are on their lower bodies, near the base of their tails. A female furry is based on a human, so they swell out from the chest. The black-and-white lines look like a dress that's boldly open at the chest.

Dorsal fin

In comparison to the large dorsal fin that protrudes perpendicular to the body of a male killer whale, the female's is a lot smaller and is curved like a sickle. This is one of the characteristics that distinguishes female killer whales from males.

Side view

Body

Killer whales do not have body fur. Create their bodies in the same way as for a naked human form, with a < shape for the navel and lines for the ribs.

Lower body

Create a sensual look for the line that equates to a human's waist to hip area. Make good use of the distinct black and white to convey the look of a tight skirt.

🐾 Expert Tip ❷: Finned Furries

Use the head and dorsal fin to emphasize femininity

In contrast to the sharply angular head of the male furry, emphasize the roundness of the female's head to achieve a gentle line. Make the eye patch slightly rounder and smaller and raise the white section on the jawline for a more feminine effect. You can also try treating the dorsal fin as hair tied at the nape of the neck.

Tail

Draw the line of the tail as if they're female legs next to each other and emphasize the curves. This distinguishes the female from the male furry.

Bone Structure A human upper body; a killer whale head and lower body

Furry bone structure

The shoulder blades protrude prominently to support the thick arms. The length ratio of the humerus and forearm bones is similar to those of humans, but the thickness differs significantly. The phalanges are even thicker, exactly like gloves. The spinal vertebrae flow directly to the caudal vertebrae, forming the lower body. The definitive feature of the killer whale furry is its pelvis, which should have atrophied, but remains solidly present.

Animal bone structure

Along with other cetaceans, killer whales are a species that has returned to the marine environment after living on land. For this reason, when looking at their bone structure, many of their body parts are surprisingly similar to those of land dwelling mammals. Although the measurements differ, the form of the arm bones and phalanges retain the vestiges of front legs. The hind legs have atrophied, but traces of what was the pelvis remain in the bone structure.

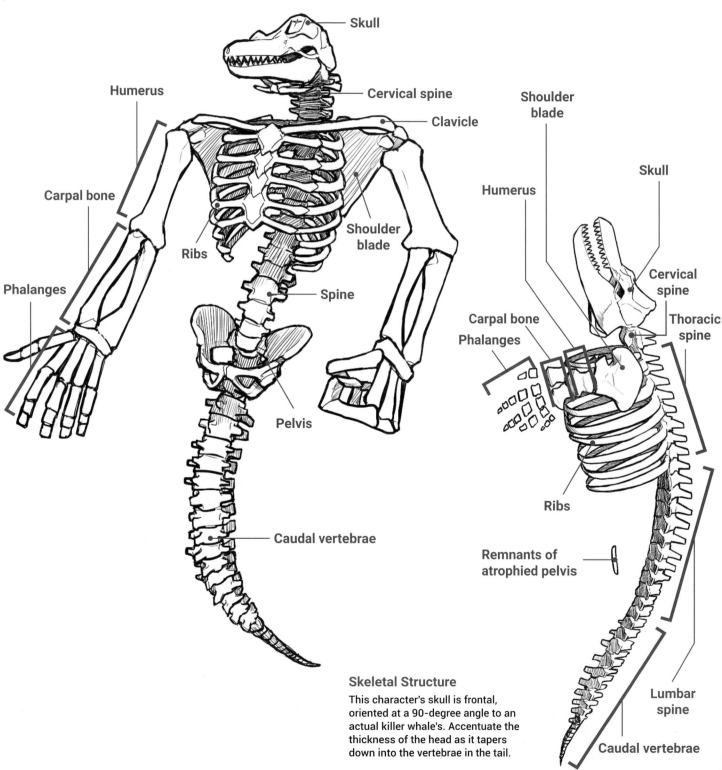

Skeletal Structure

This character's skull is frontal, oriented at a 90-degree angle to an actual killer whale's. Accentuate the thickness of the head as it tapers down into the vertebrae in the tail.

118

How to Draw the Body Use black and white to divide the body and emphasize muscles

① **Blocking-in**

Divide the killer whale furry's body into segments to create the blocked-in figure. The lower body is in the form of a tail but think of it as human legs lined up together.

The position of the killer whale's eyes is difficult to make out and the facial expression is simple, so use the gestures of the arms and fingers to express emotion.

The tail fin is different from that of a fish as it runs parallel to the shoulder blades. Don't make it too big—aim for it to be about double the size of human feet.

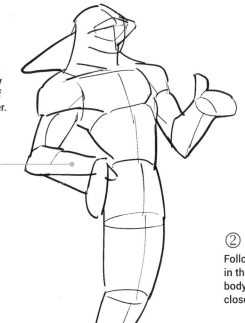

② **Rough sketch**

Follow the blocking-in to add in the muscles. As there's no body hair, make the upper body closely resemble a human's.

③ **Line drawing**

Make a clean copy. Now is the time to add in the lines separating the killer whale's characteristic black-and-white markings.

Refer to images of actual killer whales to create the lines for the black-and-white markings. Match the markings to the physique to bring out individual character.

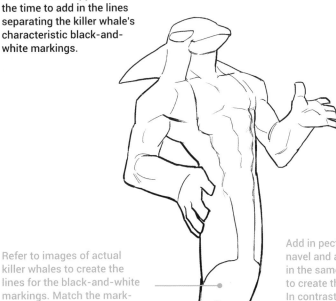

Add in pectoral muscles, the navel and abdominal muscles in the same way as for a human to create the look of strength. In contrast, use simple curves for the lower body (tail) for a cohesive result.

④ **Completion**

Apply black and white to the appropriate sections. Use white highlights to make the muscles in the black sections stand out and create a sense of dimension.

119

How to Draw the Face Use simple lines for the composition

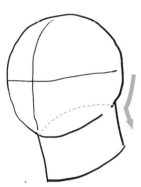

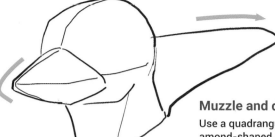

Blocking-in for the face

Create a small, slightly elliptical shape for the face. In order to create the appearance of cohesion between the thick neck and the head, block-in the neck at this time.

Muzzle and dorsal fin

Use a quadrangular pyramid with a diamond-shaped cross section to form the muzzle. To the back of the head, add a dorsal fin that is about the same length as the width of the head.

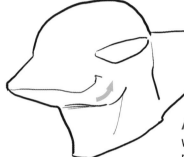

Add the facial contours

While being aware of the actual positioning of the eyes, add in the long horizontal eye patches. Slightly lifting the corners of the mouth adds expression.

Make a clean copy

Add black and white. Incorporating highlights along the cheek and edges of the dorsal fins at this time brings out the killer whale's characteristic gloss and solidity. The shape of the eyepatch and the opening of the mouth are two of the limited ways for bringing out expression.

Adding Expression Use the teeth and eyepatch to express emotion

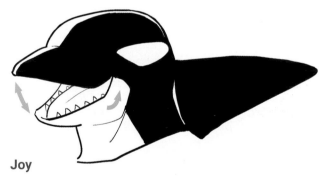

Joy

Raise the upper jaw and emphasize the sections of the mouth that are lifted. Don't make the teeth too sharp and keep the tongue soft for a good-humored appearance. Rounding the upper part of the eye patch makes for a smiling expression.

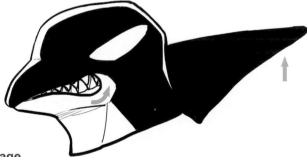

Rage

Place significant emphasis on the fangs, baring the teeth all the way to the gums. Sharpen the line of the eye patch and slightly raise the dorsal fin for an infuriated look. Firming up the facial outline also conveys the intensity of the rage.

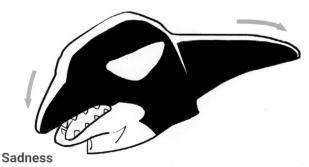

Sadness

Significantly lower the line of the upper jaw and the dorsal fin to create the overall sense of deflation. Making the upper edge of the eye patch slightly concave adds to the expression of sadness.

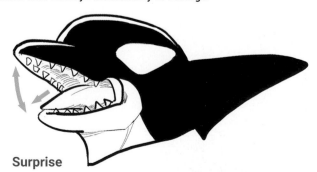

Surprise

Make the mouth open so wide that the inside of the upper jaw is visible. Make the tongue protrude slightly to create the look of alarm. Slightly rounding the eye patch makes the eyes appear open wide.

Angles of the Face Grasp the three-dimensional effect from various angles

Side

Use the thick neck as a platform to hold the spindle-shaped head. It's easy to make out the line from the roundness of the cheeks through to the muzzle. The surface between the back of the head and the dorsal fin is practically flat, with no uneven sections.

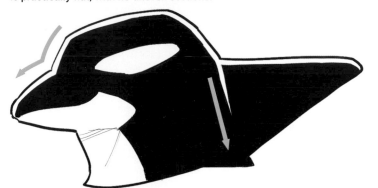

Diagonal

The killer whale's head section viewed from slightly above takes on the form of a baseball helmet with gentle curves.

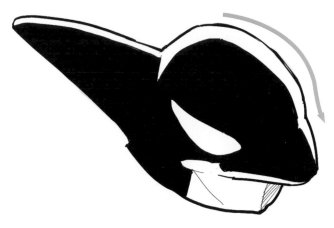

Front view

The real eyes of a killer whale furry are just beyond the front edges of the eye patches, as they are in fact looking straight ahead. The head and neck are practically the same width.

🐾 Expert Tip ❸: Finned Furries

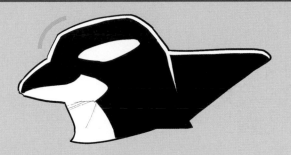

The secret to the rounding of the cheeks

The rounded section of the cheeks contains fatty tissue. Ultrasonic waves are irradiated from here, producing echoes to seek out objects in the water. In some ways, they're more important sensory organs than the eyes. This rounding of the cheeks is one of the characteristic features of the killer whale.

View from above

This shows the killer whale furry viewed from almost directly overhead. The muzzle section is slightly pointed. Be sure to make good use of this kind of sharpness when drawing killer whales.

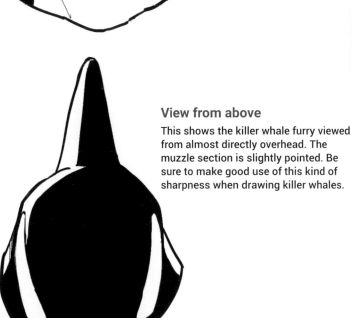

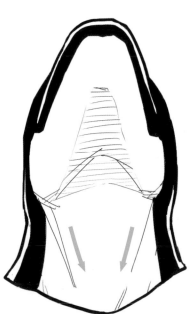

View from below

From the neck to the lower jaw is nearly completely white. Adding in the lines for the sternocleidomastoid tendons brings out a solid, strong look.

Beastly Hands The transition from hands to fins

① Human hands

The hands are the same form as human hands. As the surface of a killer whale's body is black, they appear to be wearing black gloves, and there are no nails.

② Large, square hands

The hands are large, squarish and slightly flat in order to powerfully swim through water. They're still able to grip objects.

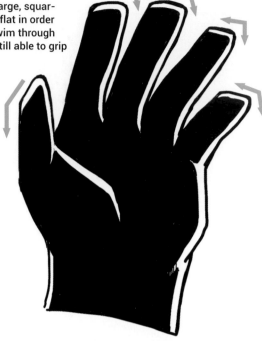

③ Hands in the form of fins

The fingers become broader and flatter, and when lined up together resemble a fin. This is close to the internal bone structure of an actual killer whale.

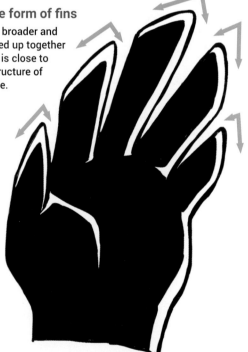

④ Chest fin

The form is exactly the same as that of a chest fin. You can either make just the palm of the hand into a fin or make the whole arm into a chest fin.

💡 Whales and hippos are relatives!?

The ancestors of whales, including killer whales, lived on land. Looking at the skeleton of a whale, traces of the pelvis remain in the lower body, indicating that there was a time when whales walked on the earth. What kind of creatures were the ancestors of whales, before they returned to the oceans? Recent research using DNA analysis has given rise to the prevailing theory that they were a kind of even-toed ungulate who shares a common ancestor with the contemporary hippopotamus.

Beastly Feet Transform two legs into a tail fin

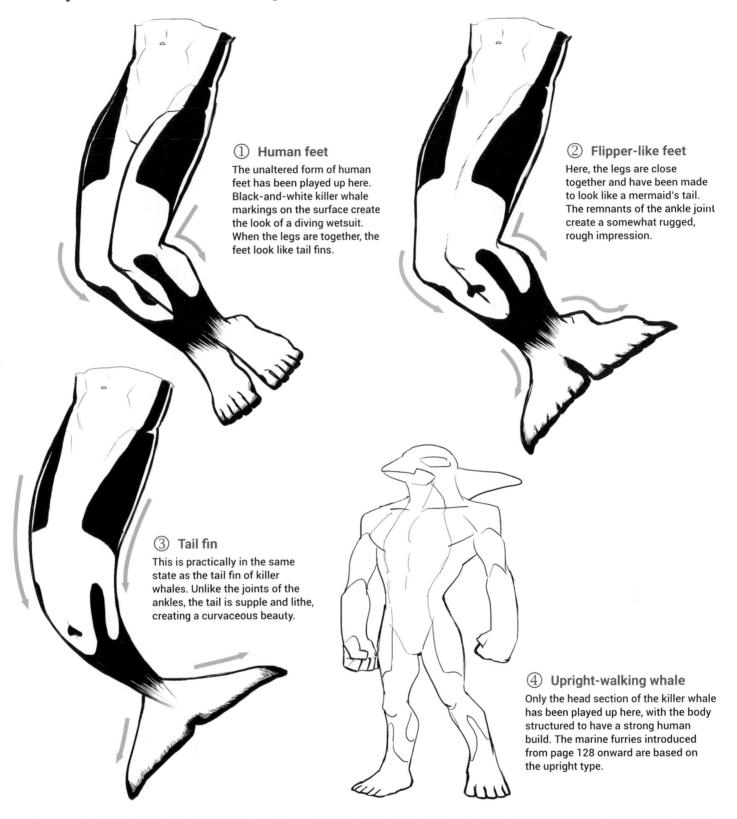

① Human feet

The unaltered form of human feet has been played up here. Black-and-white killer whale markings on the surface create the look of a diving wetsuit. When the legs are together, the feet look like tail fins.

② Flipper-like feet

Here, the legs are close together and have been made to look like a mermaid's tail. The remnants of the ankle joint create a somewhat rugged, rough impression.

③ Tail fin

This is practically in the same state as the tail fin of killer whales. Unlike the joints of the ankles, the tail is supple and lithe, creating a curvaceous beauty.

④ Upright-walking whale

Only the head section of the killer whale has been played up here, with the body structured to have a strong human build. The marine furries introduced from page 128 onward are based on the upright type.

💡 Animals whose feet have become tail fins

The flipper-like feet in step 2 above closely resemble the hind quarters of actual seals and sea lions. Like cetaceans, these creatures are mammals that live in the ocean. They are classified as pinnipeds, which means that they are mammals whose limbs have become fins. They are further divided into Phocidae, Otariidae, Odobenidae and so on, and are characterized by their tail fin-like hind quarters. They can also move around on land.

Marine Furries' Physiques

Use fat and muscle distribution to show the differences

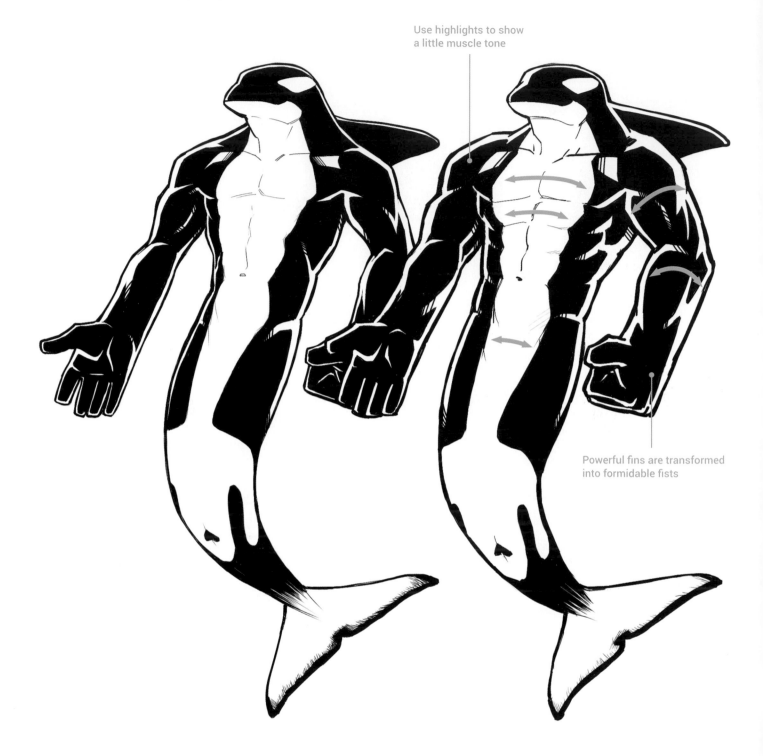

Use highlights to show a little muscle tone

Powerful fins are transformed into formidable fists

Average

Swimming all day through rough waves, marine furries fundamentally possess muscular, powerful bodies. Furthermore, they're an attractive species thanks to the curves that make them less susceptible to water resistance.

Muscular

Among the already formidable marine furries, the killer whales stand out as being particularly muscular and rugged. The pectoral and abdominal muscles are firm and taut. Use highlights on the deltoids and humerus muscles to define the bulges.

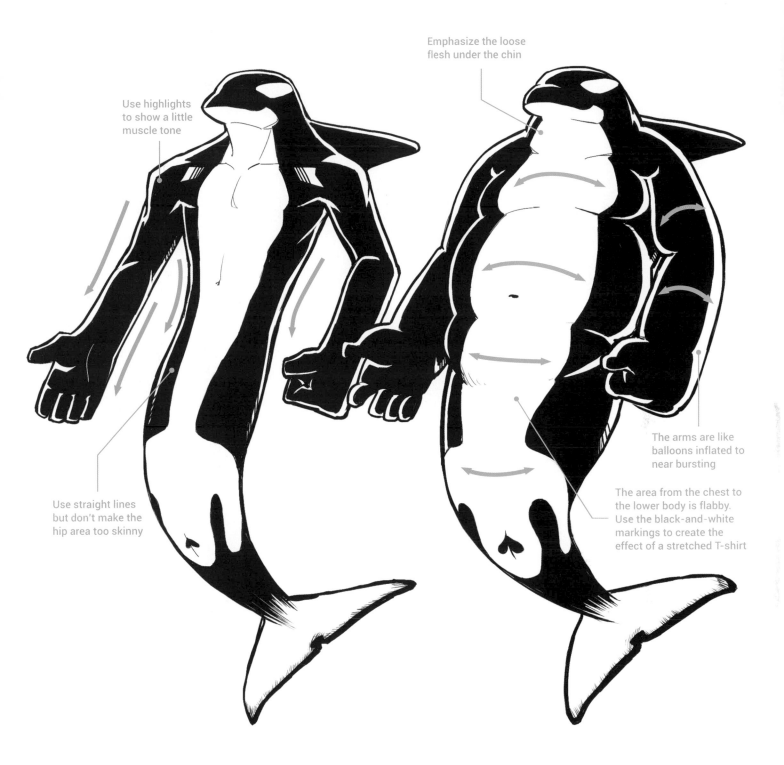

Use highlights to show a little muscle tone

Use straight lines but don't make the hip area too skinny

Emphasize the loose flesh under the chin

The arms are like balloons inflated to near bursting

The area from the chest to the lower body is flabby. Use the black-and-white markings to create the effect of a stretched T-shirt

Slim

Although a slim build, the thick neck and high shoulders remain as default features, resulting in a slim, powerful body. Don't emphasize the pectoral or abdominal muscles and use straight lines for the arms to create a neat figure.

Plump

The most uncommon form is a marine furry with an obese build. The entire body takes on a rounded shape as if it's swelled from fat. The best part is the chest, which is twice the width of the shoulders.

Marine Furries' Ages Draw features to show age differences

💡 A killer whale's physique doesn't change!?

A newborn killer whale has actually nearly exactly the same build as its parents. This is so it can swim by itself and rise to the surface of the water to breathe immediately after birth, an absolute requirement in order to survive.

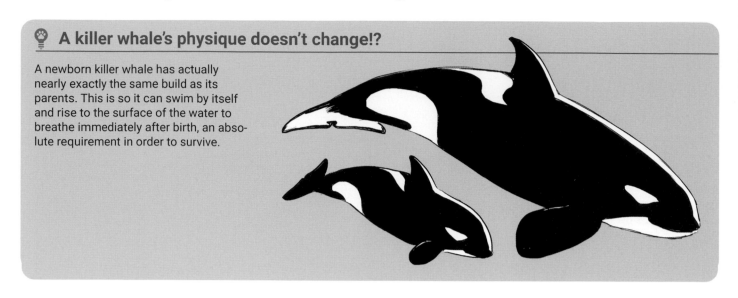

Youth (6–14 years)

Standing about five heads tall, the youthful figure has a large head and short neck with sloping shoulders. There's no indication of muscle in the torso, which is formed from straight lines.

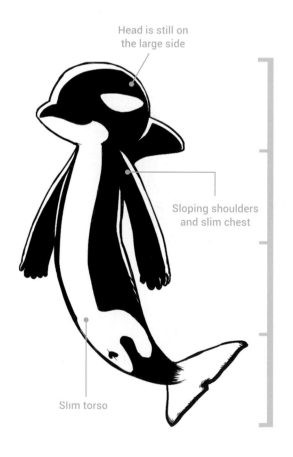

Head is still on the large side

Sloping shoulders and slim chest

Slim torso

Infancy (0–5 years)

The head is large and the stomach protrudes on an infant figure. The arm sections are depicted as having short fingers, making them practically fins. Try for the adorable look of a killer whale stuffed toy.

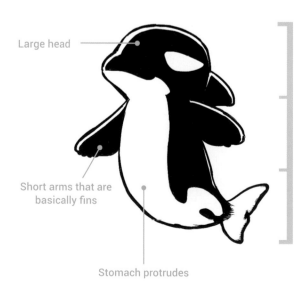

Large head

Short arms that are basically fins

Stomach protrudes

The ages indicated are based on human ages.

Adulthood (20 years and over)

The thick neck joined directly to the shoulders and the spectacular dorsal fin can be seen as evidence of full maturity. Make the thickness of the arms and size of the hands double those of the youth.

Adolescence (15–19 years)

While there are still traces of immaturity in the rounded head, the neck area that supports it is well-defined. The area from the shoulders to the arms is thin but has some muscle.

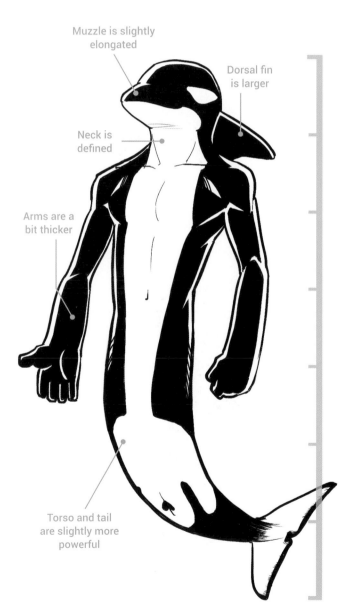

Muzzle is slightly elongated

Dorsal fin is larger

Neck is defined

Arms are a bit thicker

Torso and tail are slightly more powerful

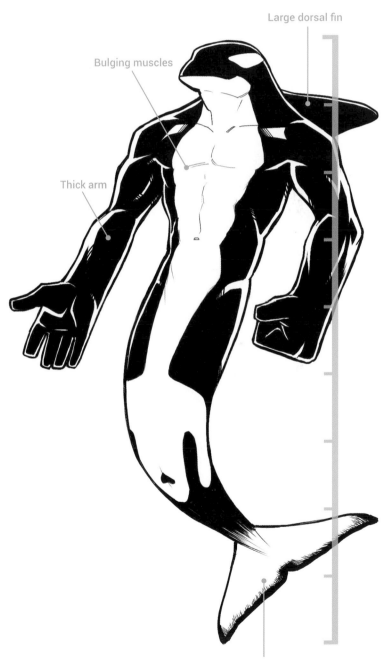

Large dorsal fin

Bulging muscles

Thick arm

Horizontal tail fin

Variation ❶ Dolphin

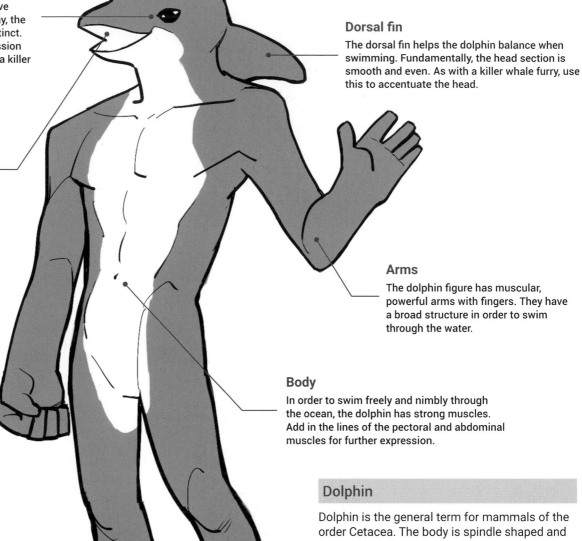

Eyes

The eyes are large and have eyelids. As the body is gray, the position of the eyes is distinct. It's easier to create expression in dolphins' eyes than for a killer whale furry's.

Mouth

The facial features are simple, so it's fine to create expression by opening or closing the mouth. There are small, detailed teeth too.

Dorsal fin

The dorsal fin helps the dolphin balance when swimming. Fundamentally, the head section is smooth and even. As with a killer whale furry, use this to accentuate the head.

Arms

The dolphin figure has muscular, powerful arms with fingers. They have a broad structure in order to swim through the water.

Body

In order to swim freely and nimbly through the ocean, the dolphin has strong muscles. Add in the lines of the pectoral and abdominal muscles for further expression.

Legs

Unlike the killer whale furry, this figure walks upright. However, the legs should be visualized as being used for swimming when in water, so make them neat and lean.

Dolphin

Dolphin is the general term for mammals of the order Cetacea. The body is spindle shaped and the upper and lower jaws hold many teeth. Many types have mouths resembling beaks and feed on squid and fish. Another characteristic is that many have dorsal fins.

Types such as the common dolphin, Pacific white-sided dolphin and bottlenose dolphin live in the ocean, but some types such as river dolphins live in freshwater. Most travel in pods and are intelligent, even conversing among themselves.

The secret of dolphin skin

Dolphins have taut, elastic skin that is smooth like rubber. It's composed of thick skin and fat and greatly assists when swimming at high speed. The skin cells renew extremely quickly, approximately once every two hours. Therefore, even when attacked and injured by an enemy, dolphins rarely die from bleeding. However, they're very susceptible to dryness and are not able to regulate their body temperature when subjected to direct sunlight for long periods of time, leading to dehydration and heat stroke.

Variation ❷ Whale

Mouth

The upper and lower jaws are covered with crusty, scab-like layers of skin. The number of bumps and their shapes differs depending on the individual creature, so make use of them when drawing to distinguish your character.

Eyes

Whales' eyeballs are positioned low and to the back of the head and they're sunken in order to avoid water resistance. They're oriented slightly downward, and they have a wide field of vision in that direction. This is why they appear a bit sleepy.

Whales

These large mammals are built for aquatic life, with front limbs in the form of fins and hind limbs that have atrophied, with the tail's exodermis spreading horizontally like a tail fin. There's a thick layer of fat beneath the skin. Whales can remain underwater for long periods of time but occasionally expose their blowholes on the surface of the water in order to allow air into their lungs. About 80 species of whales are known, including the planet's largest species, the blue whale.

Body

In order to express the massive size, the body has the form of a chunky inverted triangle. It's packed with strong, firm muscle.

Arms

Among the types of whales, some have chest fins that are as long as $1/3$ of their body length, so make the arms longer and thicker than those of other marine furries. Add the layers of skin for powerful impact.

Legs

Complementing the chunky body and long arms, the legs are thick and short. Here, the overall look evokes a gorilla's physique.

☺ Baleen whales and toothed whales

Whales can broadly be divided into baleen whales and toothed whales. Toothed whales are characterized by types such as the killer whale, dolphins and sperm whales and have sharp teeth. They prey on fish and other marine mammals. Baleen whales don't have teeth but rather baleens growing from their top jaw that they use to take in vast quantities of sea water and eat the small creatures it contains, such as krill and small fish. The baleen is an organ that has developed from skin and is found only in whales of this order.

Other Species ❶ Shark

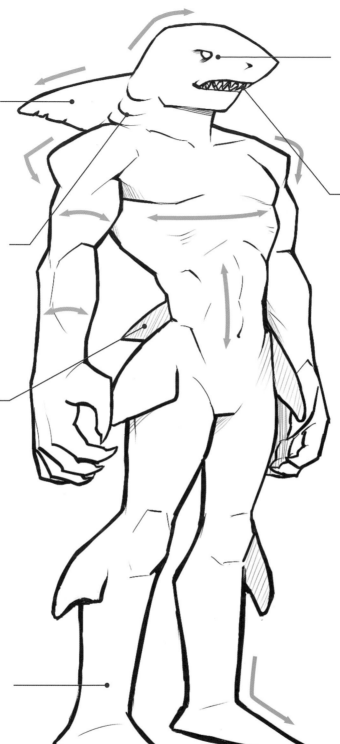

Back Fin

Triangular in shape, it's one of the shark's most distinctive features. Like on a killer-whale-based character, it's located on the back of the head placing weight on the neck.

Gills

While actual sharks have five gills on either side of the neck, here three seemed right, slits shaped like crescent moons.

Fins

Unlike marine mammals (dolphins, whales, etc.) sharks are fish, with the protruding fins that come with the part. Here front fins extend into arms, belly fins fan out to the left and right as well as flaring from the calves and buttocks.

Legs

Here the tail fin has been reinterpreted. A ridged line bulges down from the torso. Finish the feet off with pointed toes, giving them a tail-like flourish or finish.

Eyes

The eyes are sharp and in a single color with no pupils or other details drawn in. Real sharks have round eyes, but here the section above the eye forms a mound to create the look of eyebrows.

Teeth

The mouth is filled with many teeth that are long and triangular in shape. Stack them randomly in layers as on an actual shark in order to achieve a realistic result.

Shark

Shark is the general term for cartilaginous fish that have gills on the sides of their bodies. They have 5 to 7 sets of gills on their sides. Their bodies are long and slender and they generally have one large and one small dorsal fin. The top section of the vertical tail fin is longer than the lower section. They have several rows of teeth, with new teeth always growing to replace lost ones.

There are around 250 species of shark, and they're found throughout the world's oceans. In the waters around Japan, there are around 150 species including the basking shark, thresher shark, squaliform shark and sawshark. Some species have also advanced into deep-sea areas and freshwater habitats.

💡 There are no man-eating sharks!?

In reality, there are no man-eating sharks that like to attack and eat people. At times when large sharks encounter humans at close range, they mistake them for prey and attack them, resulting in accidents. The only sharks that are extremely dangerous are the bull shark, tiger shark and the great white shark. Most sharks aren't dangerous to humans.

How to Draw a Shark's Face An angular composition makes for a sharp facial structure

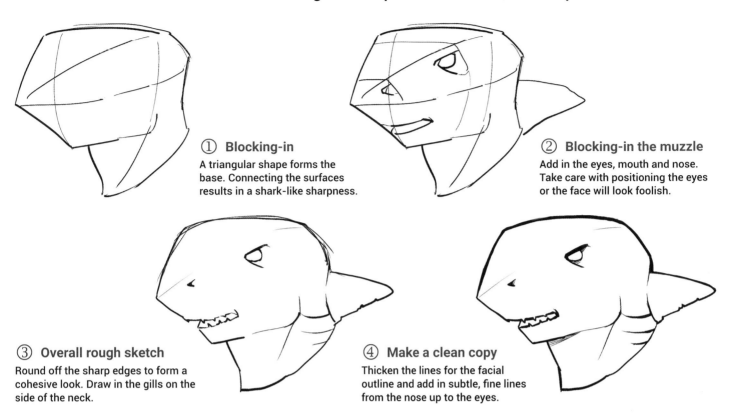

① Blocking-in

A triangular shape forms the base. Connecting the surfaces results in a shark-like sharpness.

② Blocking-in the muzzle

Add in the eyes, mouth and nose. Take care with positioning the eyes or the face will look foolish.

③ Overall rough sketch

Round off the sharp edges to form a cohesive look. Draw in the gills on the side of the neck.

④ Make a clean copy

Thicken the lines for the facial outline and add in subtle, fine lines from the nose up to the eyes.

Sharks' Expressions Create a face that isn't simply frightening, but rich in expression

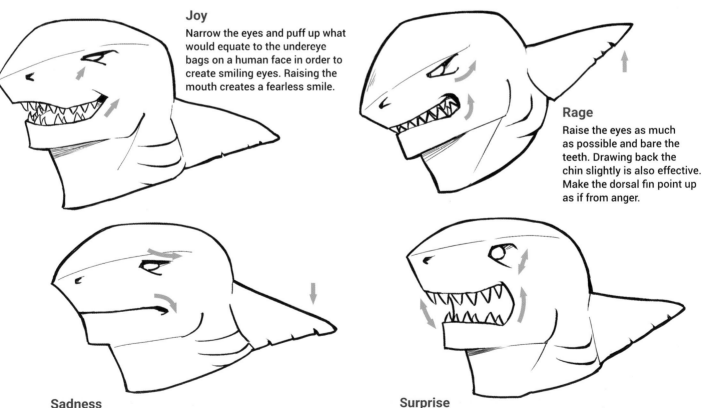

Joy

Narrow the eyes and puff up what would equate to the undereye bags on a human face in order to create smiling eyes. Raising the mouth creates a fearless smile.

Rage

Raise the eyes as much as possible and bare the teeth. Drawing back the chin slightly is also effective. Make the dorsal fin point up as if from anger.

Sadness

Lower the eyes and pull the mouth tightly closed. Not revealing the teeth is the key point at this time. Lower the dorsal fin too, as if it's lacking in strength.

Surprise

Make the eyes completely round and draw the mouth gaping open. Making the lower jaw slightly protrude exaggerates the look further.

Eyes

The eyes are large and the pupils are like those of a cat in that they're long and vertical and grow narrow in bright places. The irises are green or amber and sparkle attractively like gemstones.

Mouth

Large and small teeth on the upper and lower jaws interlace alternately. Emphasize bulges to bring out a powerful look.

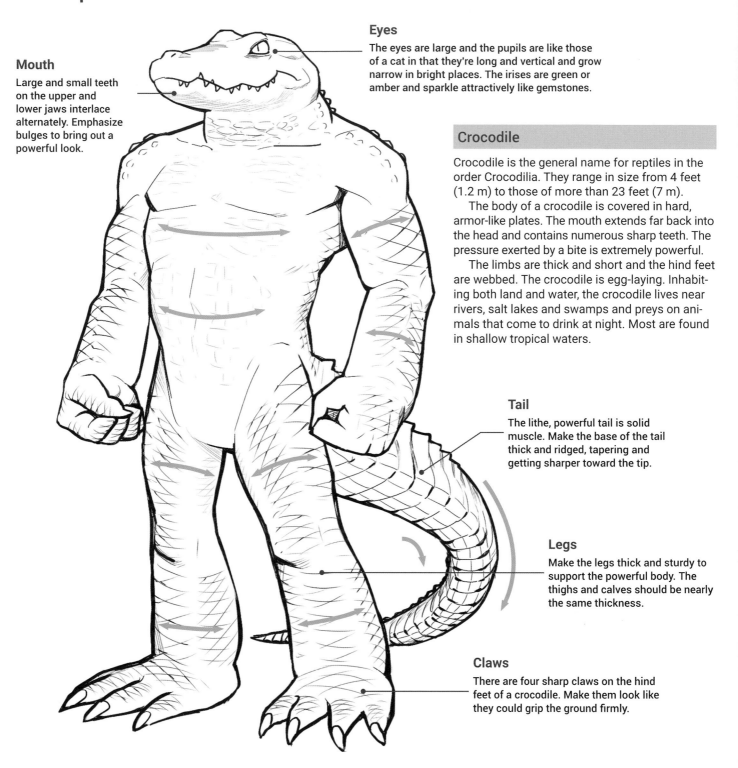

Crocodile

Crocodile is the general name for reptiles in the order Crocodilia. They range in size from 4 feet (1.2 m) to those of more than 23 feet (7 m).

The body of a crocodile is covered in hard, armor-like plates. The mouth extends far back into the head and contains numerous sharp teeth. The pressure exerted by a bite is extremely powerful.

The limbs are thick and short and the hind feet are webbed. The crocodile is egg-laying. Inhabiting both land and water, the crocodile lives near rivers, salt lakes and swamps and preys on animals that come to drink at night. Most are found in shallow tropical waters.

Tail

The lithe, powerful tail is solid muscle. Make the base of the tail thick and ridged, tapering and getting sharper toward the tip.

Legs

Make the legs thick and sturdy to support the powerful body. The thighs and calves should be nearly the same thickness.

Claws

There are four sharp claws on the hind feet of a crocodile. Make them look like they could grip the ground firmly.

💡 The differences between crocodiles and alligators

Animals of this order can be broadly divided into two species: crocodiles and alligators. Looking at an alligator's mouth from the side, the fourth tooth on the lower jaw fits in under the upper jaw and is not visible from the outside, while the same teeth on a crocodile are on the outside and have a fang-like appearance. In terms of looks, the crocodile has a more ferocious appearance.

How to Draw a Crocodile's Face

The mouth takes up nearly the whole face!? Getting the balance right

① **Blocking-in**

Use an egg-shaped sphere for the head, connecting it to a flat, oblong shape for the mouth. Add the protruding eyes and check the overall balance.

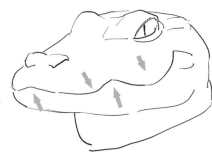

② **Blocking-in the muzzle**

Draw in the mouth, the key feature of the crocodile furry. Take care with the way the jaws interlace. Draw in cats' eyes.

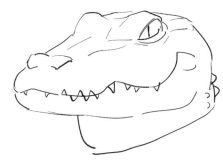

③ **Overall rough sketch**

Add in the teeth. Some come from the upper jaw and others from the lower jaw, so make sure to distinguish them as you draw. Add in the creases on the head.

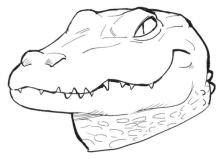

④ **Make a clean copy**

Add in scales and creases. Be careful to differentiate the texture of the tough scales toward the back of the head and those around the throat.

Crocodiles' Expressions

Give the reptilian face a charming look

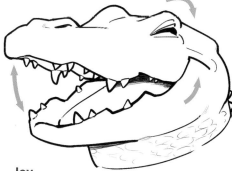

Joy

Close the eyes to create a smiling appearance. Pulling up the corners of the mouth creates a good-humored smile.

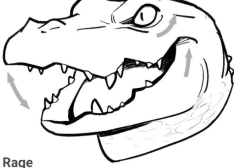

Rage

A crocodile's standard expression is frightening to start with, but raise the eyebrows and the corners of the mouth and widen the eyes to create a look of anger.

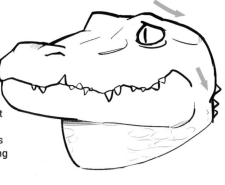

Sadness

Open the eyes wide and lower the area where the eyebrows would be so that they droop. Lowering the corners of the mouth gives the animal the look of being on the verge of tears.

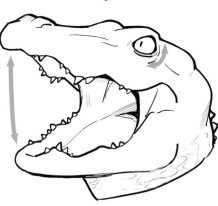

Surprise

Open the mouth beyond its widest limits. Make the eyes big and open wide, with the pupils rendered as mere dots. As the saying goes in Japanese to express surprise: "the eyes turned to dots."

Facial Expressions

Joy is an emotion that's particular to humans. However, few animals use muscles of facial expression to show joy, and apart from primates, they do not "smile."

This is because few creatures have evolved to communicate by expressing emotion using their faces the way that humans do. In fact, the concept of facial expressions itself could be said to be unusual in the animal kingdom. For this reason, apart from some mammals such as dogs and cats, most animals do not possess the ability to express actual emotion.

In the wild, expression is barely visible. In this book, we've incorporated human expressions onto the faces of animals.

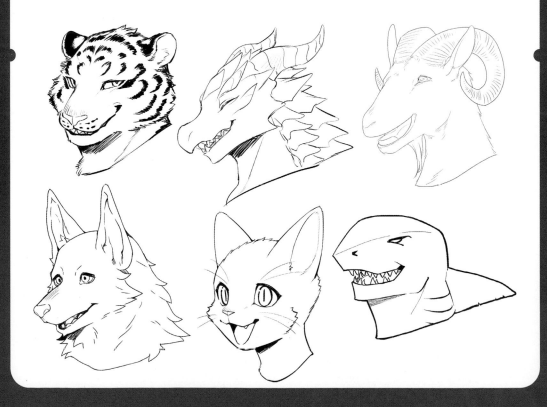

Furry Fine Points: Telling Your Characters Apart

Comparison of Actual Heights

Until this point, all the furries in this book have been presented at a uniform size. In this chapter, we'll compare the average sizes of the animals used as models for the furries. Whether to make all the animals the same size or to draw them to reflect their actual size is an important factor when creating characters.

Looking at Differences in Physique

Comparing body length via actual animals' average sizes

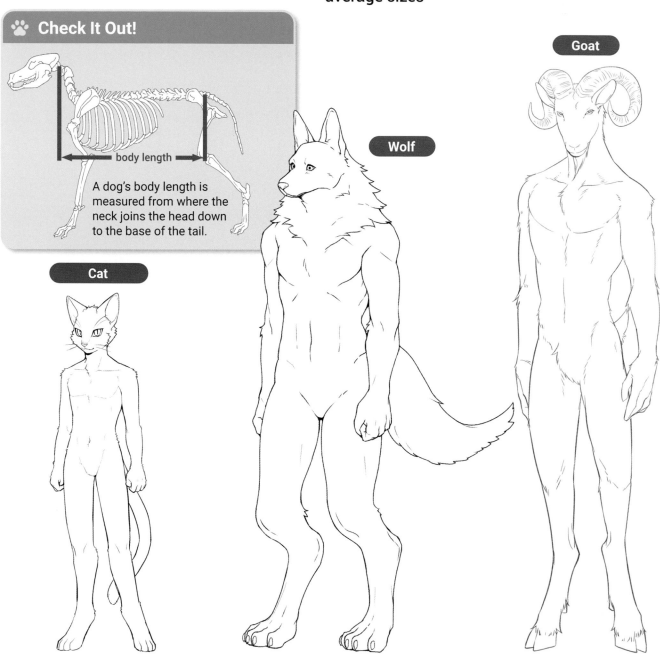

Check It Out!

body length

A dog's body length is measured from where the neck joins the head down to the base of the tail.

Cat

Wolf

Goat

16–20 inches (40–50 cm)

The smallest of the group, its compact size heightens its agility, allowing it to sneak up on prey without being detected.

32–40 inches (80–100 cm)

The wolf's build reflects the fact that its prey includes such large herbivores as deer, wild boar and moose. Still its body is well-proportioned, so it can pursue its prey for a long time over great distances.

40–60 inches (100–150 cm)

Goats actually have long bodies and the length of their lower bodies exceeds that of wolves. Their long legs are invaluable for covering ground with agility and speed.

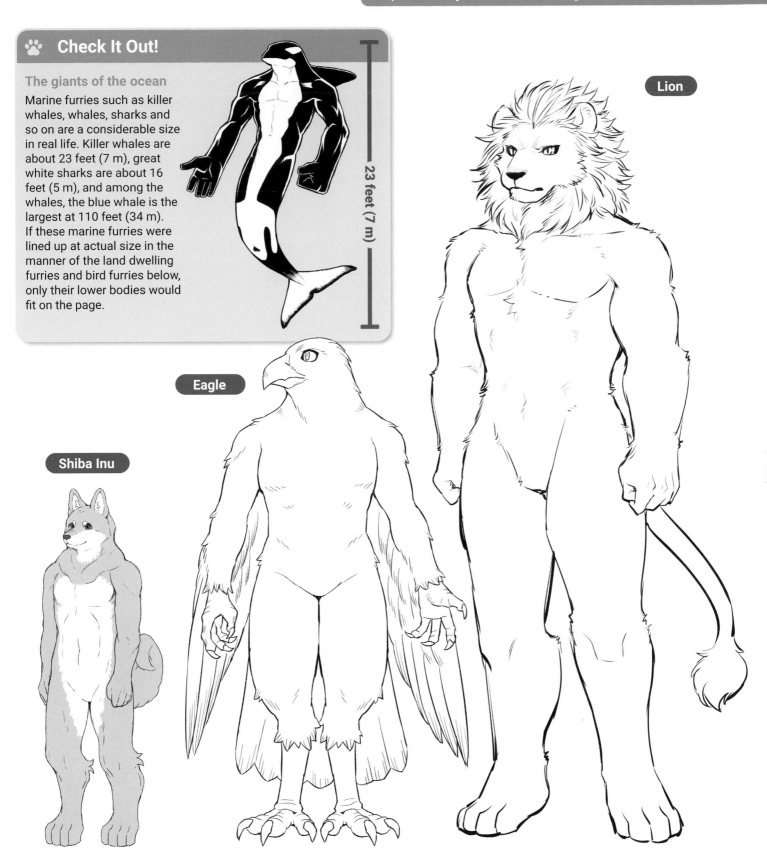

Check It Out!

The giants of the ocean

Marine furries such as killer whales, whales, sharks and so on are a considerable size in real life. Killer whales are about 23 feet (7 m), great white sharks are about 16 feet (5 m), and among the whales, the blue whale is the largest at 110 feet (34 m). If these marine furries were lined up at actual size in the manner of the land dwelling furries and bird furries below, only their lower bodies would fit on the page.

23 feet (7 m)

Lion

Eagle

Shiba Inu

15–20 inches (40–50 cm)

A medium-sized dog is about half the size of a wolf. These dogs were used since olden times in mountainous regions to assist in catching birds, rabbits and other small animals, and their size reflects this.

30–40 inches (80–100 cm)

An actual bald eagle's wing span is more than 6½ feet (2 m). As the legs have been made longer on the furry figure, the head to body ratio is on the higher side.

65–75 inches (170–190 cm)

The lion is the largest in this line-up. While it remains massive even when it is a furry, its head to body ratio is well-balanced.

Limbs and Appendages

The form of the hands and feet alter a great deal depending on the degree of evolution and on the surrounding environment. Here, all kinds of hands and feet have been divided them into four categories depending on the number of digits and the mode of walking.

Plantigrade

This means to walk on the soles of the feet, including the heels. As all five digits and the entire sole of the foot touch the ground, there's a sense of stability when standing. Then again, this isn't suitable for covering ground rapidly. When running, the heel's raised.

Digitigrade

This refers to walking on the tips of the toes with the heels raised off the ground. The four digits make contact with the ground to enable fast running. At the same time, such feet also allow for detailed movement such as quiet stalking of prey and making sharp turns.

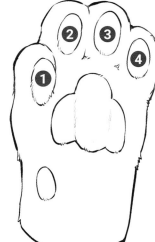

Unguligrade

This refers to walking with the heel raised and only the hooves at the end of the digits touching the ground. The two digits strike the ground powerfully, allowing these animals to run even faster than digitigrades.

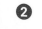

Fins

As cetaceans came to live underwater, they lost the need for legs to support their bodies, which is why their forelegs evolved into fins. The fin appears to be a single unit, but there are five digit bones that are remnants of when the animals lived on land.

Comparing Tails

Tails have various roles such as conveying emotion, providing a counterweight with which to maintain balance when running and steering when changing direction. Let's look at the differences in appearance of canine and feline tails.

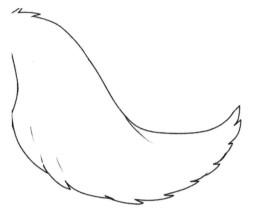

Structure of the tail

The tail contains caudal vertebrae, which are constructed from multiple bones. There are many muscles around the vertebrae, which enable various movements when they're contracted.

Canine tails

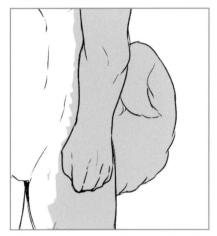

The curled-back tail of a shiba Inu
Work on the springy, rounded look.

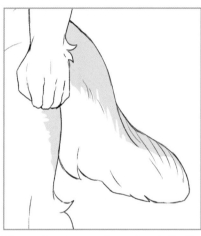

The voluminous drooping tail of a wolf
Add just a few lines to show the flow of the fur.

The fluffy fur of a fox's tail
Make the fur spring out in some places.

Feline tails

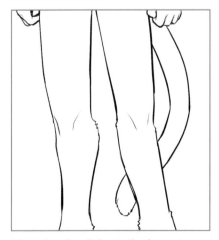

The slender, lithe tail of a cat
Make it face up or down, or even make it loop around.

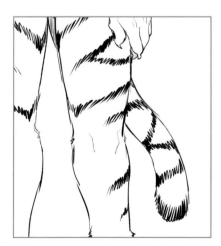

The strong, powerful tail of a tiger
Change the markings of the fur for a different look.

A tuft of fur at the tip of a lion's tail
It's fun to make only the ends of the fur move.

139

How to Draw It

Here, the dynamic, stylish physique of the furries has been reworked and transformed into the adorable chibi style. Consider how a furry youth would alter by looking at the omissions in the bone structure and the changes in physical proportions.

Chibi Tricks — Reflect characters' defining features in the chibi version

Here's a chibi furry with a slender build and tufts of hair on its head. The characteristics of tall furries and chibi beasts differ significantly. Let's find the different parts, using a tuxedo cat as a model.

Structure

A chibi beast is about 4.5 heads tall and has a small overall physique. Its build differs slightly from that of a juvenile in that there is a sharp, dynamic look to its silhouette.

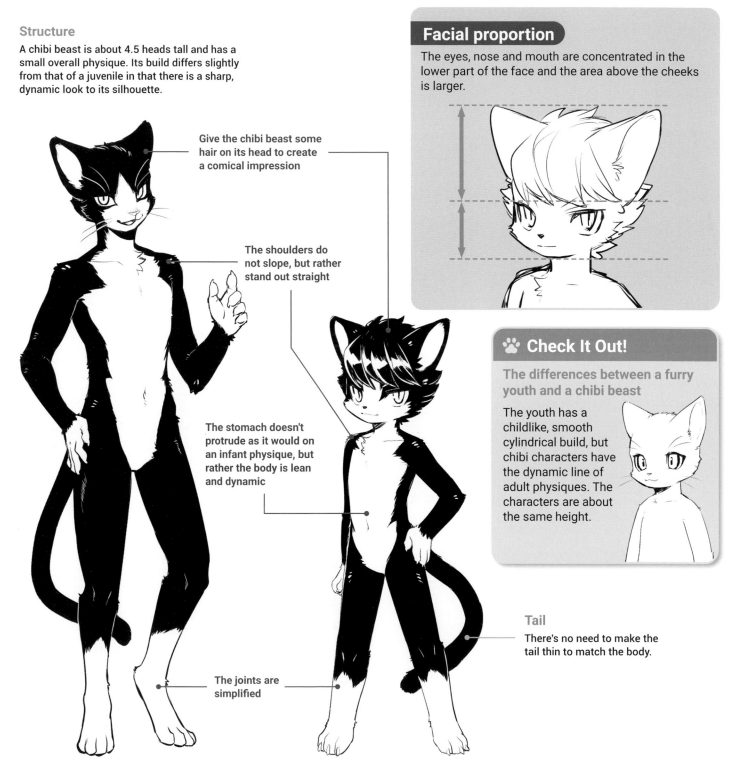

Give the chibi beast some hair on its head to create a comical impression

The shoulders do not slope, but rather stand out straight

The stomach doesn't protrude as it would on an infant physique, but rather the body is lean and dynamic

The joints are simplified

Facial proportion

The eyes, nose and mouth are concentrated in the lower part of the face and the area above the cheeks is larger.

🐾 **Check It Out!**

The differences between a furry youth and a chibi beast

The youth has a childlike, smooth cylindrical build, but chibi characters have the dynamic line of adult physiques. The characters are about the same height.

Tail

There's no need to make the tail thin to match the body.

Considering the Chibi Physique Apply chibi techniques to the blocks that make up the body

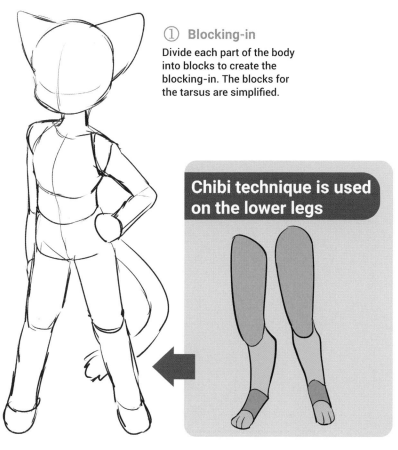

① Blocking-in

Divide each part of the body into blocks to create the blocking-in. The blocks for the tarsus are simplified.

Chibi technique is used on the lower legs

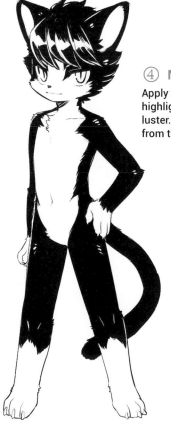

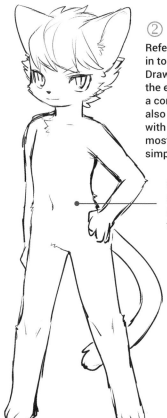

② Rough sketch

Refer to the lines for blocking-in to draw the rough sketch. Draw the double eyelids and the eyebrows and give the face a comical touch. The nose has also been created in chibi style, with a little triangle used at the most prominent part to express a simplified version of the nose.

Draw the position of the navel along the center line, keeping in mind the direction the body is facing.

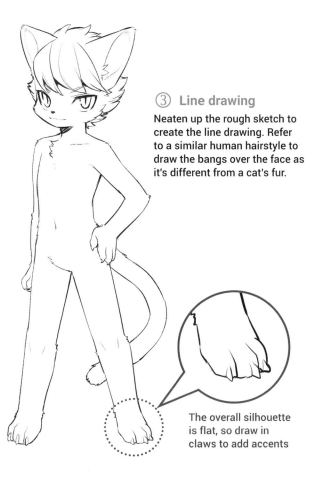

③ Line drawing

Neaten up the rough sketch to create the line drawing. Refer to a similar human hairstyle to draw the bangs over the face as it's different from a cat's fur.

The overall silhouette is flat, so draw in claws to add accents

④ Make a clean copy

Apply color to complete the work. Add highlights to the bangs to bring out luster. This makes the bangs stand out from the rest of the fur.

Before using chibi techniques

Before applying chibi techniques, this is the only fur on the head. Highlights are also low-key.

Steps to the Cover Illustration

The cover illustration shows furries wearing clothes. Here, we look at the process and little tricks for drawing an original illustration, as well as revealing the illustration that unfortunately didn't make the cut.

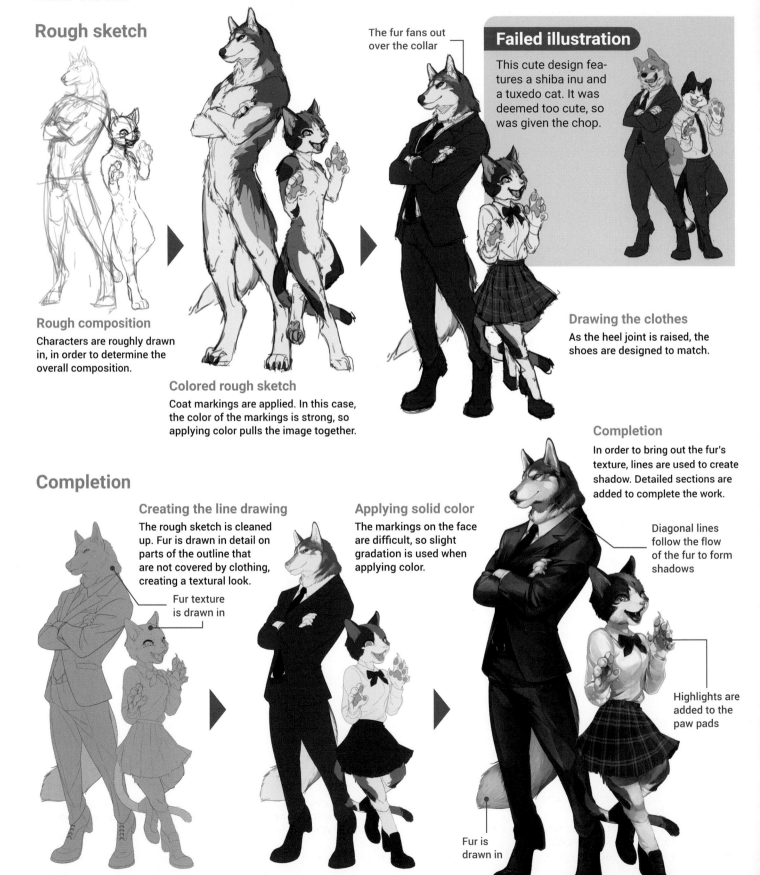

Rough sketch

The fur fans out over the collar

Failed illustration

This cute design features a shiba inu and a tuxedo cat. It was deemed too cute, so was given the chop.

Rough composition

Characters are roughly drawn in, in order to determine the overall composition.

Colored rough sketch

Coat markings are applied. In this case, the color of the markings is strong, so applying color pulls the image together.

Drawing the clothes

As the heel joint is raised, the shoes are designed to match.

Completion

In order to bring out the fur's texture, lines are used to create shadow. Detailed sections are added to complete the work.

Diagonal lines follow the flow of the fur to form shadows

Completion

Creating the line drawing

The rough sketch is cleaned up. Fur is drawn in detail on parts of the outline that are not covered by clothing, creating a textural look.

Fur texture is drawn in

Applying solid color

The markings on the face are difficult, so slight gradation is used when applying color.

Fur is drawn in

Highlights are added to the paw pads

ILLUSTRATORS' PROFILES

🐾 Muraki

is a freelance illustrator who specializes in character design and illustrations for books and games.

Credits: How to Draw Dog Furries
pp. 22–39

HP	https://iou783640.wixsite.com/muraki
Pixiv	https://www.pixiv.net/member.php?id=10395965
Twitter	@owantogohan

🐾 Hitsujirobo

specializes in character design as well as in illustrations and manga featuring animals and furries.

Credits: How to Draw Cat Furries
pp. 40–57

| Pixiv | https://www.pixiv.net/member.php?id=793067 |
| Twitter | @hit_ton_ton |

🐾 Yagiyama

is a freelance illustrator who designs and draws characters—mostly men and monsters—for play-by-web and social games.

Credits: How to Draw Hooved Furries
pp. 58–75

| HP | https://arcadia-goat.tumblr.com/ |
| Twitter | @singapura_ar |

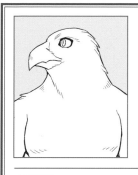

🐾 Yow

is an illustrator and manga artist specializing, most recently, in *kemono* (furry) characters.

Credits: How to Draw Bird Furries
pp. 78–95

HP	https://vish4ow.tumblr.com/
Pixiv	https://www.pixiv.net/member.php?id=60058
Twitter	@vish4ow

🐾 Madakan's

anthropomorphic illustrations are inspired primarily by insects and marine creatures.

Credits: How to Draw Marine Furries
pp. 116–133

HP	https://morderwal.jimdofree.com/
Pixiv	https://www.pixiv.net/member.php?id=13426936
Twitter	@morudero_2

References

- **Visual Museum**
 Skeleton: Steve Parker, translation by Relief Systems/published by Dohosha
- **Visual Museum**
 Mammal: Steve Parker, translation by Relief Systems/published by Dohosha
- **Drawing Animals 101.** How to draw with a veterinarian's eye: Mari Suzuki/published by Graphic
- **How to draw animals:** Jack Hamm, translation by xx Shimada/published by Kenpakusha
- **The science of creature design:** Understanding animal anatomy: Terryl Whitlatch, translation by Yuu Okubo/published by Maar
- **How to draw character sketches** by learning from anatomical figures/Kotaro Iwasaki and Kobo Kaneda/published by Seibundo Shinkosha

"Books to Span the East and West"

Tuttle Publishing was founded in 1832 in the small New England town of Rutland, Vermont [USA]. Our core values remain as strong today as they were then—to publish best-in-class books which bring people together one page at a time. In 1948, we established a publishing outpost in Japan—and Tuttle is now a leader in publishing English-language books about the arts, languages and cultures of Asia. The world has become a much smaller place today and Asia's economic and cultural influence has grown. Yet the need for meaningful dialogue and information about this diverse region has never been greater. Over the past seven decades, Tuttle has published thousands of books on subjects ranging from martial arts and paper crafts to language learning and literature—and our talented authors, illustrators, designers and photographers have won many prestigious awards. We welcome you to explore the wealth of information available on Asia at **www.tuttlepublishing.com**.

Published by Tuttle Publishing, an imprint of Periplus Editions (HK) Ltd.

www.tuttlepublishing.com

KEMONO NO EGAKIKATA
© 2019 GENKOSHA Co., Ltd.
English translation rights arranged with GENKOSHA Co. through Japan UNI Agency, Inc., Tokyo

ISBN 978-4-8053-1683-2

English Translation © 2021 by Periplus Editions (HK) Ltd.

Distributed by

North America, Latin America & Europe
Tuttle Publishing
364 Innovation Drive
North Clarendon, VT 05759-9436 U.S.A.
Tel: 1 (802) 773-8930; Fax: 1 (802) 773-6993
info@tuttlepublishing.com
www.tuttlepublishing.com

Japan
Tuttle Publishing
Yaekari Building 3rd Floor
5-4-12 Osaki
Shinagawa-ku
Tokyo 141-0032
Tel: (81) 3 5437-0171; Fax: (81) 3 5437-0755
sales@tuttle.co.jp
www.tuttle.co.jp

Asia Pacific
Berkeley Books Pte. Ltd.
3 Kallang Sector #04-01
Singapore 349278
Tel: (65) 6741-2178; Fax: (65) 6741-2179
inquiries@periplus.com.sg
www.tuttlepublishing.com

26 25 24 23 10 9 8 7 6 5

Printed in China 2306EP

TUTTLE PUBLISHING® is a registered trademark of Tuttle Publishing, a division of Periplus Editions (HK) Ltd.

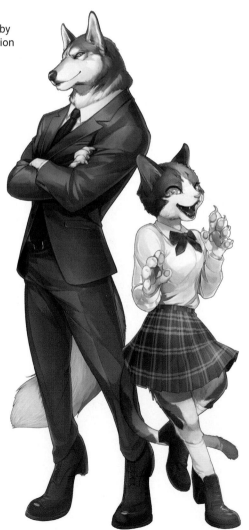